Splendors of Faith

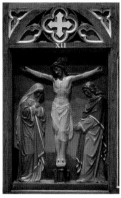
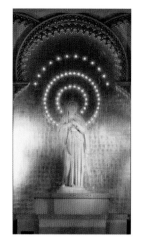

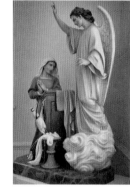

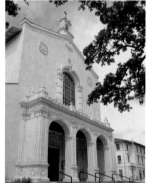

Splendors of Faith

NEW ORLEANS CATHOLIC CHURCHES, 1727–1930

TEXT BY Charles E. Nolan

PHOTOGRAPHS BY Frank J. Methe

LOUISIANA STATE UNIVERSITY PRESS)|(BATON ROUGE

Published by Louisiana State University Press
Copyright © 2010 by Louisiana State University Press
Photographs copyright © 2010 by Frank J. Methe
All rights reserved
Manufactured in China
FIRST PRINTING

DESIGNER: *Mandy McDonald Scallan*
TYPEFACE: *Aldus*
PRINTER AND BINDER: *Everbest Printing Co. through Four Colour Imports, Ltd., Louisville, Kentucky*

Library of Congress Cataloging-in-Publication Data
Nolan, Charles E.
 Splendors of faith : New Orleans Catholic churches, 1727–1930 / text by Charles E. Nolan ; photographs by Frank J. Methe.
 p. cm.
 Includes bibliographical references.
 ISBN 978-0-8071-3682-9 (cloth : alk. paper) 1. Church architecture—Louisiana—New Orleans. 2. Church decoration and ornament—Louisiana—New Orleans. 3. Christian art and symbolism—Louisiana—New Orleans—Modern period, 1500– 4. Catholic church buildings—Louisiana—New Orleans. 5. New Orleans (La.) —Buildings, structures, etc. I. Methe, Frank J., 1953– II. Title.
 NA5235.N57N65 2011
 282'.76335—dc22
 2010003945

The paper in this book meets the guidelines for permanence and durability of the Committee on Production Guidelines for Book Longevity of the Council on Library Resources. ∞

CONTENTS

Acknowledgments

I wish to thank Monsignor Crosby W. Kern, rector of the Cathedral-Basilica of St. Louis King of France, his staff, and the pastors and staffs of the other twelve parishes for generously helping Frank J. Methe and me as we visited and photographed the churches. Monsignor Kern extended the hospitality of the cathedral rectory during my New Orleans visits from the Gulf Coast. Dr. Emilie Leumas and the staff of the archdiocesan archives made available the rich resources that are woven into the thirteen church histories.

The staff of Louisiana State University Press not only first approached me about this project, but also assisted at every step along the way. Margaret Hart Lovecraft helped develop the book's plan and format, meticulously edited the drafts, and assisted Frank and me in every way. Catherine L. Kadair shepherded the manuscript through its final stages. Mandy Scallan designed the book's layout, combining text and photographs. Mary Lee Eggart prepared the map of parishes.

Splendors of Faith

INTRODUCTION

Ε VEN AS THIS BOOK GOES TO PRESS, the landscape of New Orleans Catholic churches is shifting. In every decade since the 1830s, the number and location of Catholic congregations as well as the edifices in which they worship have changed. A new church in a growing faubourg or new subdivision here; an old church in a declining or storm-damaged neighborhood no longer there.

The first New Orleans Catholic parish, St. Louis, was established in 1720 for the newly arriving French, Canadian, German, and other European colonists as well as the African slaves. The most recent seven Catholic parishes in Orleans civil parish were established in 2008 as part of a massive reorganization following Hurricane Katrina.

The East Bank of Orleans Parish, the subject of this volume, is a mere dot, a pinpoint, on the map of the vast original Diocese of Louisiana and the Floridas. Created in 1793 by Pope Pius VI at the urging of the Spanish king, the diocese stretched from the Florida Keys up the East Coast to the southern boundary of the newly established United States, then westward in a jagged line to the Mississippi River, and then northward up the river. The unchartered lands west of the Mississippi River reached to vague boundaries with the Spanish settlements and even into a small section of lower Canada. The area included all or part of more than forty-five future Catholic dioceses.

The original diocese was greatly reduced in size by the establishment of the vicariate-apostolic of Alabama and the Floridas (1825), as well as the dioceses of St. Louis (1826) and Natchez (1837). When the rapidly expanding Catholic Church in the United States was reorganized into provinces in 1850, New Orleans was among them and included Texas (Diocese of Galveston), Mississippi (Diocese of Natchez), Alabama and part of the Florida panhandle (Diocese of Mobile), and

1

Arkansas and Indian Territory (Diocese of Little Rock). The Province of New Orleans was eventually reduced to the state of Louisiana when the dioceses in other states were placed under the newly created Archdioceses of San Antonio (1926), Oklahoma City (1972), and Mobile (1980).

Within the state, new dioceses were created at Natchitoches (transferred to Alexandria) in 1853, Lafayette in 1918, Baton Rouge in 1961, Houma-Thibodaux in 1977, Lake Charles in 1980, and Shreveport in 1986. These dioceses together with the Archdiocese of New Orleans form the Province of New Orleans. The Archdiocese of New Orleans now encompasses only the eight civil parishes in and around New Orleans: Jefferson, Orleans, Plaquemines, St. Bernard, St. Charles, St. John, St. Tammany, and Washington.

Since the city of New Orleans's founding, Orleans Parish has had eighty-five Catholic parishes with their own church. A complete list is found in Appendix 2. The first major expansion began in the 1830s and lasted until the outbreak of the Civil War. An important factor was the successful ecclesiastical and legal effort to break the stranglehold by which the St. Louis Cathedral *marguilliers*, or church-wardens, tried to block the opening of new parishes. St. Patrick was established in 1833; St. Vincent de Paul in 1838; St. Augustine and St. Anthony (the former mortuary chapel) in 1841; St. Mary's Assumption in 1843; Annunciation and St. Joseph in 1844; and Holy Trinity in 1847. Thirteen additional parishes were established in Orleans Parish before 1860.

The second major expansion took place between 1915 and 1925. Population growth and a policy of establishing separate African American parishes resulted in fifteen new parishes. Ten new parishes were established in Orleans Parish in the decade following World War II, but most of the archdiocesan parish expansion happened in the suburbs in the surrounding civil parishes.

Declining neighborhoods in Orleans Parish due to migration to the suburbs, natural disasters, and changing ethnic and racial attitudes have resulted in parish mergers and closings, always a difficult and painful process. Holy Redeemer and St. Michael closed after Hurricane Betsy in 1965. Annunciation, St. Cecilia, St. Gerard for the Hearing Impaired, Sts. Peter and Paul, and St. Vincent de Paul were merged to form Blessed Francis Xavier Seelos Parish in 2001.

The most dramatic change in the Catholic parish landscape of New Orleans took place in the three years immediately following Hurricane Katrina in 2005. The devastating storm resulted in a massive relocation of the city's population and the closing or merging of Catholic parishes. As of January 1, 2010, only thirty-five of the eighty-five Catholic parishes that were formed over the decades were still in existence.

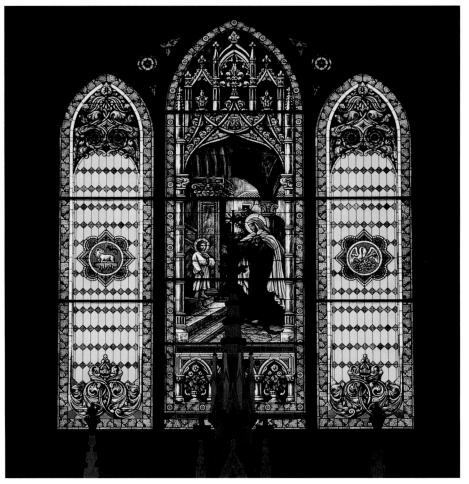

Stained-glass window (St. Teresa of Avila Church)

AN ARTISTIC EXPRESSION OF FAITH

This volume focuses on one aspect of the many Catholic churches constructed in New Orleans over the years: the artistic expression of faith embodied in thirteen edifices on the East Bank of Orleans civil parish. Many of those churches reflect the faith of first- and second-generation immigrants. The selection of thirteen rested with the author, though the general parameters and space limitations were outlined by the publisher. For inclusion, a church had to be open to the public, be constructed no later than 1930, and form part of an original parish that predated 1920, the beginning of the post–World War I city expansion. Each one selected exhibits exceptional aesthetic beauty in its architecture and décor. Three churches were excluded: Our Lady of Guadalupe, formerly the mortuary chapel and St.

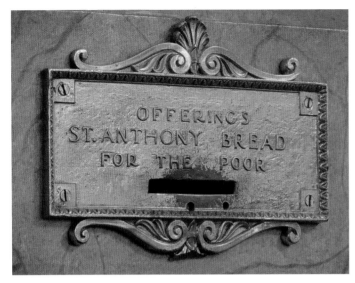

St. Anthony offering box
(St. Anthony of Padua
Church)

Anthony, on Rampart Street; St. Augustine, on Governor Nicholls Street in Faubourg Tremé; and St. Theresa of Avila, on Erato Street. Had more space been available, St. Theresa of Avila, established in 1848, would have been included. Our Lady of Guadalupe has a unique position as a quasi-parish that is part of the parish of St. Louis Cathedral; its current interior is completely changed from its original use as a mortuary chapel. Both the exterior and interior of St. Augustine have been significantly altered from their original forms.

The churches in this volume span two centuries. Parts of the foundation of the Cathedral-Basilica of St. Louis King of France date back to the city's beginnings. The first church on the site was completed in 1727. The youngest church in this volume, Immaculate Conception, was finished in 1930. In large part, it is a replica of the 1856 building.

Most of the churches gradually acquired their distinct interior décor after the walls and roof were sufficiently completed for use. Stained glass replaced plain windows. Statues that reflected the popular devotions of the period were added and—on many occasions—later removed and replaced. A high altar, suitable for a growing congregation, was installed. Stations of the cross were commissioned or commercially purchased and then blessed. In some churches, paintings, mosaics, and shrines were added.

In addition to these enhancements, churches were constantly in need of repair or renovation. Fires, hurricanes, changing neighborhoods, humidity, and termites forced aging structures to be regularly updated. Modernizing and renovating churches have not always resulted in an aesthetic improvement. At one time, the

Repairmen on roof after Hurricane Katrina (St. Peter Claver Church)

main altar, the choir stalls, the statues of Sts. Peter and Paul, and the pulpit were removed from St. Louis Cathedral. In 1938, the beautiful windows behind the main altar were boarded over. Fortunately, all have been restored or replicated. St. Patrick, on the other hand, became the first Catholic parish in the city to air-condition its church without defacing the beautiful interior.

THE CENTER OF PARISH LIFE

The church is the center of parish life, the place where people gather in community. Here parishioners experience some of their most sacred moments: the baptism of their children, the maturing of faith through confession, Communion, and confirmation. Here they are married and from here they are buried. Here they celebrate Christmas, the New Year, Easter, Pentecost, and their parish patron's feast day. Here they worship at Sunday Mass. Here they attend missions, novenas, and special events. The many forms of art in a church are created to foster the faith of those who gather and worship there regularly.

Churches also form part of a larger parish complex. All thirteen churches in this volume or their predecessors at one time had a school or schools. Much parish support, energy, and ministry have gone into the education of the young. Orphanages were located in several parishes. Ministry to the widow, orphan, and needy, often through the St. Vincent de Paul Society, have been an integral part of parish life. Rectories served as residences for the clergy; convents, for sisters. Parishes often first built a school and delayed the church until the education program was well established. Though complementary to that of the churches, the architecture and art of these other buildings are outside the scope of this volume.

By the early twentieth century, parish churches were the center of vibrant national and local administrative, devotional, and charitable societies. This was a period when men, women, and children saw participation in organizations and societies as an integral part of life. St. Stephen Parish in 1910 numbered about six thousand parishioners. The parish had eleven active societies, seven of which numbered more than a hundred members: the League of the Sacred Heart (730); the Holy Agony society (280); the Children of Mary (177); St. Ann's Married Ladies Society (168); the Holy Name Society (125); the Holy Family Society, a popular African American Society (110); and the Altar Society (106). The other four societies were the Junior Holy Name Society, the Girls Sodality, the Ladies of Charity, and the St. Vincent de Paul Conference. All, including the administrative and charitable groups, gathered regularly in the parish church to pray, worship, give thanks, and be instructed.

Steeple (St. Mary's Assumption Church)

For almost 180 years, Africans and African Americans worshiped together with white parishioners, often in a separate designated area. In 1895, Saint Katharine Parish for African Americans was established on Tulane Avenue. All those of African descent were free to attend the new parish or remain at their current parish. Archbishop Francis Janssens believed such a parish was necessary to foster leadership and independence within the African American Catholic community. Not all agreed. In the second decade of the twentieth century, New Orleans established five additional parishes for African Americans, including St. Peter Claver. A similar arrangement emerged in Texas for Hispanics and in Oklahoma for Native Americans. The pattern of parish segregation by ethnicity was transposed to racial identity in the Jim Crow era.

Churches are the most visible embodiment of a religious congregation, and each new Catholic parish in the city quickly built a place in which to worship. With the exceptions of St. Louis Cathedral and St. Peter Claver, the first parish churches were usually small, often wooden buildings with a short life span. As the neighborhood and congregation grew, the people responded generously to build a more permanent structure. National origin played a role in earlier years. In the mid-nineteenth century, French-, English-, and German-speaking churches were built within walking distance of each other below the French Quarter and in the Irish Channel.

The building and adornment of churches were both an attraction for potential immigrants and a major benefit to growing neighborhoods. On February 16, 1868, the *Morning Star and Catholic Messenger* editorialized:

> Everyone knows that the Catholic peasantry of Europe love and practice their holy religion; and when from poverty or any other cause they are compelled to leave their native homes the first thing they seek and require is facilities for attending to their religious duties.
>
> It was this feeling that made the first Irish immigrants prefer our cities to the country where there were not places of worship, and still particularly in the South keeps them there. . . .
>
> We know of no greater inducement that can be held out to those people to settle amongst us than for our citizens to encourage the building of Catholic churches in our country districts.

In the same issue, the newspaper noted that plans for a new St. Joseph church were moving forward and reminded neighbors of the benefits the new edifice would bring. "Considering the immense improvement in real estate always caused by the erection of a church, and accompanying establishment of one of the religious orders, we can not doubt that property owners in this portion of the city, without regard to religious denomination, will take an active interest in forwarding the movement."

The thirteen buildings in this volume reflect a variety of late-nineteenth- and early-twentieth-century architectural styles. All drew heavily on European models and usually combined a variety of forms. St. Mary's Assumption Church is described as German Baroque; St. Stephen, as German Gothic; St. Patrick, as English Gothic; St. Peter Claver, formerly St. Ann, as Early English; St. Joseph, as Romanesque with Gothic detail; Holy Name of Jesus, as Tudor Gothic; Mater Dolorosa, as Romanesque Renaissance; Blessed Francis Xavier Seelos, formerly

St. Vincent de Paul, as Corinthian; St. Anthony of Padua, as Spanish Renaissance; Immaculate Conception, as Moorish; St. Louis Cathedral, as eclectic; and St. Francis of Assisi, as a combination of French Gothic and Italianate with an English interior. By the early twentieth century, the archdiocese had a building committee that reviewed, amended where necessary, and approved plans for new churches. The committee initially found the neoclassical design of Our Lady of the Rosary Church more suitable for a bank or post office than a place of worship. The plans were ultimately approved with only minor recommendations.

Some churches were planned and completed quickly; others took decades. Our Lady of the Rosary was completed between 1924 and 1925; St. Anthony of Padua and St. Mary's Assumption, in less than twelve months. St. Francis of Assisi was delayed by World War I; St. Patrick, by the parish's financial distress; and St. Joseph and St. Louis Cathedral, by faulty design. In several cases, the churches were mere shells when they were first used. St. Joseph was one such case.

Architects were both local and national. Rathbone DeBuys designed Holy Name of Jesus and Our Lady of the Rosary; General Allison Owen, St. Francis of Assisi; T. E. Giraud, St. Peter Claver; Thomas W. Carter, St. Stephen; and Theodore Brune, Mater Dolorosa. Albert Diettel probably designed St. Mary's Assumption. Three parishes replaced their original church architects after major disputes. Charles and James Dakin had a falling out with the wardens of St. Patrick and were replaced by James Gallier. J. N. B. de Pouilly was replaced at St. Louis Cathedral by Alexander Sampson. P. C. Keeley of New York was called upon to complete Thomas O'Neill's St. Joseph Church. In each of these cases, the parish trustees found major defects in the original design.

Writing in the *Morning Star*'s Louisiana Statehood Centennial Edition of July 1912, Allison Owen painted a dismal picture of a U.S. Catholic, largely immigrant nineteenth-century architecture.

> This country has just emerged from the nursery days as a missionary country, and the Church's architectural work has been in the nature of emergency work, built in haste to accommodate pressing needs, and with inadequate funds, to be replaced, enlarged and developed as time goes by with the permanent work of fitting character. The art of the world, during the latter half of the past century, has had in it little of the vitality of that of the preceding period, and it has been productive of few works of importance.

In fact, the Catholic Church in the United States was officially removed from mission status in 1908. Half of the churches in this volume postdate Owen's observa-

Pew 42 (Immaculate Conception Church)

cluded the secret of his superior slowness to be, that he has learned to make shorter jumps and pause longer between them than any other known mule." The same year, the pastor of St. Vincent de Paul sponsored a major musical entertainment to help with the large debt on the new church (now Blessed Francis Xavier Seelos).

In several churches, the former practice of renting pews is still evident. The pews in Immaculate Conception bear their original numbers. Pew renting was an early source of parish revenue and also a source of family pride. After the 1915 hurricane damage was repaired at St. Stephen Church, locked pew guards were added in the center aisle, "thus removing an annoyance that some have complained of when their pews were occupied by outsiders. Plenty of free pews will remain [along the north and south walls] to accommodate all comers." Each pewholder received his or her own key.

THE SANCTUARY

There are features common to the interior of a Catholic church, many of which differ from the places of worship of other Christian denominations. The sanctuary, where Mass is celebrated, is the church's focal point. When the present Our Lady of the Rosary Church was in the planning stage, the archdiocesan building committee objected to the building's large dome over the nave because it would detract

attention from the sanctuary. The objection was overcome, and the dome remained.

Sanctuaries are elaborately furnished. Most have statuary and stained glass in the apse. Some also have mosaics and paintings. In each church, these furnishings, many of striking beauty, reflect a particular embodiment of biblical and traditional faith and devotions, national or ethnic roots and customs, or even the favorite saint of a donor. The altar is the sanctuary centerpiece. Each is a work of art and source of parish pride. Tabernacles, receptacles of the Holy Eucharist, are often ornately designed. One striking change took place in Catholic

Hand-carved wood angel (Mater Dolorosa Church)

tions. Those in this volume that stood at the time were "the permanent works of fitting character," and some were of extraordinary vitality, beauty, and design.

In the decades when the thirteen churches in this volume were constructed, parishes generally had lay trustees, a finance committee, and/or a building committee. These men advised and assisted the pastor in the multiple decisions and oversight that such a major project required. Women were involved in fund-raising activities and in furnishing the churches. New churches were financed by the small contributions of struggling families and occasionally by large donations. The present Holy Name of Jesus was built thanks to a major donation by Miss Kate McDermott. Most often, parishioners of modest or little means were the main contributors to the building of a new church. They sometimes offered their physical labor. When bricks arrived at Jackson Railroad Depot for the new St. Joseph Church, the pastor appealed to all who had carts to help move them to the church grounds. Tradition records that the parish women even carried bricks in their aprons.

Fairs, picnics, musical programs, and entertainments were among the numerous fund-raisers that contributed to financing a new church. One of the most interesting took place on the grounds of St. Joseph in July, 1868. The fund-raising picnic included "foot-ball" and a slow mule race. One mule won convincingly. "We con-

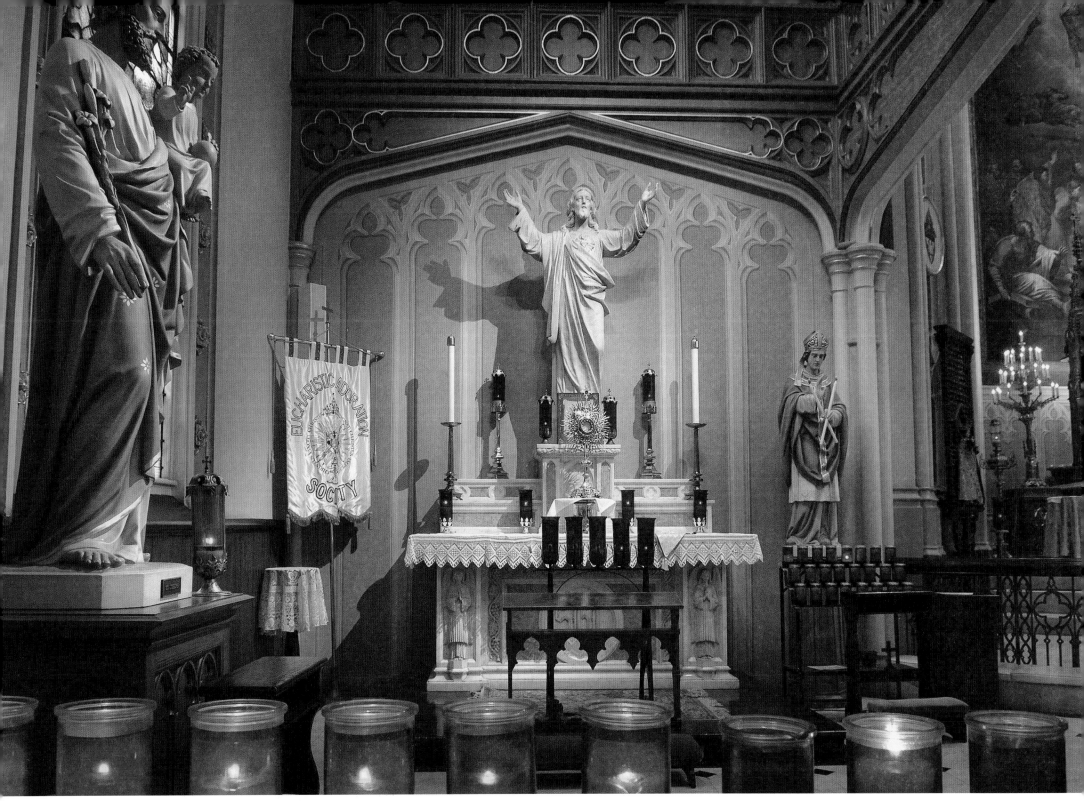

Sacred Heart altar, statue of St. Joseph and the Child Jesus in the foreground, statue of St. Blaise at right of altar (St. Patrick Church)

sanctuaries following the Second Vatican Council (1962–65). Mass, formerly of fered in Latin with the priest facing the main altar, was now celebrated in the vernacular with the priest facing the people. In each church featured in this book, a new altar of sacrifice was installed after the council. All tried to ensure that the new altar blended with the existing architecture and art. The one exception is St. Peter Claver, where only the altar of sacrifice remains; the main altar has been removed.

All of the churches in this volume except St. Peter Claver also have one or more side altars, usually one to the right and one to the left of the sanctuary. The area in St. Louis Cathedral that previously featured the altar dedicated to St. Joseph now houses the holy oils, the baptismal font, the paschal candle, and a statue of St. Joseph. In Holy Name of Jesus and Mater Dolorosa, there are four altars, two on either side of the sanctuary.

STAINED GLASS

In stained-glass windows, a medium inherited from their European forebears, these thirteen congregations expressed faith, traditions, history, and devotions. Much of the stained glass in these churches is executed with spectacular color, brilliant form and facial expression, and intricate detail. Many of the elaborately ornamented windows were designed and manufactured in Europe, particularly in France and Germany. Almost all include biblical scenes interspersed with familiar stories from the early apocryphal books, such as the presentation of Mary in the temple, the death of St. Joseph, and Mary's Dormition, or sleeping. Mary's role in salvation, both during her lifetime and in heaven, is featured prominently.

Several sets of windows in the churches tell a story. The life of St. Louis King of France is represented in the lower stained-glass windows of St. Louis Cathedral. The early Jesuits are depicted in the windows of Immaculate Conception. St. Stephen Church features St. Vincent de Paul, the founder of the Vincentians; St. Louise de Marillac, the cofounder with Vincent de Paul of the Daughters of Charity; and their congregations. The saints appear frequently in stained glass, and in some cases, such as St. Mary's Assumption and St. Patrick, they reflect the immigrant congregation's national roots. At Blessed Francis Xavier Seelos, the apparent haphazard window scenes are a result of donors' designating a namesake or favorite saint. In almost every church, the donor's name is indicated.

In several of the churches, stained-glass windows also honor the religious

Stained glass: The Annunciation (*detail*) (Mater Dolorosa Church)

orders of priests who served the parish. Capuchins from France and later Spain ministered at St. Louis Cathedral for more than a century. Jesuits founded and continue to serve at Immaculate Conception and Holy Name of Jesus. St. Mary's Assumption and St. Alphonsus were entrusted to German Redemptorists, who continue there today. St. Stephen and St. Joseph Churches were staffed by the Vincentians, who remain in charge of St. Joseph. St. Anthony of Padua has been tended by Dominicans since its founding in 1915. St. Peter Claver was first served by the Joesphites and since 1964 by the Edmundites.

While most of the architects of the thirteen churches have been identified, the same is not true for the many artists and artisans whose works enhance the churches' interiors. The origins of a number of the stained-glass windows and some altars and paintings have been identified, and some extraordinary hand-carved wood can be traced to its European artists. Stained glass, like statuary, stations of the cross, pews, paintings, and mosaics, was available through a number of U.S. manufacturers and distributors, particularly in the Northeast and Midwest. These businesses advertised in the annual Official Catholic Directory. The 1881 directory listed six companies specializing in stained glass and six in "Works of Art," and in the subsequent fifty years, much of the stained glass, statuary, and other furnishings were installed in these thirteen churches. By 1925, the directory listed twenty firms that specialized in stained glass. Among these were F. X. Zettler of Munich, Emil Frei Art Glass Company of St. Louis and Munich, the Tyrolese Art Glass Company of Innsbruck, and the Munich Studio with offices in Chicago. A 1906 ad for the Munich Studio included "Munich Artists, Munich Glass, American Mechanics." A 1908 ad for Emil Frei Art Glass Company advertised "Executed in Munich Style by Munich Artists." The Italian Daprato Statuary Company had offices in New York City, Chicago, and Montreal.

In late 1908, the Emil Frei Art Glass Company installed twelve stained-glass windows in the present-day Blessed Francis Xavier Seelos Church (formerly St. Vincent de Paul). Frei, who was trained in Munich, designed and executed the windows in his St. Louis studio. A correspondent for the *Morning Star* described the new windows as "the most handsome creations in that line of memorial art ever seen in the South." He continued,

It has often been said that superior work in stained glass windows could never be produced on this side of the Atlantic Ocean; that the Americans were a nation of daubers, and that for fine technique, quality of material and a thorough conception of all the fine and important details and attention to study and historical research that constitute the very soul of the memorial art work in our churches, the lover

of art must turn to the old world art centers; nothing good could come out of America.

In the fine and true effects seen in the memorial windows of St. Vincent de Paul's Church a splendid refutation is given to this assertion. Americans need no longer turn exclusively to Europe for artistic skill and all those gracious touches of color and expression which are the basis of real art.

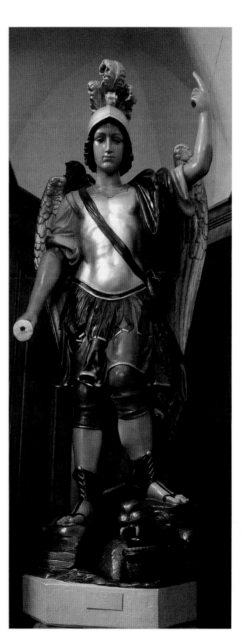

Statue of St. Michael the Archangel (St. Francis of Assisi Church)

STATUARY AND OTHER FURNISHINGS

Statuary is an integral part of these churches, all of which were completed before the Second Vatican Council and the consequent relegation of saints to secondary roles in church furnishings. Each church has statues that reflect the individual congregation's faith and heritage—French, German, Irish, Italian, Spanish, and African. Statues of the Sacred Heart of Jesus, Mary, St. Joseph, St. Anthony of Padua, and St. Therese of Lisieux are found in all or almost all of the thirteen churches. St. Anthony, with his poor box, is a constant reminder of the congregation's obligation and outreach to those in need. Statues of Sts. Joan of Arc, Martin de Porres, Patrick, Lucy, Rita of Cascia, John the Baptist, Cecilia, Francis of Assisi, and Vincent de Paul appear in several churches.

The art work in the churches is rich in New Testament symbolism. Alpha and omega, the lamb, the rose, the lily, grapes, and wheat are common motifs. Many include the young man,

Eagle, representing St. John (St. Mary's Assumption Church)

eagle, ox, and lion, symbols of the four Evangelists. Figures and stories from the Old Testament appear in some churches: Tobiah at Our Lady of the Rosary; Moses at St. Mary's Assumption; the prophet Hosea at Blessed Frances Xavier Seelos. Immaculate Conception features emblems of familiar Marian titles, such as Morning Star and Gate of Heaven, in the iron work of its pews. Paintings and statues of saintly figures from the Church in North and South America also appear: Our Lady of Guadalupe, St. Martin de Porres, St. Juan Diego, and Blessed Kateri Tekakwitha.

Mosaics adorn some of the churches. The dome of Mater Dolorosa is decorated with an elaborate work. St. Joseph's main altar includes a scene of a lamb, the symbol of Christ, flanked by the four Evangelists. A mosaic of St. Francis and two angels sits above the main entrance to St. Francis of Assisi. The dome in the baldachin in St. Anthony of Padua is also decorated with tesserae.

Each church's side walls display the stations of the cross, visual companions for the devotional practice of recalling Christ's passion and death. They are executed in various media— wood, terra cotta, stained glass, mosaic. Immaculate Conception's stations are unique in that they include four additional stations and are made of stained glass. Several churches' stations are modern replacements of earlier versions. The most recent are in Blessed Frances Xavier Seelos and replace those destroyed in a 2003 fire.

"Just within the entrance of every Catholic Church is a font and this font contains holy water, into which Catholics dip a finger, says [sic] an exchange, and then sign themselves with the sacred sign of the cross. Now, what is this water? who places it there? and for what purpose?" Thus did a writer in the *Morning Star and Catholic Messenger* of January 26, 1889, point out a characteristic component of Catholic churches. The writer went on to observe that this is one means of "keeping religion always in the thoughts of her people [and] reflecting upon its mysteries and dogmas." The Church uses water to remind the faithful of human weakness and the need for spiritual purification and a pure heart.

Many holy water fonts are works of art, often unique. The two marble angels who hold the holy water at the entrance to St. Louis Cathedral bear the scars of a rampage by a demented man in 1989. The faces of the four angels holding the holy water basins at the entrance to Immaculate Conception Church were modeled after four family members of the pastor, Father Facundus Carbajal.

Station of the Cross (St. Louis Cathedral)

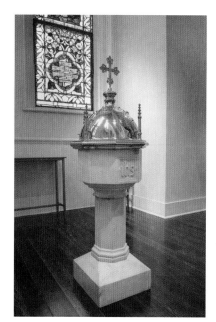

Baptismal font (Blessed Francis Xavier Seelos Church)

GOOD FRIDAY PILGRIMAGE

The custom of visiting multiple churches in New Orleans during Holy Week dates back to at least the 1860s. A writer in the *Morning Star and Catholic Messenger* on April 12, 1868, observed, "The crowds of faithful who go from one Church to another to worship at the different altars may be supposed to make amends for the negligence of the three chosen Apostles who slept while their Master agonized." The writer also described what the pilgrims found at these churches.

The various churches that we visited on Maundy Thursday had their repositories beautifully and tastefully adorned. Flowers and lights and rich ornaments beautified the side altars where the Sacred Host was preserved for the office of Good Friday, and where it received the adoration of the faithful who came in crowds for that purpose. The side altar and its surroundings is always in striking contrast with the general character of the sacred edifice, stripped of every ornament, clothed with the garments of sorrow, and presenting the general appearance of desolation so appropriate to the season.

The practice of visiting nine churches on foot in remembrance of Christ's walk to Calvary is not unique to New Orleans but is familiar to many Catholics in cities. Any nine Catholic churches may be visited. The number nine mirrors the nine days of a novena, which is often prayed in hopeful mourning or yearning or in preparation for a major feast. In the early twentieth century, young girls in New Orleans would walk to the nine churches, say prayers, and leave a small donation as a pious act of petition for a husband.

Originally the pilgrimage took place on Holy Thursday and eventually moved to Good Friday. Though not as popular a practice as in earlier decades, it is still observed today. The development of suburbs, the closing of churches, and a changed devotional atmosphere have contributed to its decline. Those who participated in 2006 found in the penitential ritual a particular poignancy for a city still bearing the scars of Hurricane Katrina.

OUR LADY OF PROMPT SUCCOR

Devotion to Mary under the title of Our Lady of Prompt Succor has been an important part of New Orleans Catholicism. Its roots extend to a historical event surrounding a statue of Our Lady of Prompt Succor, which was brought to New Orleans from France in 1810 by Ursuline nun Mother St. Michael Gensoul. On the night of January 7, 1815, the nuns as well as other faithful gathered before the statue in the convent's chapel praying that the city be spared as sixteen thousand British soldiers advanced against six thousand Americans, led by Andrew Jackson. The British were defeated on the morning of January 8 at the Battle of New Orleans on the plains of Chalmette. After the battle, the nuns nursed the sick and wounded of both sides.

Mary under the title Our Lady of Prompt Succor is the secondary patroness of the Archdiocese of New Orleans and the patroness of the Province of New

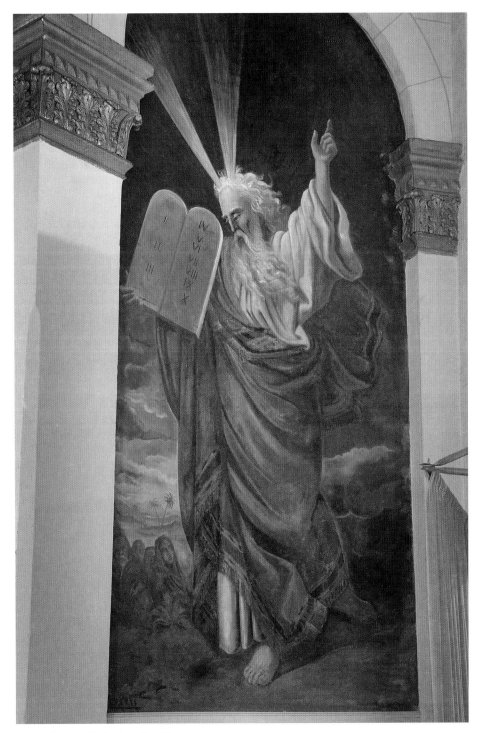

Fresco of Moses (St. Stephen Church)

Orleans. On September 11, 1851, Pope Pius IX granted permission to annually celebrate the feast of Our Lady of Prompt Succor on January 8. That observance continues today at the Ursuline Chapel on State Street. Our Lady of Prompt Succor's protection is invoked in times of danger, including the annual hurricane season.

THE RAVAGES OF TIME AND WEATHER

Three hurricanes between 1915 and 2005 had devastating effects on New Orleans's Catholic churches. "The Hurricane of Wednesday last plays havoc among churches of New Orleans," read the *Morning Star*'s headline on October 5, 1915. The article continued, "Churches that seemed strongest gave way before the fury of the gale, and those least protected often withstood the Storm King's wrath." The September 1915 hurricane destroyed churches, schools, convents, and orphanages and left many others in need of major repairs. St. Louis Cathedral, St. Joseph, and St. Patrick suffered heavy losses. St. Louis was forced to close for three years and was almost lost. Immaculate Conception was the most fortunate with only minor damage. In the wake of Hurricane Betsy in 1965, the archdiocesan building commission voted to permanently close St. Patrick. Fortunately, Archbishop Philip M. Hannan overrode that decision.

Nothing brought such destruction and displacement as Hurricane Katrina did on August 29, 2005. More than one thousand archdiocesan buildings were damaged, massive numbers of parishioners were temporarily or permanently relocated to other cities and towns, and the city's infrastructure was crippled. At the beginning of 2005, the archdiocese numbered 142 active congregations in eight civil parishes. Four years later, the number had dropped to 108. Among the nineteenth-century parishes that were permanently closed were St. Rose of Lima, St. Henry, Our Lady of Good Counsel, St. Mary on Chartres Street, St. John the Baptist, St. Maurice, Sacred Heart of Jesus, St. Henry, and St. Francis de Sales. St. Stephen Church continued as an active place of worship but for a newly formed parish called Good Shepherd.

MODEST AND HUMBLE CROSSES

In 1948, Mater Dolorosa Parish celebrated its centennial. In a message to the parishioners, Archbishop Joseph Rummel wrote:

There is always something fascinating about the history of a Catholic parish. Usually modest and humble in its beginnings, it grows larger, more dignified and more efficient with the years. It is almost human in its development and quite understandingly so, for it is composed of vibrant human beings and is intimately influenced by their genius, their moods and their fortunes. Equally true is it that a parish reflects the conditions, civic, social, economic, as well as religious, that prevail at various stages of its existence and development.

The thirteen churches in this volume all reflect a "more dignified and more efficient" phase of parishes that had humble and modest beginnings. They reflect the genius, moods, and fortunes of those who contributed to their building and adornment. Part of that genius and those moods found expression in architecture, stained glass, statuary, mosaic, and painting. The conditions and devotions of the times are also reflected there.

In 1810, seven years after the Louisiana Purchase and two years before statehood, St. Louis Cathedral was the city's only formal Catholic parish. In the records of births, marriages, and funerals that year, the cosmopolitan fabric of the city is revealed. Parishioners were natives of Spain, France, England, Ireland, Scotland, Canada, Flanders, Italy, Corsica, Bohemia, Germany, Switzerland, Cuba, the Canary Islands, Spanish Morocco, Majorca, Mexico, Martinique, Jamaica, Lima and Caracas in Spanish South America, the Windward Islands, and Santo Domingo. They were also natives of the Congo, Guinea, Senegal as well as the Arrada, Chamba, Ibo, Mandingo, Pular, and Temene nations in Africa. Still others were natives of many of the states or future states in the new American nation. These parishioners' descendants, joined by an ever-increasing number of immigrants, formed the city's new Catholic parishes and built the thirteen churches in this volume among many others. They visibly reflect the rich religious traditions and cultural heritages that make New Orleans unique.

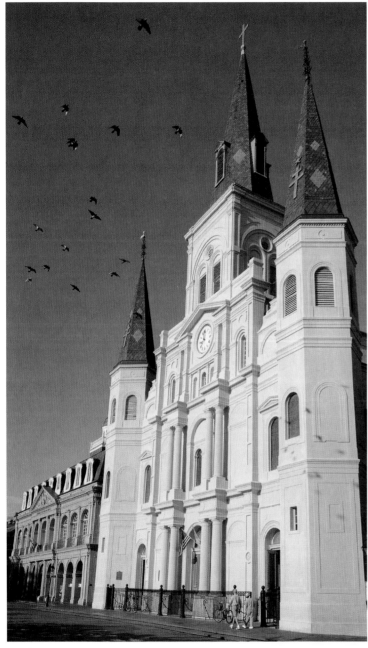

Exterior

1. THE CATHEDRAL-BASILICA OF ST. LOUIS KING OF FRANCE

OT ALONE IS IT THE Cathedral of the Catholic Church, it is the Cathedral of our mutual memories, the shrine of all Louisiana history. It is the heart of old New Orleans." Thus did the *New Orleans Times-Picayune* appeal in 1916 to citizens of New Orleans for financial help to save the historic cathedral facing Jackson Square. The cathedral had been closed in the wake of the devastating hurricane of September 1915.

The Cathedral-Basilica of St. Louis King of France is synonymous with the city of New Orleans. It appears often in modern media as the city's most familiar symbol. Through its doors, both travelers and locals enter into one of New Orleans's most revered and sacred spaces.

St. Louis is the oldest Catholic cathedral in continuous use in the United States. A church has existed on its site since 1727, when the French colonists completed the first permanent edifice. Since that date, New Orleanians have gathered at this location to worship, pray, express thanks, honor dignitaries and heroes, celebrate sacred feast days and military victories, recognize those who serve the city, be baptized, be married, and mourn the dead.

The original French church was destroyed in a 1788 fire. A new church, completed during the Spanish regime, was first used in 1794. Construction to restore the present building, built in part on the foundations of the earlier churches,

began in 1849. The restored cathedral both widened and lengthened the earlier edifice. A half million bricks were used in the new construction.

Since the 1850s, St. Louis has undergone periodic, and sometimes major, renovations. The most extensive followed the 1915 hurricane. The cathedral was again renovated in 1938 in preparation for the Eighth National Eucharistic Congress held in the city, and yet again in 1975–76 as part of the archdiocese's gift to the nation during the bicentennial celebration. Some earlier art has been removed or replaced over the years. The original mural over the altar showed St. Louis King of France offering his crown to the Blessed Mother. Stained-glass windows previously depicted the Sacred Heart, Mary, the Holy Family, and Sts. Peter, Francis, Dominic, Vincent de Paul, Patrick, Catherine of Sienna, and Anne, among others. The shrine of Our Lady of Lourdes, St. Joseph's altar, and a 1938 Mexican mahogany communion rail with elaborate wrought-iron panels and gates are gone.

Today, the very entrance to the church speaks of its long, eventful history. Plaques list or honor the rectors, bishops, and archbishops; Jean Baptiste Le Moyne de Bienville, the city's French founder; Don Manuel Gayoso de Lemos, a Spanish governor; Venerable Pauline-Marie Jaricot, a remarkable French woman whose society was a major source of financial assistance in the nineteenth century; and Henriette Delille, a local free woman of color who established a religious community despite the adverse social and political climate of antebellum New Orleans. In the foyer are also statues of Mary Queen of Poor Souls and St. Therese of Lisieux.

Hundreds of visitors enter the cathedral daily to find a hushed atmosphere with soft Gregorian chant in the background or a Mass, service, or wedding in progress. From the galleries on either side of the nave hang two rows of flags. On the right are ten flags that have flown over Louisiana from the period of the early exploration to the present. On the left are the flags of the papal coat of arms, the basilica coat of arms, and the seven dioceses that compose the Catholic Province of New Orleans.

At the rear of the church, on either side of the main aisle, stand two marble angels holding holy water fonts. The angels' arms were repaired after a violent intruder disfigured them in 1989. The center aisle was designed and installed in 1851–52 by marble cutter and sculptor Eugene Walburg (1825/1826–59), a local free man of color. It leads to the sanctuary, where colorful statues of faith (center), hope (left), and charity (right) stand above the main altar. Behind them is inscribed *Ego sum Via et Veritas et Vita* (I am the Way, the Truth and the Life). The three blue stained-glass windows above the altar were uncovered in 2009.

The main altar was built in Ghent, Belgium, by Louis Gille and installed in 1852. Its carved white marble *mensa*, or table, is supported by four angels. Above

the *mensa* is the reredos, or altar screen, with two winged angels flanking the tabernacle. Six fluted Corinthian columns support a classic upper structure beneath the statues of faith, hope, and charity. Across the center of this section are the Latin words *Ecce Panis Angelorum* (Behold the Bread of Angels). The revolving tabernacle face can be turned to show a crucifix, an empty space used for the monstrance or archbishop's candle when he presides, or a door engraved with a chalice, host, and suspended cross. On either side of the tabernacle are statues of St. Peter (with key) and St. Paul (with book).

A large mural of King Louis IX (1214–97) announcing the Seventh Crusade is on the back wall above the altar. Knights stand and kneel to the right, with the city in the background. Clerics and the laity listen on the left. This original 1872 painting, by Erasme Humbrecht, covers an earlier mural. In 1891, Humbrecht retouched the painting, which has been subsequently restored many times, including in 1918 and 1938. The mural on the sanctuary ceiling depicts a lamb and Gospel text on an altar, with God the Father hovering above while Evangelists Luke and Matthew kneel on either side and kings and angels pay homage. Below are the words *Voici l'agneau de Dieu qui efface le péché du monde* (Behold the Lamb of God who takes away the sin of the world).

To the left of the altar is the metropolitan cross, the symbol of an archdiocese, with its double cross bar. New Orleans was raised to an archdiocese in 1850, the year before the present cathedral was completed. The metropolitan cross is used during Mass and other formal ceremonies in the church when the archbishop presides. On either side of the sanctuary are choir stalls. At one time, like many of the great churches of Europe, St. Louis Cathedral had canons. The choir stalls and pulpit, replicas of the originals and carved by Wood and Iron Works in California, were installed in 2008 and 2009, respectively. Beneath the sanctuary, eleven bishops and archbishops are buried. Commemorative plaques with brief biographical information line the sanctuary and the front of the side walls.

On the right side of the sanctuary is the baptismal font from the earlier church. The font was previously located in the baptistry at the rear of the church (now the Henriette Delille Prayer Room). Above the holy oils is a large nineteenth-century painting of St. Francis of Assisi done in Belgium in the 1850s. The crucifix on the wall to the right of the baptismal font hung in the earlier Spanish church. Tradition has it that King Charles IV of Spain bestowed the crucifix when the Diocese of Louisiana and the Floridas was created in 1793.

On the left side of the sanctuary is an altar and statue honoring Mary under the title of Our Lady of Prompt Succor. The baroque altar was executed by Gille with the main altar and installed at the same time. The painting of Mary above

the altar was done contemporaneously in Belgium. To the right of Mary's altar is a mosaic from the Vatican Mosaic Studio in Rome depicting Christ's triumphal entry into Jerusalem. The work was a gift to the cathedral in 2007 from Francesco Cardinal Marchisano, then archpriest of St. Peter's Basilica and head of the Fabbrica of St. Peter's.

The three large murals on the nave's ceiling portray the birth of Christ, Christ as the Good Shepherd, and the Archangel Michael slaying Satan in the form of a dragon. In the central mural, Christ the Good Shepherd is surrounded by the apostles and is handing the staff of his authority to Peter. God the Father and the Holy Spirit hover above with the cross on Calvary in the background. The cross is surrounded by sheep, the flock redeemed by the cross; the banners on either side say *Paissez mes agneaux, paissez mes brebis* (Feed my lambs, feed my sheep).

At each corner of the center mural are smaller paintings of the four Evangelists: John with a chalice, symbolizing his nearness to Christ at the last supper; Mark with a lion, for his Gospel begins with John crying in the wilderness; Matthew with a child, as his Gospel begins with Jesus' genealogy; and Luke with an ox, because his Gospel emphasizes the sacrificial aspects of Christ's life. Ten apostles (minus Peter and Judas) are portrayed on the walls of the clerestory. Each apostle holds an instrument of his death, a sign of martyrdom for the faith. Much of the ceiling adornment dates from the 1880s and 1890s.

Flanking the nave are two galleries. Their walls contain simple clerestory windows designed to allow as much light as possible into the interior of the cathedral. Added to their ceilings in 1938 are portraits of Pope Pius XI and the archbishops of New Orleans beginning with Archbishop Antoine Blanc (1835–60). The most recent archbishops are portrayed in the ceiling below the left gallery.

Ten stained-glass windows recall the main events in St. Louis's life. Created at the Oidtmann Studios in Linnich, Germany, in 1929, the scenes include: young Louis with his mother, Queen Blanche; his coronation as Louis IX, King of France (1226); his marriage to Marguerite of Provence (1234); Louis as builder of Sainte-Chapelle, one of Paris's architectural gems (1248); leaving on Crusade (1248); receiving the key to the city of Damietta (1249); ministering to lepers; his illness and death (1270); the return of his body to France (1271); and his canonization as a saint (1297).

Also along the side walls are terra cotta stations of the cross, installed in 1905. They are among the most beautiful and detailed stations in New Orleans. The agony of the walk to Calvary, the Crucifixion, and Christ's entombment are graphically portrayed in the faces of Christ, Mary, and each of the accompanying persons.

At the rear of the church, a large mural with a scrolled background rises above the pipe organ. At the top, surrounded by two angels, is St. Cecilia, the patroness of music. Lower to the left is David, the psalmist, and to the right, Pope St. Gregory, the father of church music. The inscription reads: *Te Deum Laudamus, Te Dominum Confitemur* (We praise you, God, we acknowledge you, Lord). At the lower ends of the scroll are the words *gloria* and *honor.*

On April 25, 2004, a new 4,600-pipe Holtkamp organ in the choir loft was blessed. It suffered major damage in Hurricane Katrina and was reinstalled in 2008. Concerts featuring internationally renowned organists are held periodically in the cathedral. In the choir loft is also a remarkable clock. In 1851, the clock was rebuilt and improved by French clockmaker Stanislaus Fournier, who used parts from an earlier Jean Delachaux clock. Fournier cleverly designed a single mechanism to run three dials, the one in the church steeple, the second over the organ, and the third on the rear wall of the church.

At the back of the cathedral are statues and sacred objects that reflect French heritage, the church's status as a basilica, sacramental life, and outreach to the poor. Statues of St. Louis King of France and St. Joan of Arc stand on either side of the main entrance, the former hand carved in South America and installed in 2008, the latter installed in 1920. Also found in the back are statues of the Sacred Heart of Jesus and St. Anthony of Padua. Below the statue of St. Louis is a copy of the saint's thirteenth-century Bible, of which a limited number of replicas were authorized in 2000. The original Bible, copied and illustrated between 1226 and 1234, was a gift to King Alfonso the Wise and is housed in the Cathedral of Toledo.

In 2008, the Henriette Delille Prayer Room was opened off the foyer. The stained-glass windows, depicting Delille's ministry to the young and old, were executed by local artist Ruth Goliwas. One shows Delille as a godmother in this former baptistry. The symbolic bust of Delille, entitled *Full Circle, from Africa to Africa,* was sculpted by Judith Nolan of Chicago. The piece reflects the African belief that life is a process without beginning or end, a seamless continuum that flows back upon itself.

On the church facade are six windows, four donated by the Spanish government in 1962. They are back lighted and visible at night. One represents King Charles IV; another, Pope Pius VI; a third, Don Andrés Almonaster y Roxas, who helped fund the church's building; and the fourth, Bishop Luis Peñalver y Cárdenas, all contemporary with the 1794 Spanish church. The other two windows depict the coats of arms of Castille and the Archdiocese of New Orleans. A plaque on the facade commemorates the most renowned of the church's visitors, Pope John Paul II, who met with clergy and religious at St. Louis in September 1987.

In 1964, the Cathedral of St. Louis was raised to the status of a minor basilica. Selected churches around the world are honored as basilicas because of their antiquity, historical importance, and significance as a place of worship. One symbol of the cathedral's basilica status is the *ombrellino*, a canopy on a wooden frame with alternating bands of red and yellow silk, reflecting the papal colors and a special relationship to the Holy Father. The *ombrellino*, located in the back of the cathedral, is surmounted by a gilt copper cross, and its eight sides display a series of symbols, including the basilica's coat of arms. The second basilica emblem is the *tintinnabulum*, a special bell that originally was used in Rome's major basilicas to announce the pope's arrival. This bell, made of silver, brass, and copper, includes a statue of St. Louis and the lion of Judah around the staff.

In 1908, Father Celestin Chambon captured the distinctive atmosphere that greets a visitor to St. Louis when he wrote in *In and Around the Old St. Louis Cathedral of New Orleans*, "It is impossible not to feel the peaceful repose, the strange stillness that pervades the atmosphere of Saint Louis Cathedral: romance and religion blend there more closely than at any other spot in this quaint old city." The cathedral-basilica reopened days after Hurricane Katrina despite damage to the roof and a lack of electricity. Parishioners, first-responders, the military, and volunteers worshiped together by candlelight amid the devastation in the building that stands as the symbol of New Orleans and a symbol of hope.

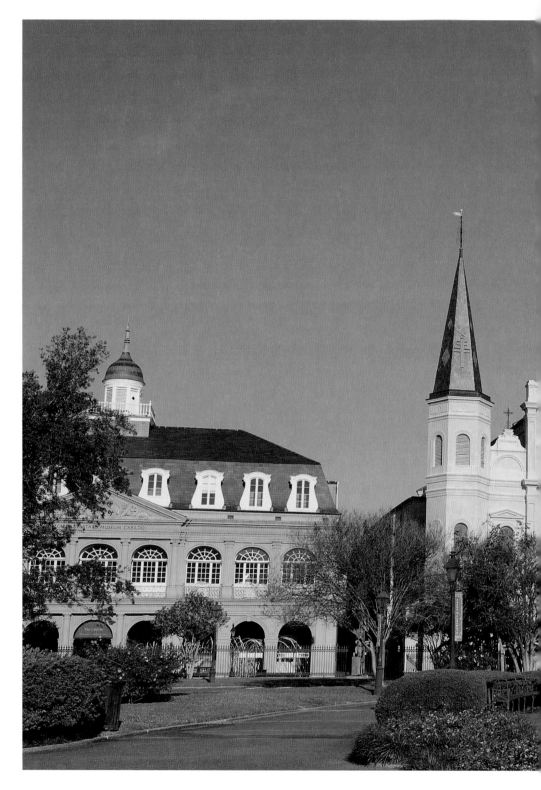

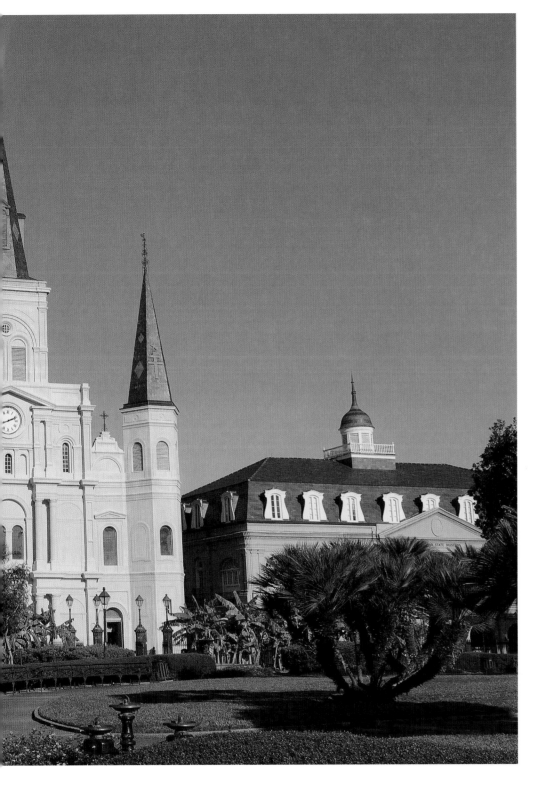

Cathedral facade as seen from Jackson Square

Exterior crosses from
St. Anthony's Garden

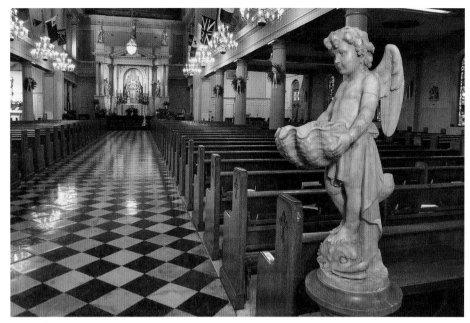

Center aisle

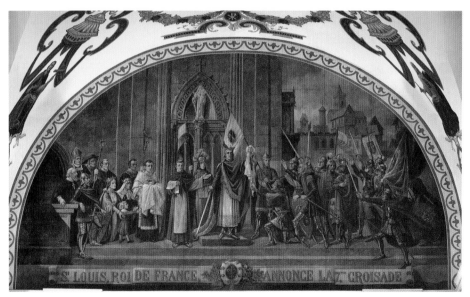

St. Louis mural

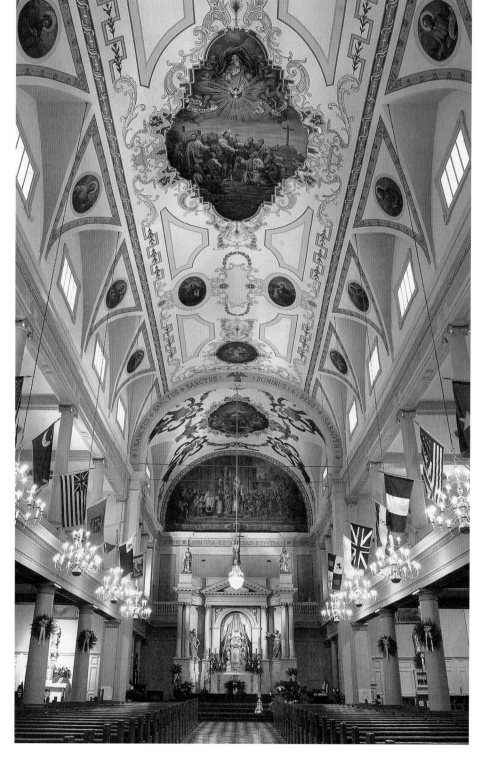

View of ceiling and sanctuary

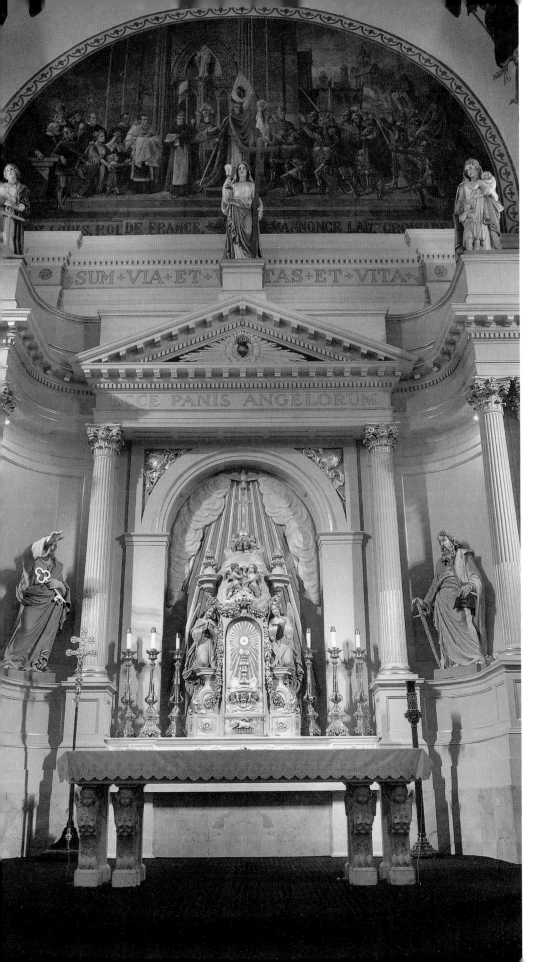

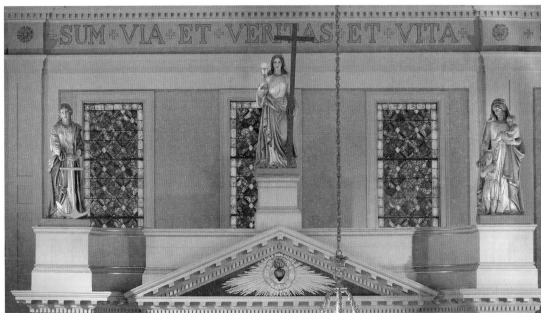

Statues of Hope *(left)*, Faith *(center)*, and Charity *(right)*

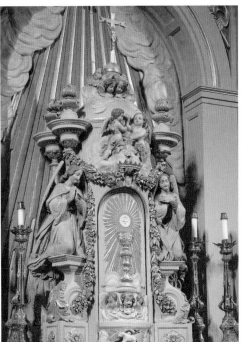

Tabernacle

Altar with statues and St. Louis mural

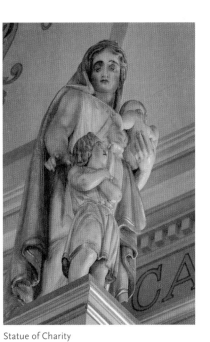

Statue of Charity

Spanish Cross *(detail)*

Baptismal font, painting of St. Anthony

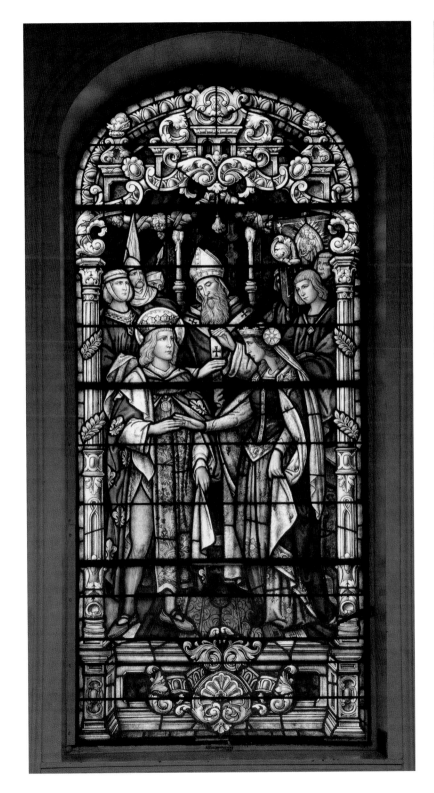

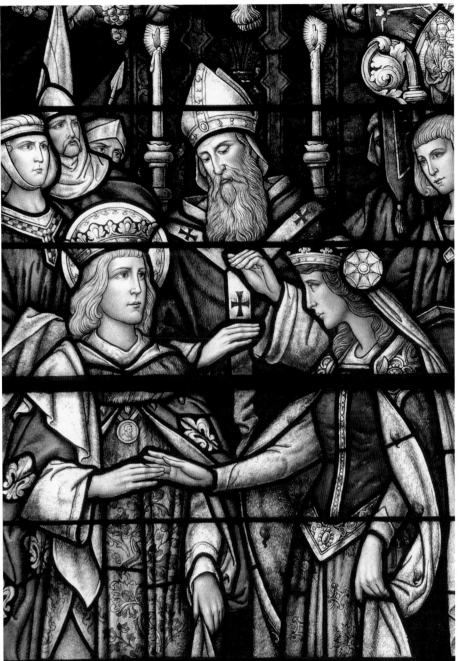

Marriage of King Louis *(detail)*

Stained glass: Marriage of King Louis

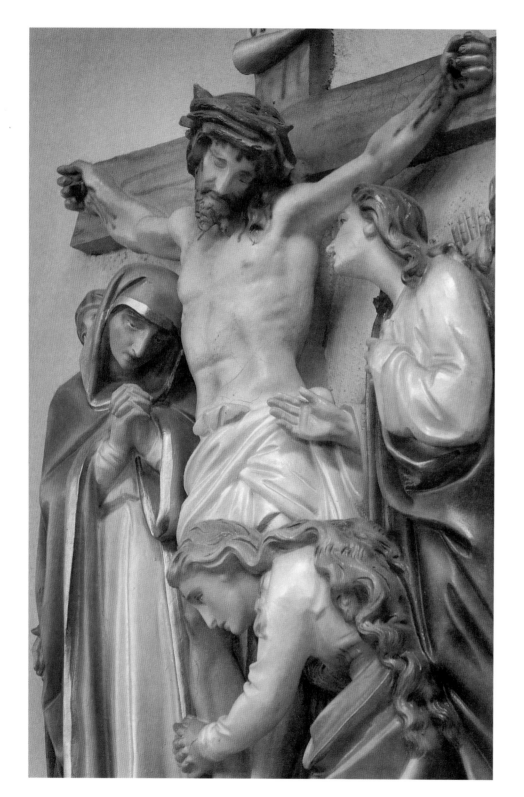

Station of the Cross XI: Crucifixion (*detail*)

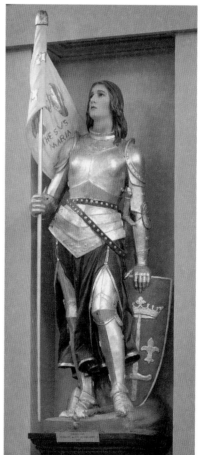

St. Joan of Arc statue

Stained glass: Henriette Delille as godmother

Station of the Cross: Crucifixion

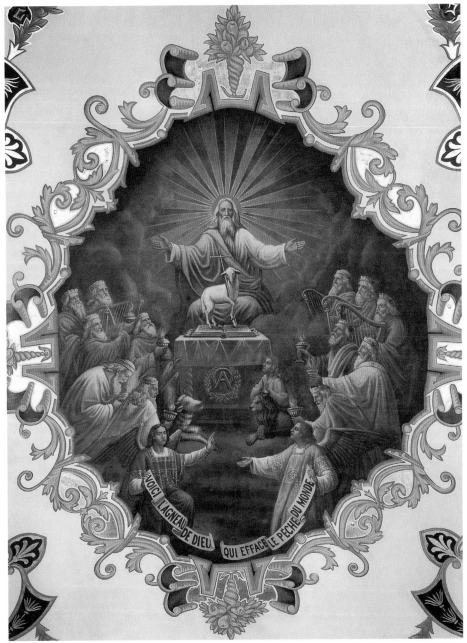

Lamb of God fresco

Good Shepherd fresco

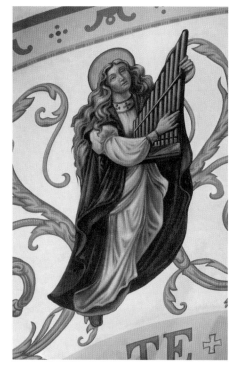

Choir loft mural detail: St. Cecilia

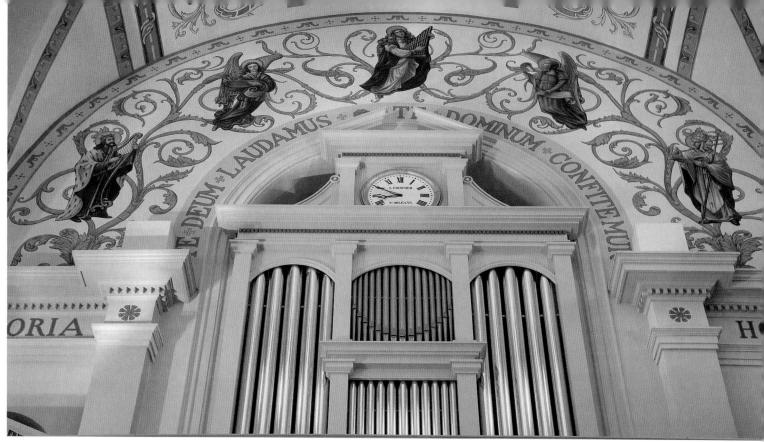

Choir loft mural

Holy water fonts *(right)*

Pulpit *(far right)*

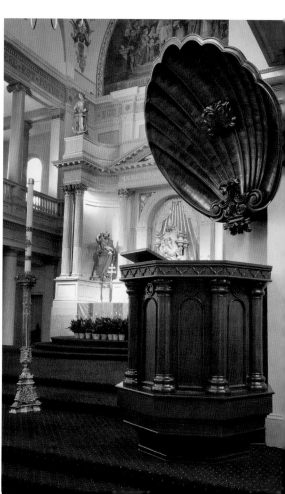

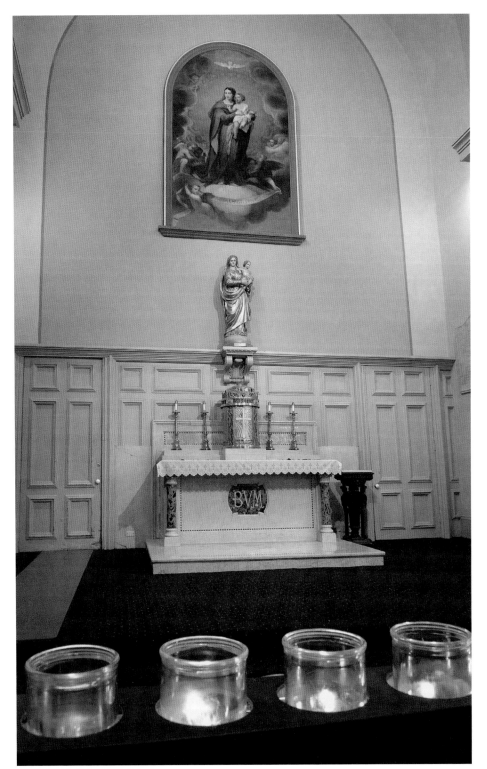

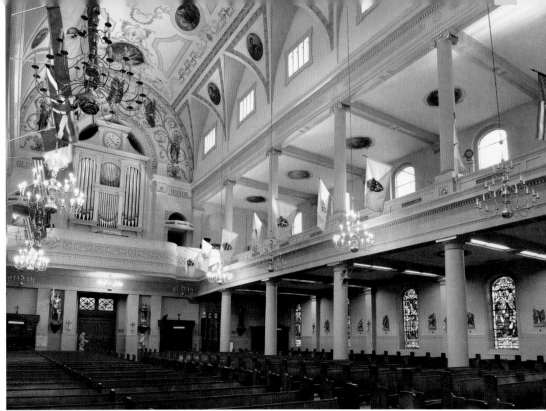

Side and back view of church interior

Mary's altar *(far left)*

Tintinnabulum *(left)*

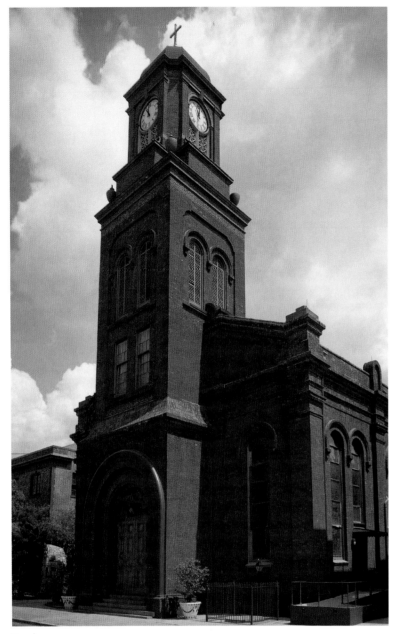
Facade

2. BLESSED FRANCIS XAVIER SEELOS CHURCH

IKE THE LEGENDARY PHOENIX, Blessed Francis Xavier Seelos Chuch, located on Dauphine Street below the French Quarter, has been born again, not once but twice. On the second occasion, the building arose from literal ashes. It also suffered damage in the 1915 and 1965 hurricanes.

A venerable structure of red brick, the church first served the French congregation of St. Vincent de Paul, one of a cluster of parishes established within blocks of one another in the 1830s and 1840s to serve French-, English-, and German-speaking residents. The original frame church of St. Vincent de Paul Parish was built in 1838. On April 24, 1866, the cornerstone of the new brick church was blessed, a bold undertaking in a city suffering the political, economic, social, and financial aftermath of the Civil War. The Corinthian style structure was completed and in use in early 1868.

In 2001, St. Vincent de Paul Church became the house of worship for Blessed Francis Xavier Seelos Parish, created when five area parishes were suppressed and merged into one. The five parishes were St. Vincent de Paul (1838); Annunciation (1844); Sts. Peter and Paul (1851); St. Cecilia (1897); and St. Gerard, a nonterritorial parish for the hearing impaired (1971). Migration to the suburbs, changing neighborhoods, and an aging Catholic population caused the merger. This was the building's first rebirth.

On May 26, 2003, a four-alarm fire swept through the church, destroying the main altar, some statues and tapestries, and the stations of the cross. Some of the

magnificent murals painted by Achille Perretti in the early twentieth century were lost, and others were damaged; four of them are now in storage. The fire also severely damaged the pews and organ. Firefighters and parishioners rescued most of the other furnishings.

After nearly two years in exile at the nearby former Sts. Peter and Paul Church, the congregation returned to its extensively restored home in 2005. Shortly afterward, the edifice received door, window, and roof damage in Hurricane Katrina. In July 2006, with approval from the Vatican, the church was rededicated to Blessed Francis Xavier Seelos, making its name the same as the parish's.

Each phase of the building's history is evident in the current interior. The walls and stained glass are vestiges of the nineteenth- and early twentieth-century St. Vincent de Paul. The altars and statuary, many from the four other closed churches, reflect the 2001 creation of Blessed Seelos Parish. The bare ceiling, new stations of the cross, statues of three saints of the Americas, painting of Our Lady of Guadalupe, new organ, expanded choir loft, and paintings of John the Baptist and the Prophet Hosea represent the 2005 restoration as well as a congregation that is one-third English-speaking, one-third Spanish-speaking, and one-third hearing impaired. Overall, the church's artwork spans a century and a half.

Blessed Seelos's main front door of sunken cypress has replaced what was blown off during Hurricane Katrina. In the small front foyer is a Pietà that originally stood in Sts. Peter and Paul Church. When the statue was restored, it was discovered that the piece was an original of hand-carved wood, richly detailed with remarkable expression in the figures' faces. Above the entrance leading from the foyer to the church is a small stained-glass window with a cross in its center welcoming parishioners and visitors with the words *Domus Dei, Porta Caeli* (House of God, Gate of Heaven).

The interior nave and two side aisles are divided by four plain round columns on either side. The columns were added in 1923 to provide additional support to the upper structure. The red brick walls and ten stained-glass windows with brilliant colors and marvelous detail survived the 2003 fire intact, though some windows suffered minor stress fractures. Two were broken by flying debris during Hurricane Katrina. All have been restored.

Five pairs of double windows line the left wall. Beginning at the front, they depict St. Sophia; St. Charles Borromeo; the Nativity of Jesus; young Jesus teaching in the temple, with the words *Plenus Gratia et Sapientia* (Full of grace and wisdom); Mary and the toddler Jesus hugging one another, a moment seldom seen in American Catholic art; John the Baptist and a lamb, with the words *Ecce Agnus Dei* (Behold the Lamb of God); the Baptism of Jesus, with the words

Ecce Filius in quo Complacui (Behold [my] Son in whom I am well pleased); the resurrected Christ; St. Anthony of Padua, patron of the poor; and St. Vincent de Paul. The window against the back wall shows the sorrowful Jesus with wrists bound and head crowned with thorns. To the left of his head is a plaque in Latin that translates *Jesus of Nazareth, King of the Jews*.

Starting at the front, the windows on the right show St. Stephen; St. Francis Xavier; the Annunciation; St. Anne; St. Joseph; the Presentation of Jesus in the temple, with Simeon's words *Nunc Dimittis* (Now you can dismiss); Mary's Visitation to Elizabeth; the Coronation of Mary; Our Lady of Perpetual Help; and St. Peter. The window on the back wall illustrates the Mater Dolorosa, or Sorrowful Mother, and is a companion window to that of the sorrowful Christ.

The windows were installed in the late nineteenth and early twentieth centuries. Executed in brilliant color with remarkable intricacy, they convey general themes that were common in the European churches from which many of the parishioners immigrated. Some of the depicted saints reflect the names of the donors or those in whose memory the windows were donated.

Two windows dated 1906 and one dated 1898 are by the Stolzenberg Company. When Emil Frei Art Glass Company of St. Louis installed twelve windows in mid-December 1908, a correspondent for the *Morning Star*, struck by their exquisite beauty, wrote that the Annunciation window is "out of the ordinary": "The Blessed Maid of Nazareth is seated in her lowly home; the morning sun streams in and lights up the beautiful face as Mary scans the Sacred Scriptures. She raises her eyes, and there, in the majesty of the messenger of God, stands the Angel Gabriel. Respect, dignity, sublimity characterize the entire portraitures. One seems to feel the very voice of God speaking in answer of the purest of virgins. The coloring is rich, the tone and effect in keeping with the theme." Also along the side walls are modern stations of the cross, hand painted on mahogany and sealed with wax. They were fashioned by Argentinian artist Saskya Lainez to replace those destroyed in the 2003 fire.

The tall, beautiful nineteenth-century main altar was originally in Sts. Peter and Paul Church. It was dismantled, refurbished, and retrofitted for St. Vincent de Paul's sanctuary after the 2003 fire. The gold tabernacle and the terra cotta Last Supper scene below the altar table are original to the church. The Last Supper scene was executed in Cincinnati in 1912. The altar of sacrifice with its bas-reliefs of the Annunciation, Last Supper, and Nativity is actually the lower section of the main altar from Sts. Peter and Paul.

Three statues adorn the main altar. That of the Sacred Heart came from Sts. Peter and Paul. The statues of Blessed Kateri Tekakwitha and St. Martin de Por-

res, executed by Demetz Art Studio in Italy, exemplify saints of North and South America, respectively, and were installed after the 2003 fire. To the left of the sanctuary, a terra cotta statue of St. Joseph gazes at the main altar. The statue predates 1860 and stood in the original wood church of St. Vincent de Paul. The base for the statue with its gold leaf was originally in St. Cecilia.

The altar to the right of the sanctuary is dedicated to Redemptorist priest Blessed Francis Xavier Seelos, who died in New Orleans in 1867 serving the city's yellow fever victims and who was beatified in 2000. An elaborate reliquary on the altar holds remains of Seelos's bone. Above the altar are the words *In Cruce Salus* (Salvation [is] in the Cross). The lectern with its onyx pillars is from St. Cecilia and was modified for its placement in the present sanctuary. On the nearby wall is a large pre-1860 crucifix and a statue of St. Michael slaying not the usual dragon, but Satan himself, who withers under Michael's spear. Both are original to the church.

Mary's altar to the left of the sanctuary reflects the congregation's Hispanic membership and traditions. The large painting of Our Lady of Guadalupe was donated by the Cardinal Archbishop of Mexico City in 2002. The statue of Saint Juan Diego, who was canonized in 2002, is also new. Nearby is a familiar statue of St. Therese of Lisieux that has always stood in the church.

At the back of Blessed Seelos, statues of Sts. Peter (left) and Paul (right) occupy either side of the main aisle as they long have. Below them are holy water fonts from Holy Trinity Church. Also in the back are statues of Sts. Anthony of Padua, Vincent de Paul, and Louise de Marillac, all original to the church; the Annunciation piece is from Annunciation Church. Looking down from the choir loft are statues of St. Patrick from Sts. Peter and Paul Church and St. Cecilia from St. Cecilia Church

After the 2003 fire melted the existing organ, a new organ was constructed from two 1920s Möller organs in Spokane and Seattle, Washington, with elements from seven other organs as well as new parts. The new organ, installed in June 2008, has 313 pipes with 14 ranks. It was specially constructed so the vibrating pipes could be felt by the congregation's hearing-impaired through their feet. The organ was donated and installed by members of the Pipe Organ Foundation, who spent more than 4,000 hours building the new instrument. Three Seattle-area Presbyterian congregations also sponsored the installation. Some of them had volunteered three weeks in 2006 rebuilding the Katrina-damaged parish hall, the St. Gerard Center for the hearing impaired.

On either side of the new confessional at the back of the church are new paintings of St. John the Baptist, with *repent* in English and Greek, and the Old Testament prophet Hosea. Both are by Saskya Lainez. Above the confessional is one of the three original paintings of the Divine Mercy. This devotion, which emphasizes God's mercy toward us and our need to be merciful and forgiving toward others, originated with St. Faustina Kowalska, a simple Polish nun who died in 1938 and was canonized in 2000. Replicas of the Divine Mercy image are found in several other churches in this volume.

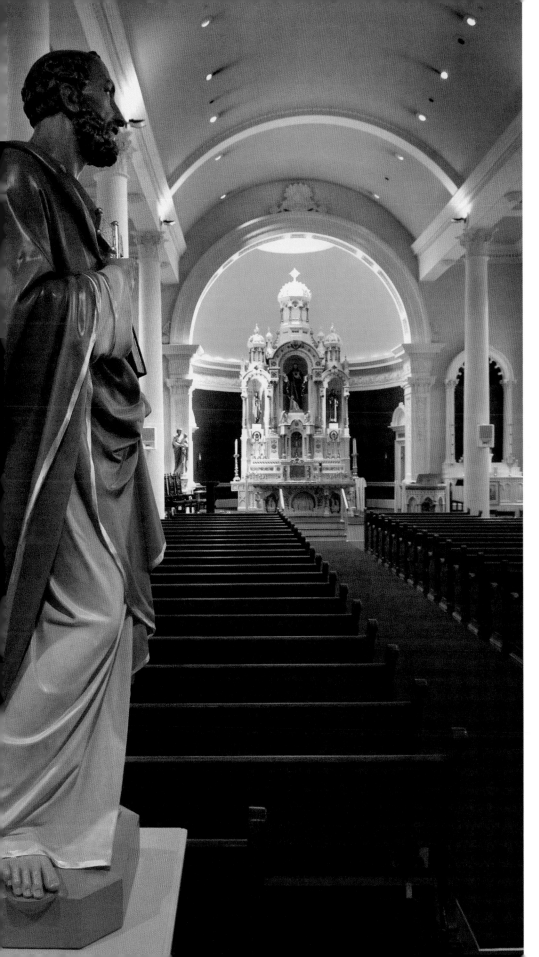

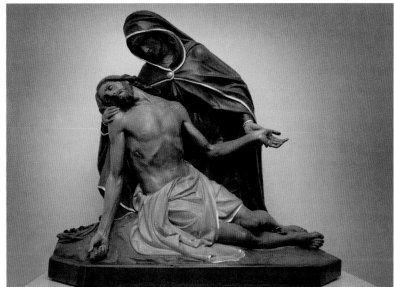

Pietà in foyer

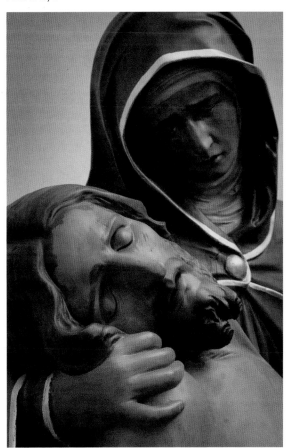

Pietà *detail (left)*

Front of the church with statue of St. Peter *(far left)*

Blessed Kateri Tekakwitha

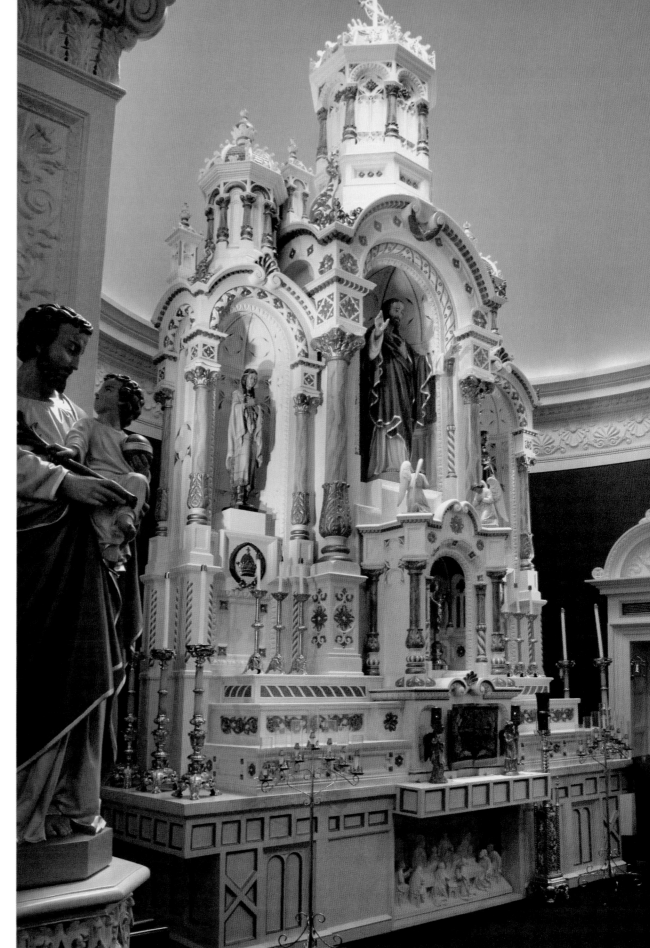

Main altar with St. Joseph
statue at left

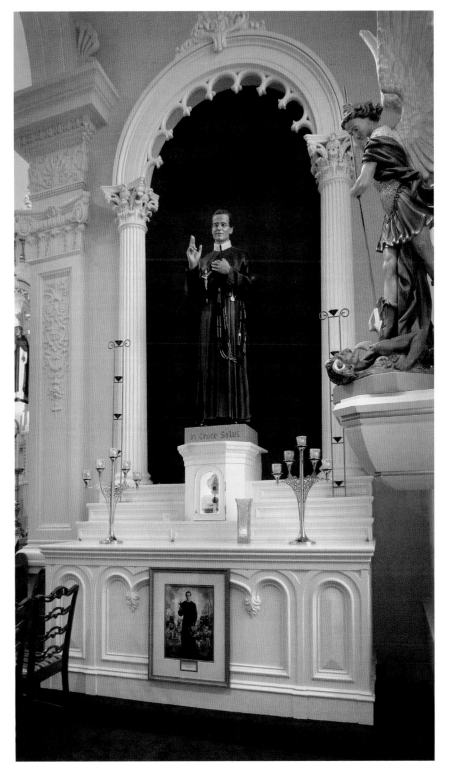

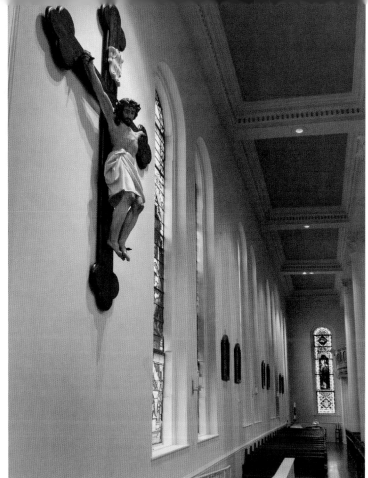

Crucifix, side aisle

Blessed Seelos altar *(far left)*

Blessed Seelos reliquary*(left)*

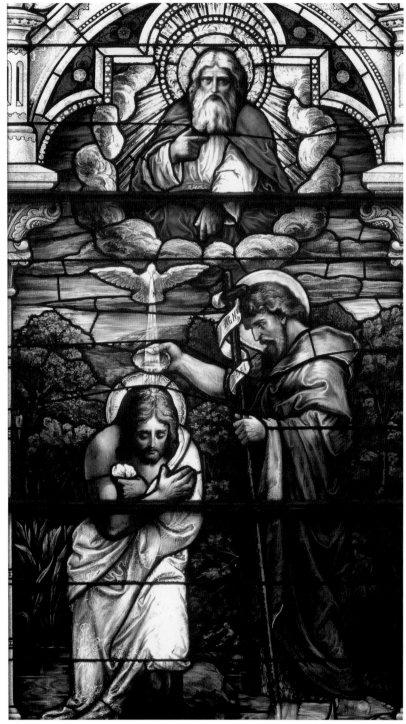
Stained glass: Baptism of Jesus *(detail)*

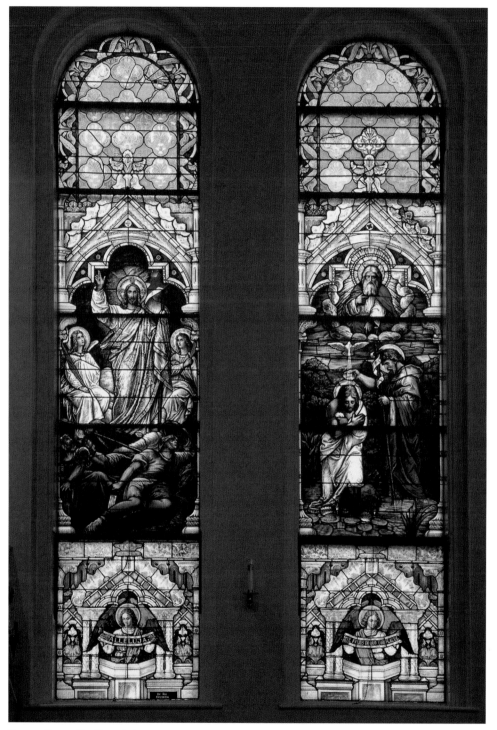
Resurrection and baptism windows

Sts. Vincent de Paul and Louise de Marillac

Painting of St. John the Baptist

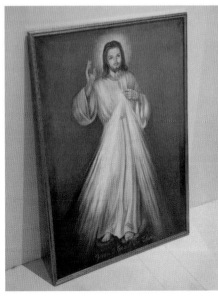

Painting of the Divine Mercy

Statue of St. Paul with St. Anthony in background *(far left)*

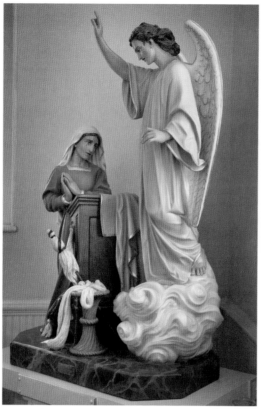

Statue of the Annunciation

Exterior of church door
(right)

View of main aisle and
altar *(far right)*

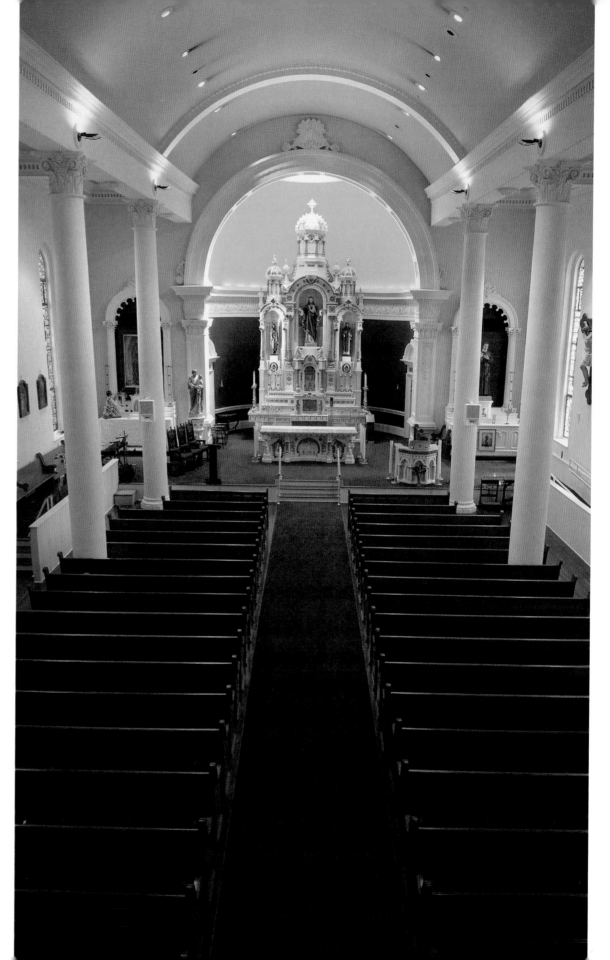

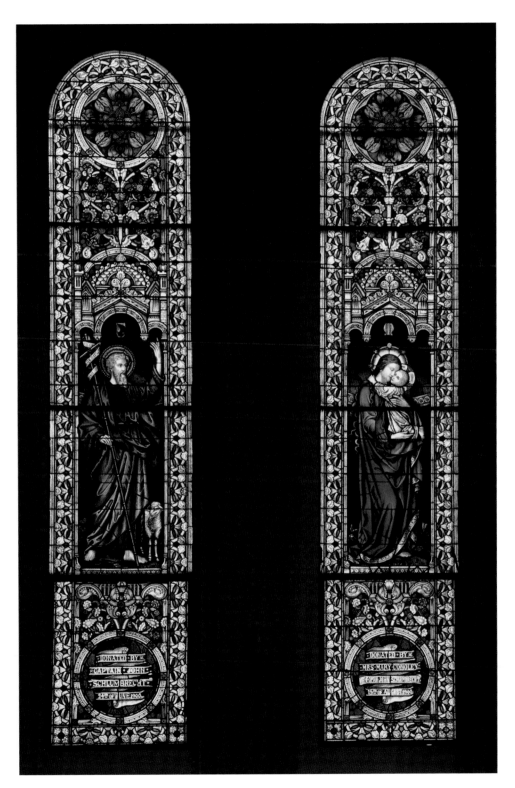

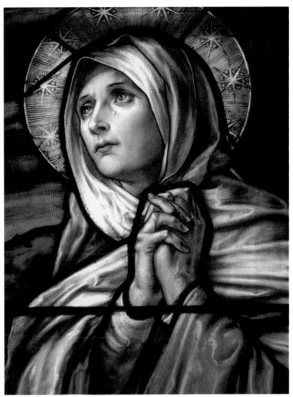

Stained glass: Mater Dolorosa detail

Stained glass: St. John the Baptist and Mary hugging Jesus

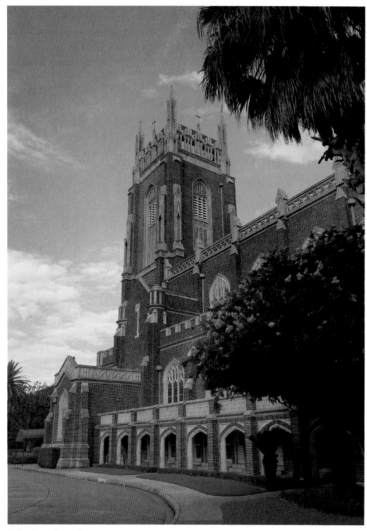
Side view of exterior

3. HOLY NAME OF JESUS CHURCH

OLY NAME OF JESUS PARISH was established in 1892 as a suburban mission. On May 29 of that year, Mass was first celebrated in a small wooden church known as Little Jesuits to distinguish it from the Jesuit church Immaculate Conception on Baronne Street. By January 1, 1894, the parish numbered about ten families. In 1910, the church was lifted on rollers and moved closer to St. Charles Avenue to make room for Loyola University's Marquette Hall and Louise Thomas Hall. In 1922, after the present church was completed, Little Jesuits was dismantled, ferried to Westwego, and reassembled to serve as the church for the recently established Our Lady of Prompt Succor Parish.

The present Holy Name of Jesus Church, located on the campus of Loyola University of the South, was designed by Rathbone DeBuys. The church, 240 feet long by 40 feet wide with a 165-foot tower, sits to the left of the circular drive that welcomes visitors to the campus. Its colonnaded side blends with the university architecture. The church, like the university, bears the stamp of the Jesuit fathers who founded and administer both.

"The munificence and piety of a good Catholic lady, Miss Kate McDermott, has made it possible to rear on this significant spot, fraught with the memories of two centuries ago, a beautiful temple to the honor and glory of the Most High God." Thus did Jesuit Father Albert Biever address those gathered for the laying of the church's cornerstone on January 2, 1916. The ceremony, which included a blessing

of the foundation and the site of the main altar, "was witnessed by an immense throng, representing all walks of life and many faiths."

The property was originally part of the Jesuit colonial plantation before the order was arbitrarily expelled from Louisiana in 1763. "A splendid church will rear its noble spire but a stone's throw from the spot where the only Jesuit allowed to remain in Louisiana at the time of the expulsion died a broken-hearted man," Father Biever noted. Father Michael Baudouin, a native of Canada and veteran of more than two decades of missionary labor among the Choctaw Indians, was seventy-two years old and in poor health at the time of the expulsion. He was allowed to remain. The Jesuits returned to Louisiana in 1837 to open a college in Grand Coteau, and they came back to New Orleans a decade later.

Holy Name of Jesus, described as Tudor Gothic in style, was built over four and a half years. Ground breaking took place on May 1, 1914. The completed church was dedicated on December 9, 1918. In its early years, the church was also known as McDermott Memorial Church in honor of its generous donor. A contemporary described the sound construction of the new edifice: "The church will be of entirely incombustible material, with the sole exception of the pews, which will be wood. For the general construction, steel columns and trusses are to be employed, and also reinforced concrete. For the exterior and interior walls, hard building brick and hollow tile will be used, faced with tapestry brick. Exterior detail will be of Indiana limestone up to the level of the main parapet, from which point upwards terra cotta, with the limestone finish, will constitute the material for that portion."

Between the main doors, welcoming all who enter, stands a statue of Jesus as a young boy holding grapes and wheat. Over his head are the words *Church of the Most Holy Name of Jesus*. At the center of the vestibule is a bell from the original church. Around its base are engraved the words *And you shall name him Jesus—in the Name of Jesus every knee shall bend—Christmas, 1892*. Two large marble angels holding holy water fonts greet parishioners and visitors as they enter the church.

The ornate Gothic interior reflects both the Jesuit devotion to Jesus Christ and the religious order's unique history. Majestic arches and columns on either side of the nave lead to the elaborately decorated sanctuary, with its altar rail and main altar both of Carrara marble. The altar of sacrifice, also of Carrara marble, was installed in 1977. The main altar supports a graceful, detailed superstructure that surrounds the marble Crucifixion scene. On one side is a statue of Mary; on the other, one of Christ. Below the altar table is carved the Last Supper. Behind the altar on the left and right are stained-glass windows depicting the four Evangelists. They are set against a russet-red background with gold crosses, a pattern repeated with smaller crosses behind the side altars.

Five upper windows look down on the altar. The far left shows the Wedding Feast at Cana, water turning to wine as it is poured from the jugs. Next, moving to the right, are the Ascension, Pentecost, and the Assumption of Mary. On the far right, the risen Christ is represented triumphant over death. In these and other windows, Jesus wears a robe of striking red; Mary, one of deep blue. Above the windows, from left to right are the first words of the Gloria. In the upper wall above the altar, twelve angels surround Christ. Each holds a scroll with Latin words from the Gloria of the Mass: *Sanctus Sanctus Sanctus, Dominus Deus Sabaoth, Benedictus Qui Venit in Domine Domini* (Holy, Holy, Holy, Lord God of Hosts, Blessed is he who comes in the name of the Lord).

The Carrara marble pulpit was installed in 1919. The seven steps leading to it represent the seven gifts of the Holy Spirit. Its twelve Gothic arches signify the twelve apostles and match the arches in the main body of the church and in the altar rail. Six fourteen-inch hand-carved marble statues grace the front of the pulpit: Moses; the four Evangelists; and St. Thomas Aquinas, the great thirteenth-century Dominican theologian. The shell above the pulpit is trimmed with gold leaf; the image of a dove, representing the Holy Spirit, is painted on its interior. The entire pulpit rests on an octagonal base of onyx marble.

To the left of the sanctuary, the altar of the Blessed Virgin, made of white Carrara marble, was also installed in 1919. It matches the Gothic style of the main altar. Mary is portrayed as assumed into heaven. In the altar's lower section is an image of the Archangel Gabriel appearing to Mary. To the left of Mary's altar is a statue of the great Jesuit missionary to the Far East, St. Francis Xavier (1506–52), and an altar dedicated to the Sacred Heart. Jesuits were great promoters of devotion to the Sacred Heart during the seventeenth century in reaction to Jansenism. Above this altar in twin stained-glass windows, Jesus appears to Saint Margaret Mary Alacoque.

To the right of the sanctuary is an altar honoring St. Joseph. This too is of white Carrara marble. Below the altar table is a representation of the death of Joseph, attended by Mary and Jesus. Nearby, facing the center aisle, is an altar dedicated to St. Ignatius Loyola (1491–1556), the founder of the Jesuit order. Below the altar table, Mary with the infant Jesus appears to Ignatius, who sits at a desk with a quill in his hand and an open book on which to write. A statue of Jesuit St. Aloysius Gonzaga (1568–91), the patron of youth, stands to the left of St. Ignatius's altar. Above the altar to the left, a stained-glass window depicts Abraham meeting the high priest Melchizedek, who is offering bread and wine. In the window to the right, an angel restrains Abraham's hand as he prepares to sacrifice his son Isaac, a foreshadowing of God the Father sacrificing his son.

Four large stained-glass windows grace each side of the church while four more adorn the choir loft. In addition to familiar scenes such as the birth of Christ, Jesus blessing the children, and the Agony in the Garden, the window subjects include four that are unique among the churches in this volume: two depict Jesus's miracles; one shows Jesus as a carpenter with his family; and one honors Mary as Queen of the Society of Jesus.

The windows beginning at the left front depict Jesus teaching in the temple; Jesus rescuing Peter from the turbulent sea as the other disciples anxiously look on; Mary as Queen of the Society of Jesus with St. Ignatius and St. Francis Xavier; and Jesus blessing the children. The scene with the grays of the turbulent sea and the violets of the stormy background clouds exemplify the rich colors of the glass.

Beginning at the right front, the windows illustrate Jesus as the Good Shepherd; Jesus with his disciples; the Agony in the Garden; and Jesus raising the daughter of Jairus from the dead. Prominent in the Agony in the Garden window are the apostles, who have fallen asleep. In the choir loft are stained-glass scenes of the Nativity, the visit of the Magi, Jesus teaching in the temple, and Jesus the carpenter with his family.

The stations of the cross were installed in 1917 and restored in 1977. In the back of the church is a shrine honoring St. Anne with young Mary and statues of St. Anthony of Padua, Our Lady of Prompt Succor, and Our Lady of the Rosary.

Father Donald Hawkins, S.J., aptly summarized Holy Name of Jesus in his history of the parish: "The church serves as a monument not only of architecture and design but also of spirituality and the Christian life. Its Jesuit heritage is plain for all to see."

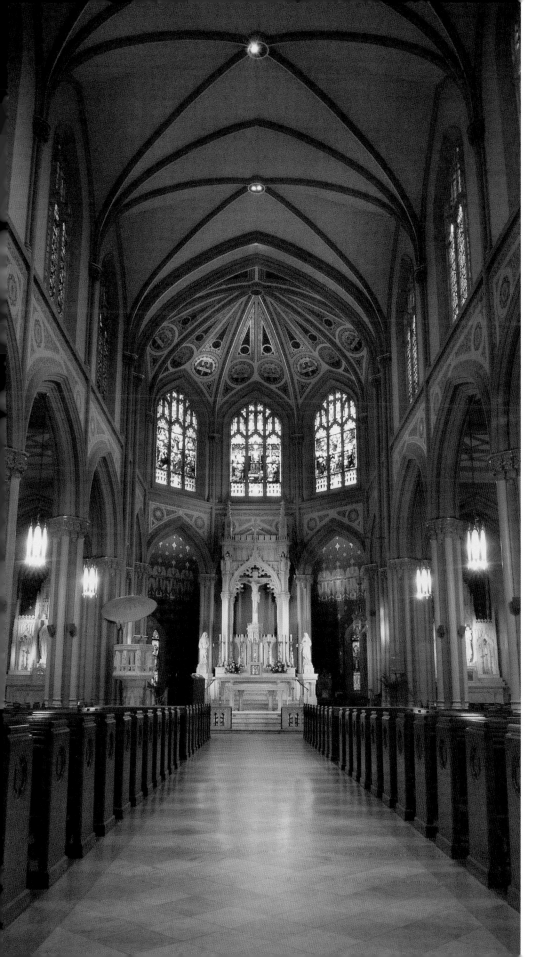

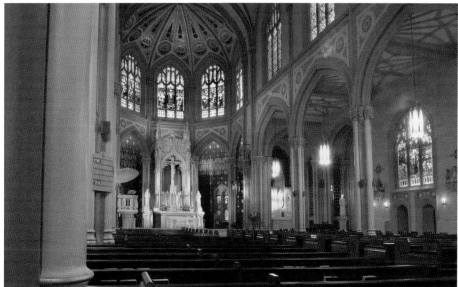

Church interior from a side pillar

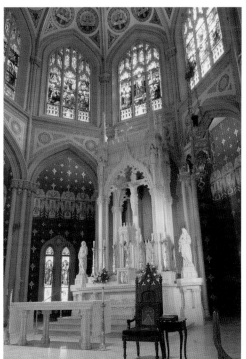

Main altar and altar of sacrifice

Central aisle and sanctuary

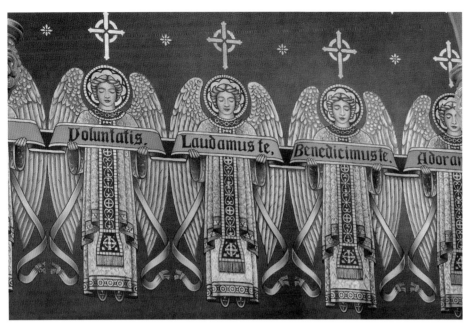

Angels on the wall behind the altar *(detail)*

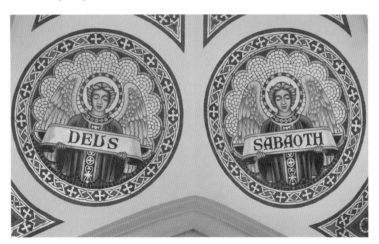

Gloria angels *(detail)*

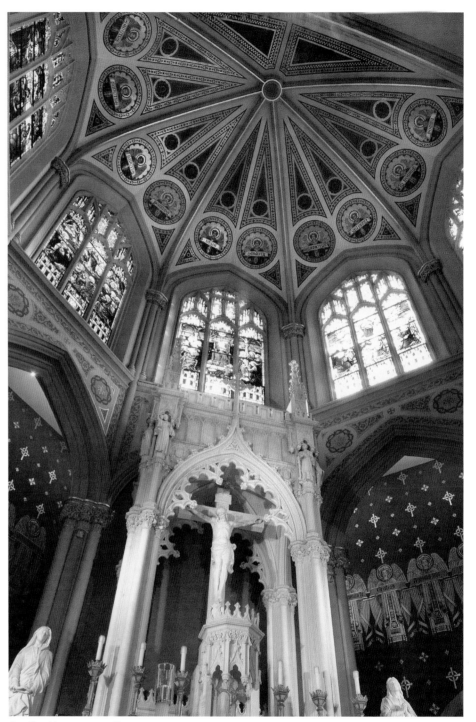

Crucifix with sanctuary ceiling

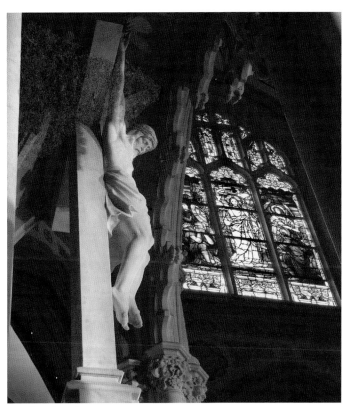

Crucifix and window

Stained glass: Jesus calms the sea (far left)

Jesus calms the sea (detail of apostles, left)

Stained glass: Jesus raises Jairus's daughter

Stained glass: Jesus as the Good Shepherd

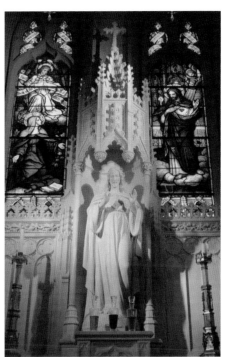

Sacred Heart altar with stained-glass windows of Jesus appearing to Blessed Margaret Mary Alocoque

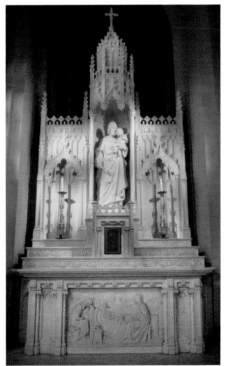

St. Joseph altar *(left)*

Stained glass: Mary Queen of the Society of Jesus, Sts. Ignatius and Francis Xavier *(far left)*

Pulpit stairs

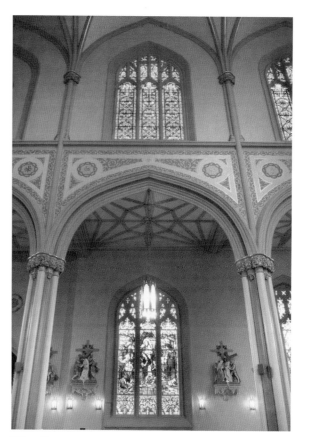

Side wall

Pulpit *(detail)*

Station of the Cross I *(detail)*

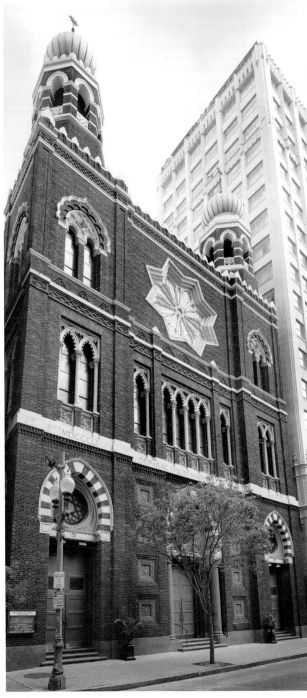
Facade

4. IMMACULATE CONCEPTION CHURCH

MMACULATE CONCEPTION CHURCH is located in the heart of the Central Business District, across Canal Street from the French Quarter. The church is surrounded on three sides by tall commercial buildings, and its interior beauty is apparent only when fully lighted. It offers a refuge for worship, quiet, and reflection to those passing on the busy outside street. The lofty architecture, elaborate stained-glass windows, and majestic high altar convey "the gentle feeling of peace," a parish historian wrote in 1978.

The history of Immaculate Conception—the church and the parish—is intertwined with that of the rapidly growing American section of New Orleans in the years prior to the Civil War. The Jesuit fathers, expelled from Louisiana in 1763, returned to the state in 1837. A decade later they were asked by Bishop Antoine Blanc to open a college for boys and to staff an adjoining church. They purchased swampy land at Baronne and Common. On June 10, 1848, ground was broken for a college, chapel, and residence. The College of the Immaculate Conception, the forerunner of both Jesuit High School and Loyola University of the South, began classes on February 1, 1849. Thirty-two children were baptized at Immaculate Conception Chapel in the first year.

The small chapel soon proved inadequate, and Father John Cambiaso, a priest of extraordinary talents, drew up plans for a new Moorish-style church. Working with an architect with the surname Touggourt, Father Cambiaso oversaw the construction, which began in 1851. Plans for a massive structure three stories tall

had to be modified because of the resulting weight. Two towers in the original design were also omitted. Mass was first celebrated in the new church on August 15, 1857. The church was dedicated to Mary under the title of the Immaculate Conception. Three years earlier, Pope Pius IX had declared the dogma of the Immaculate Conception, which holds that Mary, by a singular grace and in view of the merits of Jesus Christ, was preserved from original sin.

Immaculate Conception became a vibrant American sector parish, particularly in the decades following the Civil War. There were 312 baptisms in 1867. In 1888, there were 431, including 41 adults; about a quarter of those baptized were of African descent. The parish also had a small Italian community and nine active societies—the Apostleship of Prayer, two Sodalities of the Blessed Virgin Mary (one for women, one for men), a Total Abstinence Society, a St. Vincent de Paul Society, Lady Servants of the Poor, and Catholic Knights of America, among others.

The parish peaked in membership around the turn of the century but then began to rapidly decline as commercial buildings replaced family residences. There were 543 baptisms in 1900, but by 1920 the number fell to 49, including 24 adults; parishioners numbered only 300. Still, visitors flocked to the church for Mass, and more than 56,350 people received communion that year.

In addition to the large number of nonparishioners they served, the Jesuit fathers reached out regularly to the poor and needy. During the 1853 yellow fever epidemic, Father John Duffo slept in the rectory's parlor so he could be readily available to answer calls to assist the sick and dying. Priests from Immaculate Conception also ministered to several growing communities across the Mississippi River on the West Bank. In 1926, Jesuits were routinely visiting St. Rosalie Church in Harvey, St. Anthony Church in Barataria, Sacred Heart Chapel in Lafitte, and a new mission chapel at Crown Point.

In the 1920s, Immaculate Conception re-created itself as a haven in the core of the city's commercial center. Unlike a traditional parish with defined boundaries, it accommodated people from throughout the city who worshiped there regularly. The men's sodality had 370 members, more than the total number of parishioners. The Bona Mors (Good Death) Society, founded in Rome in 1648 during a plague outbreak to prepare members for a holy death, numbered more than 15,000. The church attracted thousands each day, some for a brief visit, some for a more lengthy time of quiet and prayer. On October 21, 1927, 4,376 people visited the church between 5 a.m. and 8 p.m. Not all were Catholics "since many of all faiths seek brief Sanctuary in the dim religious light of the church." The following November 26, the priests kept a careful tally of the 85,196 persons who passed in front of the church between 8 a.m. and 7 p.m.—56,096 on foot; 15,260

in autos; and 15,840 in street cars. "Among the 24,972 male pedestrians, 12,190 doffed their hats as they passed the church."

Pile driving for the adjacent Pere Marquette Building, constructed in 1927, badly damaged Immaculate Conception's structure. The final blow came when dynamite was used to prepare the foundation for the Canal Bank Building a half block away at the corner of Baronne and Common. A Jesuit diarist noted, "Not once did the pile driving of the Pere Marquette Building shake our church so violently as the blasting carried on." On April 29, 1928, the church was declared unsafe for worship and was permanently closed. The dismantling of the interior began immediately, and the edifice was taken down piece by piece. By early October, the demolition was completed.

Despite a dwindling number of registered members, the parish community undertook the ambitious program to build another imposing church modeled on its predecessor. In 1929 and 1930 as the Great Depression began, the parish spent more than $428,000 for the new structure. On October 30, 1928, the first pilings were driven. Into each of the first five, more than sixty feet in length, a hole was drilled and a small statue inserted; the hole was then capped with iron. The statues were of Christ the King, the Immaculate Conception, St. Joseph, St. Louis King of France, and St. Ignatius Loyola. On February 4, 1930, as construction neared completion, two magnificent bronze doors, each weighing 1,500 pounds and adorned with Moorish design, were installed. Two days later, a historic statue of Mary was placed in its new niche. The altars were reinstalled on February 10; the pews, on February 17. On March 2, 1930, Mass was celebrated in the new church for the first time.

The architecture of Immaculate Conception is unique among the city's Catholic churches. A replica of the 1857 church, it combines Gothic elements with Moorish or Sarracenic architecture of Spain, particularly Andalusia. The tall, graceful arches, intended to lift one's spirit in prayer, are Gothic. The sanctuary's Gothic design is blended with the Moorish dome overhead. Much of Immaculate Conception's interior—altar, stained glass, statues, pews—were taken from the original church. A parish historian wrote in 1928, "In all details of the interior can be found a strong Hispano-Moresque influence, recalling Toledo, Cordova, Sevilla, and Grenada." Father Cambioso, the original church's designer, "during his sojourn in Spain became enamored of the Moresque style of architecture, and he designed and executed a classic example of this architecture in the Jesuits' church on Baronne Street."

As one enters the church, attention is drawn to the sanctuary and its graceful cupola, the statue of Mary in the niche above the main altar, and the remarkable

statuary. The solid marble statue of Mary as the Immaculate Conception was carved in France by Denis Foyatier for Queen Marie Amélie, wife of King Louis Philippe, and was intended for the royal chapel. When the 1848 revolution thwarted the statue's original purpose, Foyatier had to sell it. Via New York, the statue found its way to New Orleans, where the Jesuits purchased it for $1,500. It stands "in serene simplicity, like a mother beckoning her children to come closer and to be in peace," wrote Father Hilton L. Rivet, S.J. Additional statues flank Mary's. Above them, stained-glass windows depict the Annunciation; Adam and Eve expelled from the Garden of Eden, with Mary crushing the head of the dragon; the Assumption; the Coronation of Mary as Queen of Heaven; and Mary at the foot of the cross. These windows were executed in France in 1878 by Hucher Rathouis.

The altar of gilded bronze was designed by New Orleans architect James Freret and built in Lyon, France, in 1867. It won first prize in the Paris Exhibition of 1867 and was first used in Immaculate Conception Church on December 8, 1873, the Feast of the Immaculate Conception. The altar has been dismantled and refurbished several times. In 1955 it was plated with 24-karat gold. The tabernacle and altar statues are remarkable for their detail. Four statues represent the Evangelists; statues of angels are on either side of the tabernacle. The smaller altar of sacrifice complements the main altar and has a hand-carved design of wheat and bread, and grapes and wine. Behind the main altar are four large paintings that portray Mary with her parents, Sts. Joachim and Anne; the Nativity; Pentecost; and Mary's Dormition.

To the right of the sanctuary is St. Joseph's altar. Adjoining it is a large stained-glass window depicting St. Joseph on his deathbed, attended by Jesus and Mary. A guardian angel stands nearby. To the left of the sanctuary is an altar dedicated to the Sacred Heart. Next to it is a large stained-glass window of Christ revealing his heart to St. Margaret Mary Alacoque. Present also in the scene are Mary as the Immaculate Heart; Father Claude de la Colombière, Margaret Mary's Jesuit spiritual director; and Pope Clement XIII, who approved the general devotion to the Sacred Heart.

The massive church includes three levels of stained-glass windows. The lowest level depicts the worldwide experiences of early Jesuits, 1534–1720, particularly in North America. They include eight martyrs who died ministering to Native Americans, St. Francis Borgia's conversion after seeing the remains of Empress Isabella of Grenada, and St. Charles Spinola, burned to death in Japan, plus many others. Below each window is an identifying plate.

The second tier of windows, partially visible from the ground floor, includes thirty-six non-Jesuit saints, some well known and others less familiar. Among these are Sts. Thomas More, John the Baptist, Louis King of France, John of the Cross, Angela Merici, Bridget of Sweden, Patrick, Elizabeth of Portugal, John the Apostle, Augustine, Elizabeth of Hungry, Cecilia, Dominic, Charles Borromeo, Teresa of Avila, Rose of Lima, Francis de Sales, and Vincent de Paul. The top level of windows, excepting the six above Mary's niche, display designs rather than figures.

Along the side walls are the church's unique stations of the cross—large, richly detailed stained-glass windows. They date to the original church and are remarkable for their artistry as well as their number, eighteen rather than the usual fourteen. The Agony in the Garden and Crowning with Thorns are added at the beginning; the Resurrection and Ascension, at the end. Over the main entrance to the church, a stained-glass window depicts the head of Mary; over the choir loft is the head of Jesus with sunlike rays with symbols of Mary and Jesus.

In the church vestibule are statues of St. Peter and St. Anthony of Padua. The former is a smaller bronze replica of the original in St. Peter's Basilica in Rome. Like the original, one toe is worn smooth by the touch of visitors. Over the years, hundreds of keys for every use have been left on, behind, or under the statue, "expressive of the faithful's belief that St. Peter will help them obtain that which the key which is left represents." The 1928 parish historian wrote, "For centuries interminable lines of persons have marched by this statue [in St. Peter's], each one kissing the right foot, to testify their reverence for the prince of the Apostles. In New Orleans our people have followed the example of the pious pilgrims to the tombs of the Apostles."

The two mosaic shrines to the right and left of the main entrance were executed in Italy. The right one depicts Mary under the title of Our Lady of Perpetual Help; above it is *IHS*, the abbreviation for Christ. The right mosaic represents Our Lady of Prompt Succor protecting New Orleans during the 1815 battle and a supposed 1812 fire. St. Louis Cathedral and the Chalmette Battlefield are included at the bottom of the mosaic.

The faces of the angels that form part of the four holy water fonts all differ. Each was modeled after a female member of the family of Father Facundus Carbajal, the parish pastor from 1930 to 1932. The fonts were installed in 1931. The cast-iron pews, original to the church, retain the numbers used when pew rental was a source of parish income. Symbols of eight of Mary's titles— including Morning Star, Gate of Heaven, House of God, and Ark of the Covenant—are repeated in their design.

A major renovation of Immaculate Conception took place in 1997. Decades of soot and candle wax were cleaned off the walls and ceiling, and softer colors and

new lighting further brightened the interior. The original architecture was better revealed after many of the stencil patterns were removed. The niche holding the statue of Mary was covered with 24-karat gold leaf. The baptismal font with its flowing water was added in the main aisle as one enters the church. The restoration was part of a master plan to reestablish Immaculate Conception Parish as a church that serves the business community as well as the poor and elderly, its own members and the larger New Orleans community. It is both an active parish and a haven of quiet, prayer, and devotion for those who pass by each day.

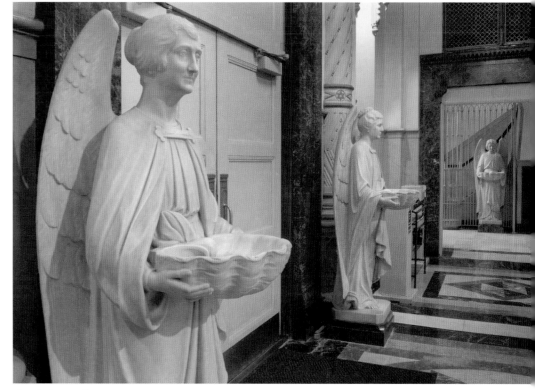

Three holy water fonts

Holy water font *(detail)*

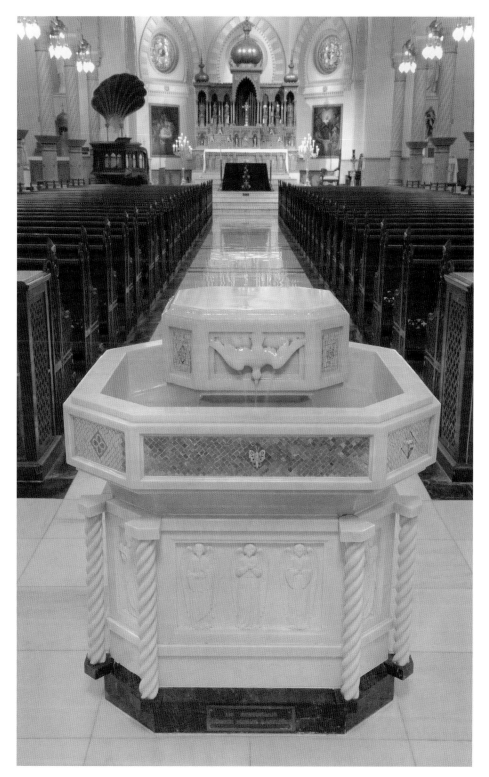

St. Peter statue

St. Peter statue, right foot *(detail)*

Baptismal font and front view

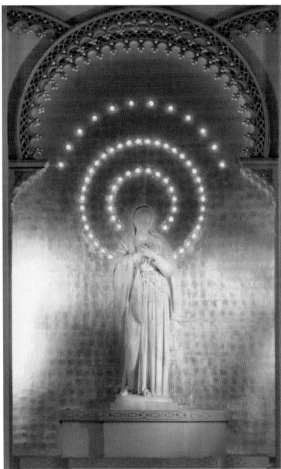

Statue of Mary, as the Immaculate Conception

View of front of church *(far right)*

Mosaic of Our Lady of Prompt Succor *(right)*

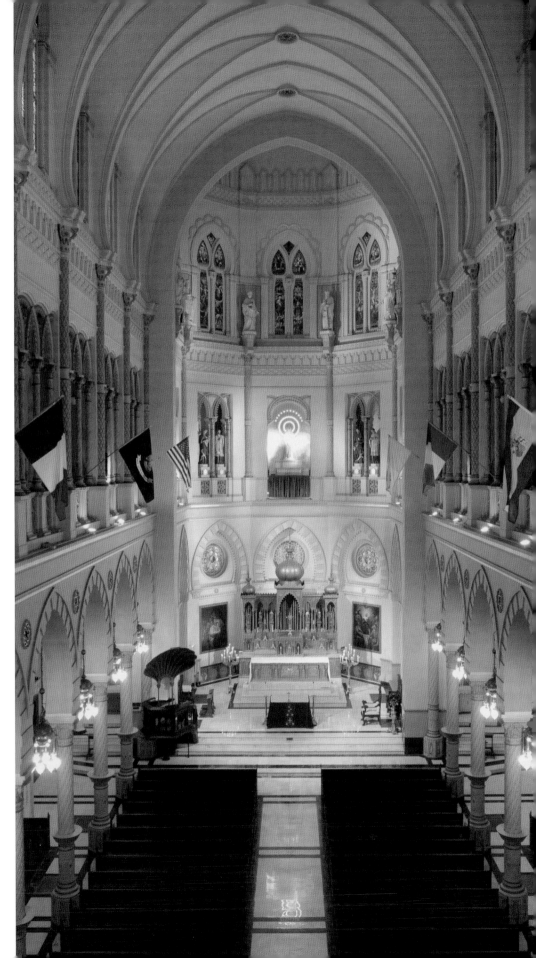

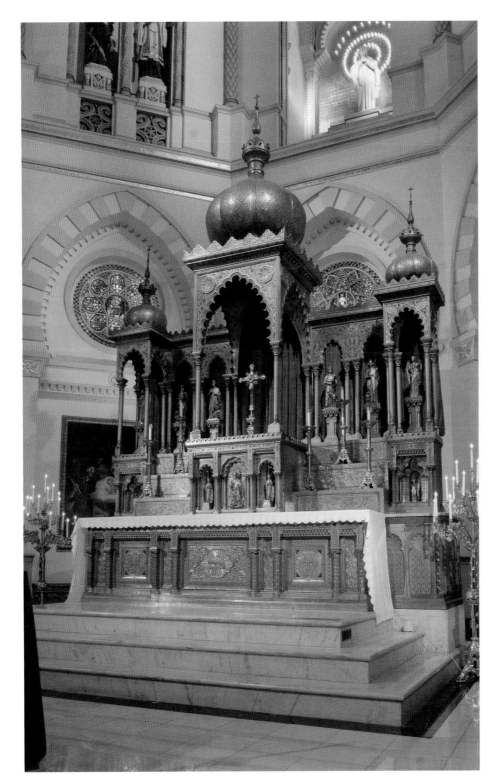

Main altar

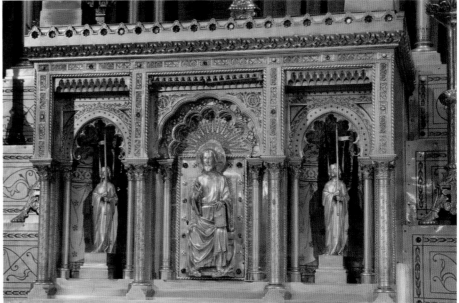

Tabernacle

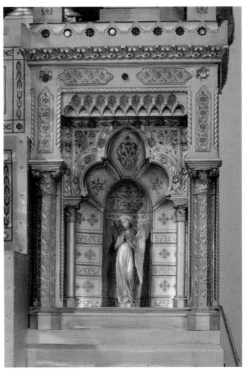

Altar (detail)

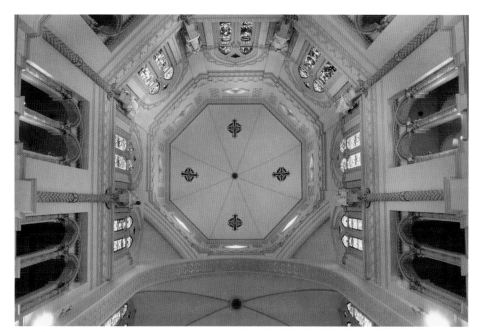

View of sanctuary ceiling

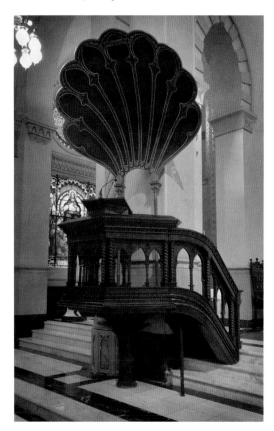

Pulpit

Column (detail)

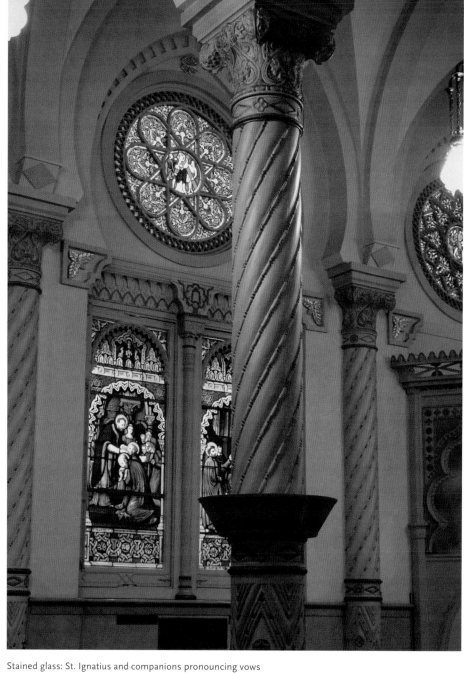

Stained glass: St. Ignatius and companions pronouncing vows

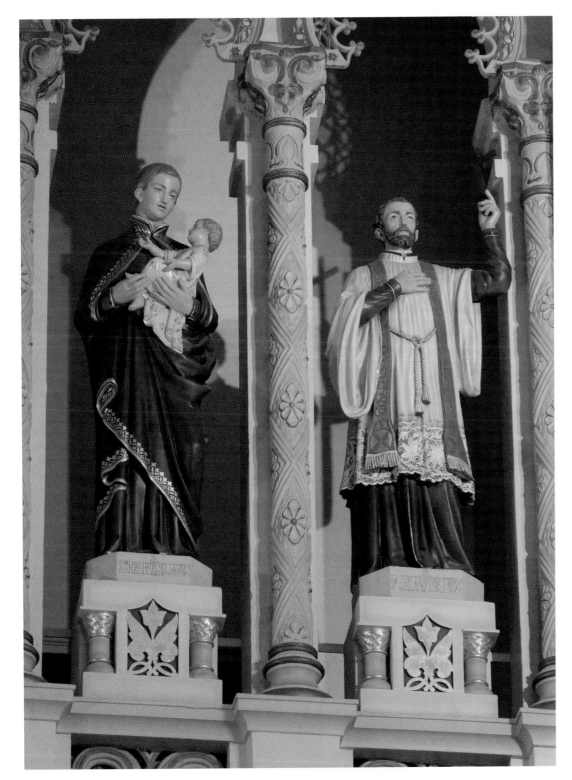

Stained glass: Death of Joseph

Painting: The Dormition of Mary

Statues of Sts. Stanislaus and Francis Xavier *(left)*

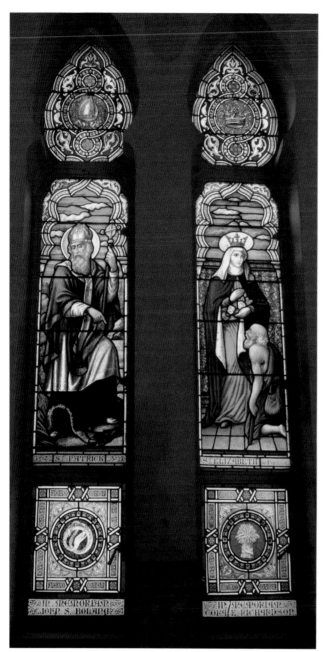

Stained glass: Sts. Patrick and Elizabeth of Hungry

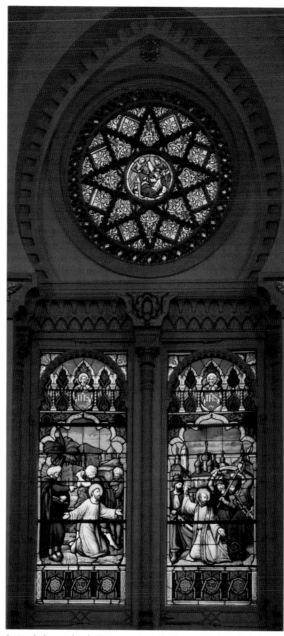

Stained glass: John de Brito, martyr in India, and Andrew Babola, martyr in Poland

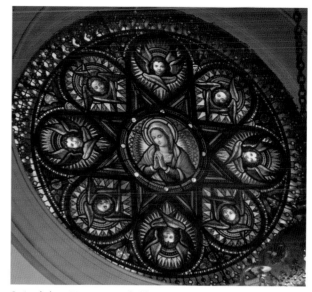

Stained glass: Mary surrounded by angels

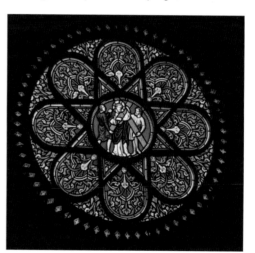

Stained glass: Station of the Cross II, Jesus carries his cross

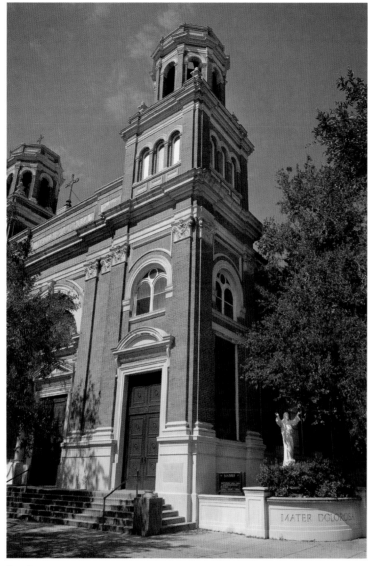
Facade

5. MATER DOLOROSA CHURCH

ATER DOLOROSA HAS A UNIQUE early history. A decade prior to the construction of the present church, Mater Dolorosa Parish had been formed from two often-antagonistic immigrant parishes in Carrollton, one French (St. Mary of the Nativity) and one German (Mater Dolorosa). Their tensions reflected conflicts between the German states and France under Napoleon, as well as in 1848 and 1870.

Carrollton's history goes back to the first half of the nineteenth century. In 1835, the New Orleans and Carrollton Railroad Company completed a line from New Orleans to the new community, where a resort hotel was erected. The local residents of the future Carrollton area were first served by priests from St. Charles Borromeo Parish in Destrehan. Around 1845, Father Flavius Rossi was assigned there. In 1848, Father Ferdinand Zeller, a native of the French region Lorraine who spoke French, German, and English, was appointed the first pastor. Mass for the growing congregation was initially celebrated in a private home. A small frame church seating about 200 was dedicated on September 8, 1848, under the title St. Mary of the Nativity.

Although the parishioners were mainly German, there were also French and English speakers in the area. Among the family names found in the early church registers are Hageman, Dreis, Hoffmann, Schmidt, Roettel, and Zimmermann as well as Sullivan, Ryan, Mooney, Bienvenu, LeBlanc, and Labarre. Initially, sermons were preached in German. When the French and English speakers refused to

attend church and rumors spread that the church would be burned down, Father Zeller began preaching in German, French, and English.

Tension between the French and Germans, always simmering in Carrollton, was inflamed by the German victories in the Franco-Prussian War of 1870–71. When a new Belgian pastor who did not speak German was assigned in 1870, the Germans were indignant and demanded their own church. The Irish and French protested. German parishioners collected funds and purchased property, which was turned over to the archdiocese on the condition that it be used for Carrollton's German community. Mass was first celebrated in the newly completed Mater Dolorosa Church on December 17, 1871. Sermons, instructions, catechism, and announcements were exclusively in German.

In 1899, despite protests by German parishioners, St. Mary of the Nativity and Mater Dolorosa parishes were merged. St. Mary of the Nativity Church was sold to the Illinois Central Railroad and demolished a decade later. Even with improvements to Mater Dolorosa Church, the need for a larger building was evident. Property for the new church was purchased in 1904. Father Francis Prim, the pastor from 1898 to 1933, engendered, according to parish historian Roger Baudier, "a new spirit . . . a spirit of unity, co-operation and zeal" that overcame the long-standing antagonism and differences between the two major factions in the parish. This "fusion of differing spirits and temperaments into a parochial entity" produced the financial support needed for a new church. The old Mater Dolorosa was purchased by the Josephites, who established a new parish for African Americans under the title St. Dominic. The church was destroyed in the 1915 hurricane, and the parish was later renamed St. Joan of Arc. In 2008, Blessed Sacrament and Joan of Arc parishes were merged into one, worshiping at St. Joan of Arc Church.

In April 1908, Archbishop Shaw approved the cruciform design of the new Mater Dolorosa, by architect Theodore Brune. On May 1, the first pilings were driven. The cornerstone was blessed on the following August 9. The completed church, 152 feet in length by 58 feet in width with an 84½ foot transept, was dedicated on March 7, 1909. In April, the principal stained-glass windows, executed by the Emil Frei Company, were installed. The handsome stations of the cross, each donated by an individual or society in the parish, were installed on May 21. The central theme of the church's interior is Mary, the Sorrowful Mother of Christ (Mater Dolorosa). In mosaic, stained glass, statuary, and fresco, Mary is portrayed throughout her son's life, death, resurrection, and ascension. She is also depicted within the wider context of her own life from infancy to coronation as Queen of Heaven.

The carefully designed wood main altar includes two hand-carved statues: one of St. Anne with young Mary holding a scroll; the other of Mary the Sorrowful Mother. Beneath the altar table is an elaborately chiseled Last Supper scene. On either side of the altar are hand-carved angels, their faces rendered with expressive detail. Behind the altar are two stained-glass windows of St. Joan of Arc. In one, she holds a sword and scroll; in the other, flowers. To the left of, and facing, the altar is a large painting of Mary's Dormition, with the apostles and angels present. To the right of the altar is a painting of the death of St. Joseph, attended by Mary, Jesus as young man, and angels. Both paintings depict familiar apocryphal scenes.

Above the sanctuary is a large five-panel mosaic. The Pietà is featured in the center panel. To the left are depicted Nicodemus and Mary with St. Bernadette Soubirous; to the right, the apostle John with Mary Magdalen, and Veronica holding a veil with the imprint of Christ's face. Above the mosaic is a painting of the Trinity holding the letters alpha and omega and flanked by angels. The Father and Son are seated on royal thrones while the Holy Spirit appears in the form of a dove over them.

The church's two transepts are richly adorned and counterbalance each other. In the left transept, a half-circle stained-glass window portrays the suffering Christ with an elaborate IHS, a pierced heart, and a cross with a crown. In the upper cross section are paintings of two Evangelists, Mark (with the lion) and Matthew (with the young man). Both have a scroll and writing instrument in their hands. Facing them is a painting of St. Francis of Assisi and a large stained-glass window of the Assumption of Mary. The curved ceiling includes paintings of two events in Mary's youthful motherhood—the Presentation of Jesus in the Temple and the Flight into Egypt. The left transept houses two altars. The one nearest the sanctuary depicts Mary appearing to St. Bernadette Soubirous at Lourdes; the other, the Sacred Heart. Above Mary's altar are angels and the words *Misere Nobis* (Have mercy on us).

In the right transept, a half-circle stained-glass window portrays the suffering Mary with an elaborate *M*, a heart, and a cluster of roses. In the upper cross section are paintings of two Evangelists, Luke (with an ox) and John (with an eagle). They also have their writing instruments. Facing them is a painting of St. Dominic and a large stained-glass window of the Coronation of Mary as Queen of Heaven. Jesus in royal garb is placing a crown on Mary's head, and the Holy Spirit hovers above. Of the two altars in the transept, the one nearest the sanctuary honors St. Joseph; the other features a Pietà. The walls here, as throughout the church, are elaborately decorated. The curved ceiling includes paintings of Mary's meeting with Jesus as he carried his cross and an unusual scene of Mary and Joseph encountering a lame beggar.

The nave ceiling is also ornately painted. Near the altar, angels appear with the words *Sanctus, Sanctus, Sanctus*. One holds a cross and draped linen; one, a hammer and tongs; and the third, three nails—all instruments of Christ's execution. Three other ceiling paintings portray Mary during the events of Good Friday: Christ on the cross, with Mary, John, and Mary Magdalen nearby; Jesus's body lowered from the cross; and Mary and John leaving the sealed tomb. In each, Mary's sorrow is graphically portrayed, and she is garbed in white rather than the customary blue.

Along the side walls of the nave, six tall, graceful stained-glass windows portray the central events in Mary's life as passed down in biblical narratives and early apocrypha. Beginning at the left front, the window scenes include the betrothal of Mary and Joseph, the Annunciation, and the birth of Christ. The windows continue on the right back with the Presentation, the Visit of the Magi, and the Flight into Egypt. The two transept windows, depicting the Assumption and the Coronation of Mary, complement these six. All of the church windows' frame and lead work were reset in 1934.

In the back of the church are statues of Sts. Jude, Rita of Cascia, Lucy, Therese of Lisieux, Anthony of Padua, and Frances Xavier Cabrini. All were popular devotions in the early twentieth century. St. Frances Xavier Cabrini, the first American citizen to be canonized, was a missionary to the country's Italian immigrants. She visited New Orleans on several occasions, and her sisters have served there continually. The unique hand-carved statue of St. Anthony with a child and beggar is original to the church. The five beautiful bronze doors produced by Michael Bronze Company of Covington, Kentucky, were installed in 1941.

On May 16, 1908, the *Morning Star*, in announcing plans for Mater Dolorosa Church, captured its symbolism to the Carrollton community. "A magnificent new Church . . . [it] will be a perfect specimen of the pure Romanesque-Renaissance style of architecture, classical in every feature, and will not only be a great ornament to beautiful Carrollton Avenue, but it will tell generations to come how faithfully the Catholics of that populous center worked for their religion, and how from small beginnings the section grew into a powerful center of Catholic life and faith, animating and vivifying all, and bequeathing its blessings to ages yet unborn."

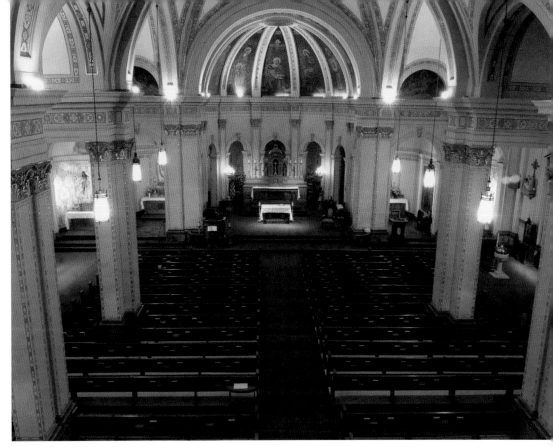

View of interior from choir loft

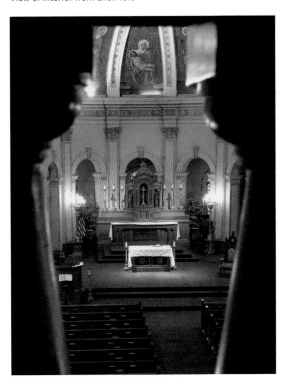

View through the railing in the choir loft

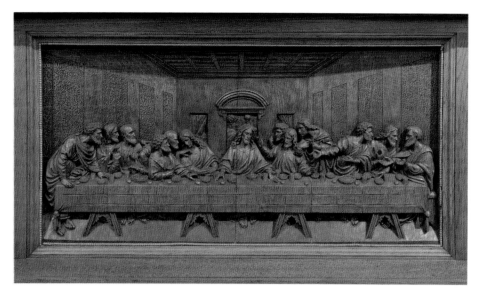

Last Supper *(altar detail)*

Anne and young Mary *(altar detail)*

Mater Dolorosa *(altar detail)*

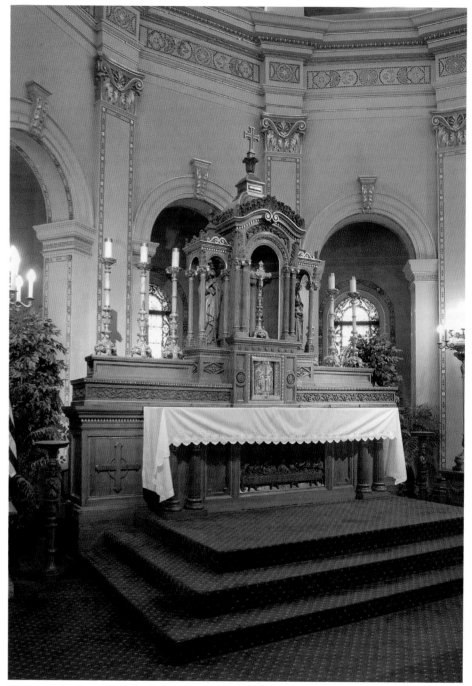

Altar

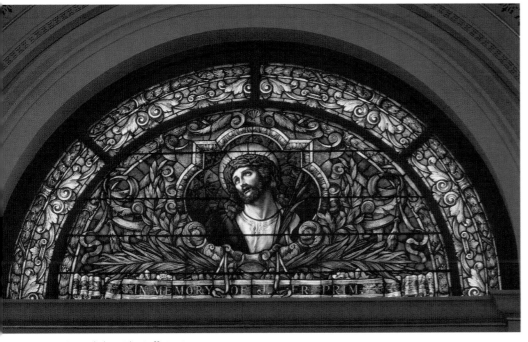

Stained glass: The Suffering Jesus

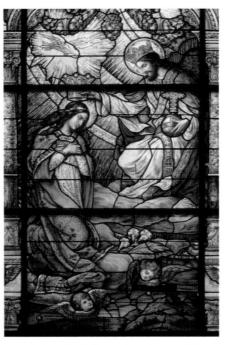

Stained glass: Mary's Coronation as Queen of Heaven

Stained glass: The Flight into Egypt

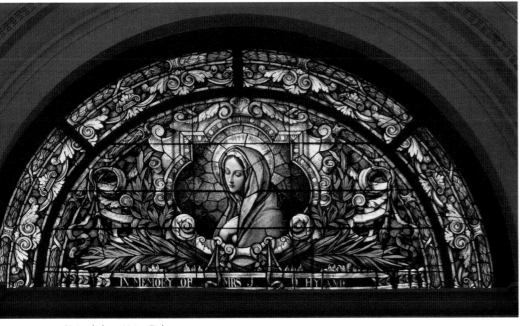

Stained glass: Mater Dolorosa

Stained glass: Visit of the Magi *(detail)*

Sanctuary mosaic

Ceiling painting of the Crucifixion *(far left)*

Ceiling painting of the Mater Dolorosa *(left)*

Ceiling painting of Jesus taken down
from the cross *(right)*

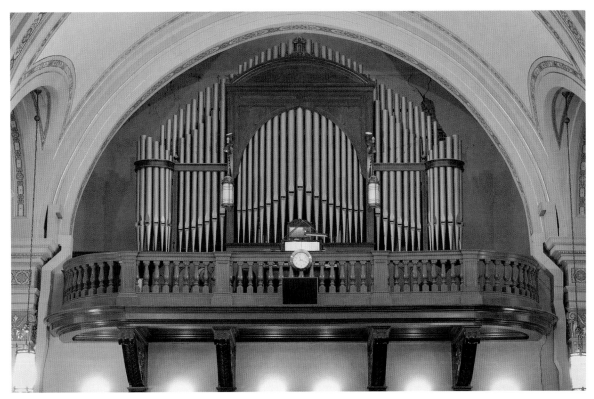

Choir loft

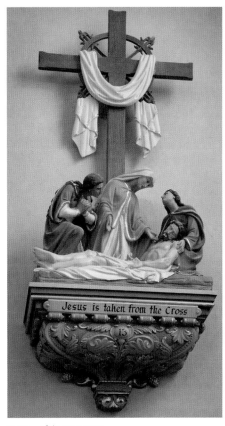

Station of the Cross XIII

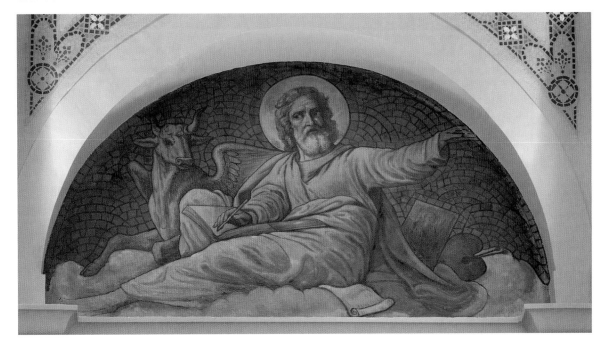

Painting of St. Luke with ox

Statue of St. Frances Xavier Cabrini

Facade

6. OUR LADY OF THE ROSARY CHURCH

 N JUNE 15, 1922, the archdiocesan building committee initially reviewed and expressed grave reservations about the architectural plans for the new Our Lady of the Rosary Church. They found the neoclassical design with its squarish shape, classical facade, and portico more suitable for a bank, post office, or public building than a church. They also objected to the imposing dome over the church's nave, which they considered a distraction from the altar. By October 27, Father William Vincent, the pastor, and Rathbone DeBuys, the architect, had met with the committee and resolved the differences. The church remained much as DeBuys designed it.

Our Lady of the Rosary Parish was established in 1907 to serve the expanding population of upper Esplanade Avenue near St. Louis Cemetery #3. Archbishop James H. Blenk celebrated the first parish Mass on December 26, 1907, in a room in the parish rectory. A frame church was in use by January 1908, and Father Vincent and the parishioners quickly began planning for a larger, more permanent church. The pastor reported on December 31, 1916, that $32,000 had already been placed in a building fund. The following year, he lamented that his promise to build a church within ten years was not fulfilled, but the 1915 hurricane, the expense of rat-proofing neighborhood homes, and the world war had interfered. By the end of 1923, the fund, managed by the pastor together with a cooperative association of laymen, amounted to more than $95,000. With a loan from Hibernia National Bank, the parish was at last ready to begin the new church.

The low bid was $166,495, by contractor James A Petty. Excavation was almost

complete by May 1924, and the cornerstone was laid on July 13. The building was finished in March 1925, and the church was dedicated on November 22 of that year. By 1927, all lower stained-glass windows, stations of the cross, and statuary were in place.

The building sits on nine piers—poured concrete areas that rest on 182 pilings and are connected by nineteen bays. The six massive portico columns are made of Indiana Bedford stone. Above the main entrance, a marble tympanum in bas-relief depicts Mary giving the rosary to St. Dominic and the infant Jesus handing a rosary to St. Catherine of Siena. In the left niche, St. Michael the Archangel holds a spear and crushes Satan's head. In the right niche, St. Raphael the Archangel protects Tobiah from a large fish. The young man holds a small fish, a rod, and a sack in his arms; on the left near the base is the little dog that accompanied them on their journey.

Despite the presence of a large dome over the center of the church, the sanctuary dominates the interior, which harmoniously blends altars, stained-glass windows, mosaic stations of the cross, and matching marble statuary. The main altar, consecrated on December 6, 1925, is white marble with multicolored reddish-brown columns and paneled areas, and three gold mosaic-covered cupolas. Two columns with Corinthian capitals support a massive center canopy with a gold mosaic between white marble ribs. Inscribed in front is *Ecce Panis Angelorum* (Behold the bread of angels). The altar was donated by Jean Louis Vincent, a river boat captain and the father of Father Vincent.

The gold tabernacle is encased in white marble. The semicircular roof over the tabernacle includes a tympanum in bas-relief of the Lamb of the Apocalypse resting on a book (scroll) with seven seals and bearing the victorious banner of the cross. A sheaf of wheat and a cluster of grapes are carved on separate superstructures on each side of the altar. A replica of Leonardo da Vinci's *The Last Supper* is carved in bas-relief below the altar table.

On each side of the altar and part of the superstructure are two niches with supporting columns crowned with Doric capitals. On the left side is a statue of St. Peter holding the keys of the kingdom in his right hand and a book of the Gospels in his left. The instruments of his martyrdom, the prison chain and upside-down cross, are in the medallion below. On the right is a statue of St. Paul holding a two-edged sword in one hand and a scroll, symbolic of his many writings, in the other. In the medallion below in bas-relief is a sword, the instrument of his martyrdom. Water gushes in three streams where the sword point touches the ground. Three fountains are said to have sprung from the earth when Paul's severed head struck the earth three times. Below the two medallions are the words *Per Crucem Alter Alter Ense Triumphans* (One triumphant by the cross, the other by the sword). On free-standing pedestals on either side of the altar are two angels, bending in adoration and holding candelabrae. Below the one on the left, the Greek letter alpha is imposed on a cross; on the right, the Greek letter omega.

The altar of sacrifice, designed to complement the main altar, was added after Vatican II and consecrated on December 6, 1969, by the pastor, Bishop L. Abel Caillouet. To the left and right of the altar of sacrifice are statues of the Sacred Heart and Joan of Arc. The ceiling of the sanctuary apse was painted by Vlademir Kjeldgaard of New York in 1940. Like the tympanum over the building's entrance, the center piece features Mary giving the rosary to St. Dominic while her son, seated on her lap, gives a rosary to St. Catherine of Siena, at whose side is a crown of thorns symbolizing her offer to become a sacrificial victim to bring about unity in the Church, caught up in the Great Schism of 1378. In front of Dominic is a dog with a burning torch in his jaws. Dominic's first biographer recounted a vision Dominic's mother had while pregnant with the saint. She dreamed she bore a dog holding in its mouth a burning torch with which he set the world afire. Early Dominicans saw this as a prophecy of Dominic's setting the world afire by his evangelizing. While he was preaching in southern France, Mary gave him the rosary. Below this painting is written in Latin *Regina Sanctissimi Rosarii, Ora Pro Nobis* (Queen of the Most Holy Rosary, pray for us).

Above this painting is another depicting God the Father sitting on a throne, surrounded by adoring angels. Below the angel on the left, a medallion surrounds a circle of roses, emblematic of Mary's all-surpassing love of God. On the right, a medallion surrounds a circle of lilies, symbolic of Mary's purity. Two panels, separated by simulated architectural ribs, are on either side of the central area. On the upper section of the left panel is a hand representing the hand of God doing great things for Mary. Beneath is the ark of Noah, with a dove bringing an olive branch indicating the receding waters. On the panel's lower section is a painting of the Annunciation. On the upper section of the right panel, a dove symbolizes great things accomplished through Mary by the power of the Holy Spirit. Beneath appears the Ark of the Covenant. On the panel's lower section is a painting of the Coronation.

Represented in stained glass in an inverted semicircle above Kjeldgaard's painting is God the Father, the Ancient of Days described in chapter 7 of the book of Daniel. Behind his head is a triangle symbolizing the Trinity. Adoring angels are before the Father with crosses and a globe with a cross. At the lower left and right are angels with trumpets summoning all creation to praise the Lord.

The pulpit, installed in 1932, is carved from a single block of white marble and sits on a marble base. The faces of the four early Doctors of the Church are

sculpted around its exterior: from left to right, the priest St. Jerome, with a cowl; Pope St. Gregory I, with a tiara; St. Ambrose, Bishop of Milan, with a miter; and St. Augustine, Bishop of Hippo, with a miter. The lectern, added in 1955, includes a representation of the tablets of the Ten Commandments in two panels, along with a candle on one side and a staff on the other. A painting of the Holy Spirit in the form of a dove adorns the inside of the pulpit's shell.

Along the pulpit's base, symbols of the Evangelists are repeated in a bas-relief frieze: a spread-winged eagle (St. John), the face of a child (St. Matthew), a lion (St. Mark), and an ox (St. Luke). The decorative swastika frieze on the upper part of the pulpit is the pagan symbol adapted to signify the cross of Christ. The pulpit was executed before the rise of Adolph Hitler, and a parish historian noted that the swastika "never became a favorite Christian symbol. Its use by Hitler as the emblem of the Nazi Party served as the death knell of any further acceptance in Christian symbolism."

Mary's altar is located to the right of the pulpit. Statues of St. Anne with Mary as a young girl and of St. Joachim are on either side. A medallion of Mary in marble bas-relief surrounded by gold mosaic is carved in the marble altar rail in front of her altar. Adjoining Mary's altar is the Calvary group: Jesus on the Cross, his mother gazing up at him, St. John with head lowered, and Mary Magdalen kneeling at the foot of the cross, looking up at Jesus. This notable statuary was installed in 1926. The wood and stone were shipped from Jerusalem, including stone from the Grotto of the Agony in the Garden.

The eleven stained-glass windows on the sides of the church recall main events in the life of Jesus and Mary. Each is richly ornamented, and the facial expressions capture the significance of the events. Beginning at the left front, adjoining Mary's altar, the windows show the Annunciation, the Visitation, the Nativity, the Presentation in the Temple, and Jesus teaching in the temple (behind the confessional). In each window, the background figures are carefully arranged to highlight Mary or Jesus. Beginning at the right back (behind a confessional) are the Agony in the Garden, the Scourging at the Pillar, the Resurrection, the Ascension, the Descent of the Holy Spirit, and the Assumption of Mary.

High above the pews in the interior of the dome are stained-glass windows installed in 1946 depicting familiar saints: Thomas Aquinas, Augustine, Jerome, Ambrose, Gregory I, Patrick, Francis of Assisi, Francis de Sales, Frances of Rome, Elizabeth of Hungary, Teresa of Avila, and Rose of Lima. Each saint is identified. The large rose window in the choir loft depicts St. Cecilia, patroness of music. Unusual organ pipes jut out of the choir loft into the main body of the church.

The mosaic stations of the cross were installed in 1927. Their figures are carefully balanced. The small wood cross over each station is made of olive wood from Gethsemane in Jerusalem.

Throughout the church are unpainted life-size marble statues, carved in marvelous detail. They include the familiar figures of the Sacred Heart, Mary, Joseph, Sts. Anne and Joachim, the four Evangelists on the main pillars facing the center of church, Sts. Peter and Paul, St. Therese of Lisieux, St. Anthony of Padua, St. Rita, and St. Vincent de Paul. Less familiar is St. John Vianney, the patron of parish priests, whose statue stands to the right of the sanctuary where St. Joseph's altar is located. John Baptist Marie Vianney, known popularly as the Curé of Ars, died in 1859 after more than a quarter century as pastor of Ars-en-Dombes. He was a priest of great personal austerity and a renowned confessor.

Unlike earlier parishes, Our Lady of the Rosary did not reflect a predominately first- and second-generation immigrant population. The eighty-six baptisms that took place in 1908 included two adults and five African American children. Surnames reflect the varied ethnic and national composition of the new parish: Quinn, Carey, and McCue; LaBranche, Charbonnet, and St. Amant; Gottschalk, Butzman, and Muller; Viglia, Genusa, and Catalinotta. A vestige of the French heritage of some of the founding parishioners is reflected in the parish's original name, Notre Dame du Rosaire.

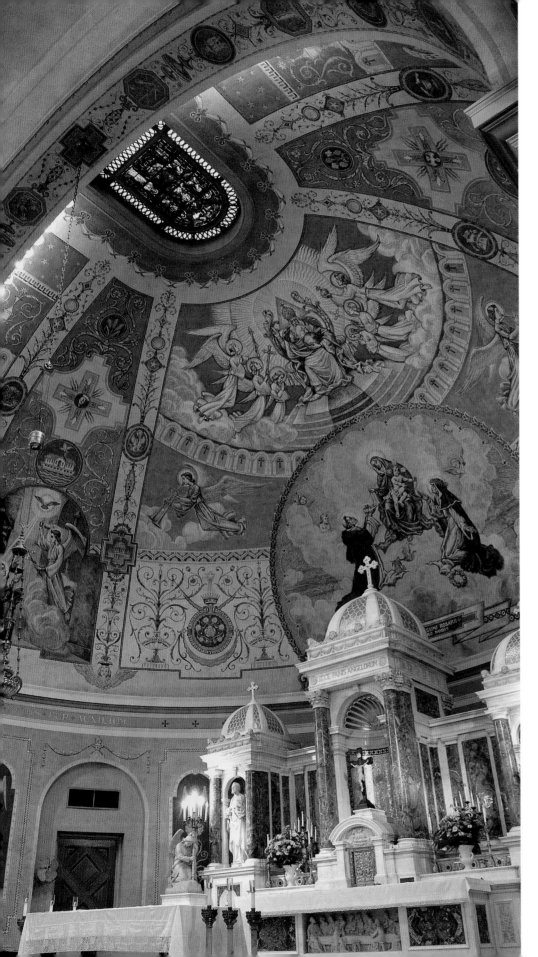

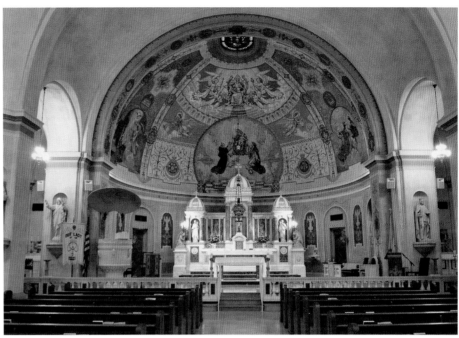

View of front of church

Altar railing detail: Mary

Painting on sanctuary ceiling *(left)*

Our Lady of the Rosary Church ∾ 65

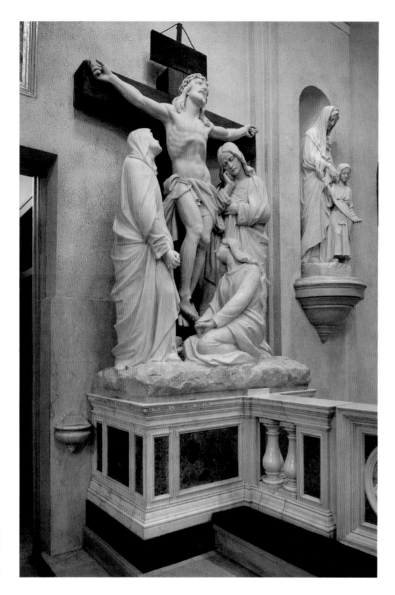

Calvary group
with a second
statue of St. Anne
and young Mary

Mary Magdalen (*Calvary group detail*)

Mary's altar (*far right*)

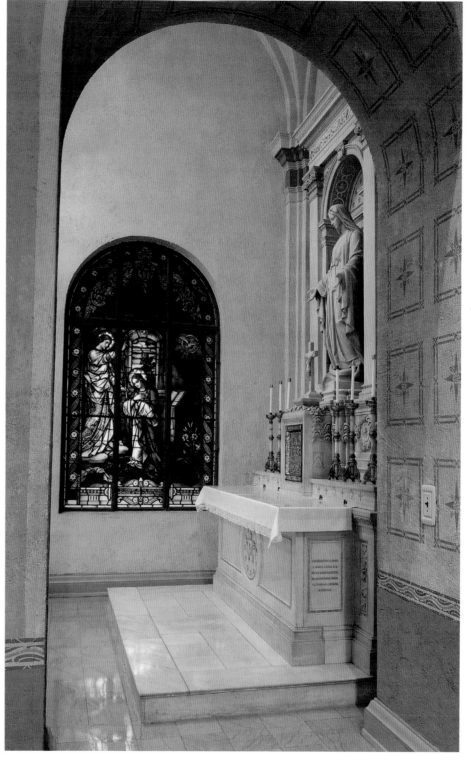

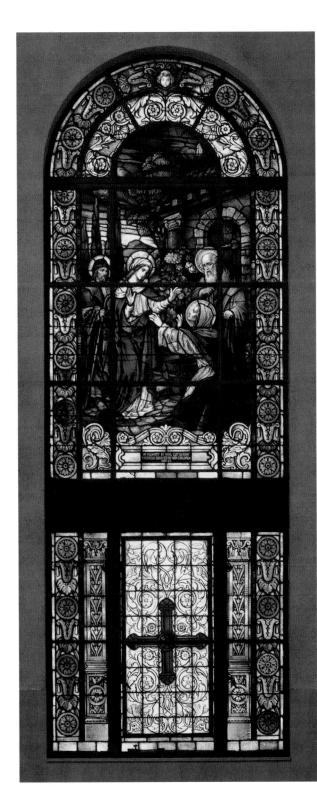

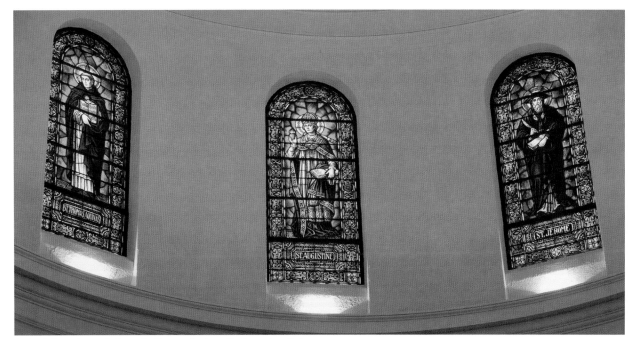

Stained glass, dome windows: St. Thomas Aquinas, St. Augustine, St. Jerome

Choir loft window and organ pipes

Stained glass: The Visitation

Stained-glass window, Scourging at the pillar; Stations of the Cross VII and VIII

St. Augustine (*pulpit detail*)

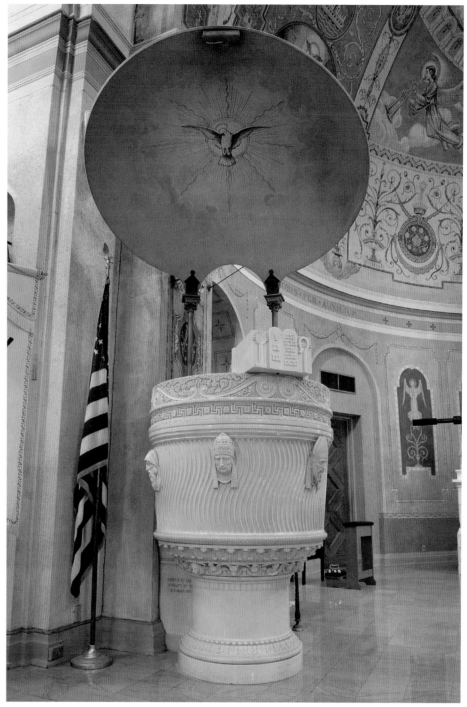

Pulpit

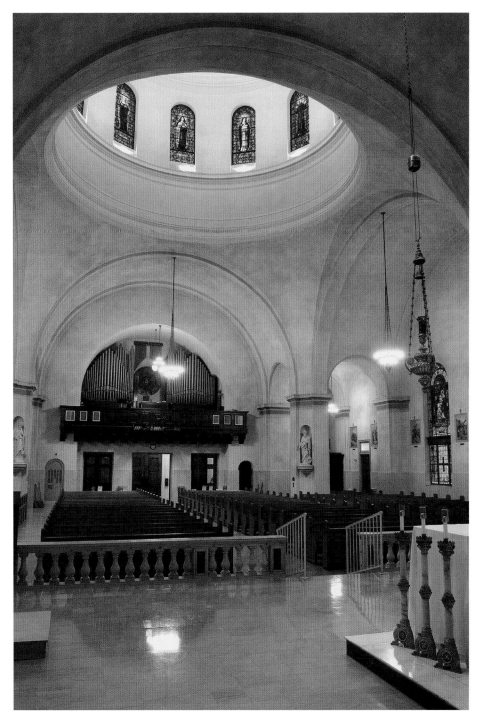

View of rear of church

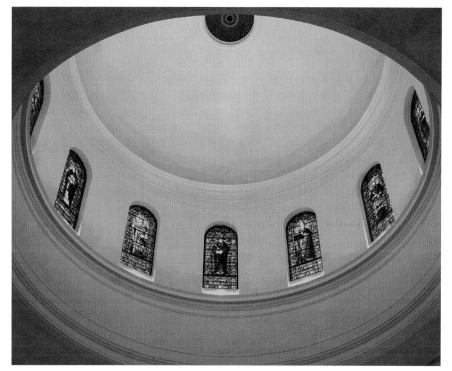

View of dome

St. Joan of Arc and St. John Vianney statues

Statue of St. John Vianney (*detail*)

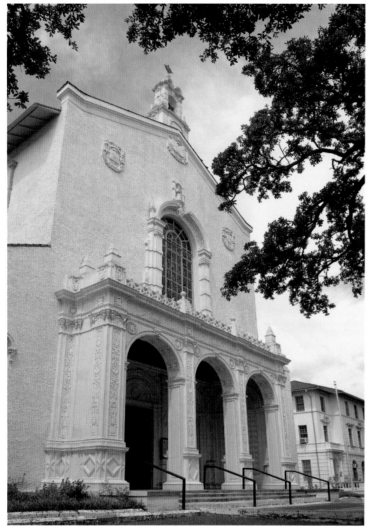

Facade

7. ST. ANTHONY OF PADUA CHURCH

HEN THE ARCHDIOCESAN BUILDING committee reviewed the plans for St. Anthony of Padua Church in 1922, it noted, "This church in Spanish style will be a novelty in our Diocese, but it will have a very beautiful and pleasing aspect. At the same time, the building will be very substantial and durable."

St. Anthony of Padua on Canal Street traces its roots to the Spanish-American War, during which time New Orleans Archbishop Louis Placide Chapelle served as papal envoy to Cuba, Puerto Rico, and the Philippines. At the University of San Tomas in the Philippines, Chapelle met Spanish Dominican Father Thomas Lorente, whom he eventually persuaded to come to New Orleans. In 1903, the Spanish Dominicans took charge of St. Anthony Chapel on Rampart Street (now Our Lady of Guadalupe).

Around 1909, the area from Carrollton Avenue to Lake Pontchartrain—described then as "a kind of wilderness"—was assigned to the Dominicans. Father Lorente borrowed a horse and buggy and celebrated Mass at the old pavilion near the lake on May 12, 1912. Ave Maria Chapel on Chapelle Street was dedicated on October 21, 1912; a second chapel on Polk Street was dedicated in early 1913. The latter was destroyed by fire on March 21, 1915; the former, by the September 29, 1915, hurricane. They were the predecessors of St. Dominic Parish, established in 1924.

In 1915, as the city was expanding toward Lake Pontchartrain, Archbishop Blenk closed St. Anthony Parish on Rampart Street and commissioned Father Lorente to establish a new St. Anthony of Padua Parish on Canal Street between Olympia and

St. Patrick Streets. In his decree establishing the parish, Archbishop Blenk cited "the needs of the Catholic population living in that section of the City of New Orleans, bounded by North Carrollton Avenue, West End, New Basin and Orleans Street and Avenue [sic]." He noted that distance made it difficult for these residents, particularly "the old, the infirm, and the young," to attend Mass and receive the sacraments at Sacred Heart of Jesus Church on Canal Street. The new St. Anthony Parish was carved from Sacred Heart Parish and included the Lakeview area as a mission. The parish's first structure was a wood-frame multipurpose building with a chapel on the first floor, a school on the second, and a residence for the Dominican priests on the third. It was later moved and used as a convent for sisters.

When blessed on August 15, 1915, the church was filled to overflowing. "Loving hands had made beautiful the new church, and its pretty altar was radiant with costly blooms, while palms and greenery had converted the sanctuary into a tropical bower. A beautiful statue of the Wonder Worker of Padua, with the Divine Child in his arms, beamed down upon those who came with such love and pride to do him honor." Father Lorente celebrated the Mass. The parish suffered a major loss when he died nine days later.

As an early twentieth-century parish, St. Anthony grew rapidly with members of many ethnic backgrounds. By January 1, 1916, there were about 1,500 parishioners and eight active societies. By 1921, the number of parishioners increased to 2,320; by 1926, to 4,000 after the spin-off parish of St. Dominic was created; and by 1935, to 5,000, with 1,975 members in the Rosary Confraternity.

On May 17, 1922, the Dominican priests asked the archbishop to approve the construction of a larger church to accommodate St. Anthony's growing congregation. On the twenty-second, the archbishop responded favorably, citing particularly the importance of ensuring that the edifice be "a suitable place for divine worship." On May 30 the archdiocesan building committee approved the plans of New Orleans architects Wogan and Bernard as "clear and thorough." The cornerstone for the Spanish Renaissance–style edifice was laid on February 4, 1923. It was completed in ten months and dedicated on November 8.

The church is a soaring white stucco structure. Its portico, with three Romanesque arches, sits slightly forward from the entrance; a matching arched window is above. An observer noted that the "high arches gallery almost spans the white facade giving the structure a satisfying effect of mass, dignity and repose." The interior is equally striking. The flat ceiling has intricate, inlayed designs. The upper window frames and side walls have matching rich ornamentation. Tall columns and Romanesque arches separate the central nave and two side aisles. A high, imposing arch with flower and shield motifs frames the sanctuary.

The church initially included the intact altar table from St. Anthony Chapel on Rampart Street. After many years of parishioners' contributing to a fund for a new main altar, the parish received a bid of $40,500 from the Dapratao Studios in November 1949 for the present towering graceful marble altar and baldachin—also designed by architects Wogan and Bernard—and tabernacle. The contract specified a combination of marble types: Blanco P #21, Rosso di Levanto #19 or Verde Alpi #10, Beccia del Buchette #34. Furthermore, "the vaulted ceiling inside the baldachin is to be of genuine mosaic and is to have a blue background with the design in gold. The symbols to be shown in this ceiling are of the Four Evangelists." The hanging crucifix was also to be of matching marbles; the tabernacle, of bronze.

The baldachin sits high above the main altar on four large, richly ornamented columns. Panels are inset with reliefs depicting well-known Dominican saints. Scagliola, a plasterwork imitation of ornamental marble, is molded into the altar rail and pulpit. Over the main altar are the Dominican shield and the word *Veritas* (truth). The shield interestingly includes a Star of David, though its symbolism can only be speculated at present.

The church's lower stained-glass windows with their vivid colors and detailed background figures and images feature Spanish and Dominican themes. The great thirteenth-century Dominican theologian Thomas Aquinas is accompanied by the words *Thou Hast Written Well About Me*. St. Vincent Ferrar has the words *For the Lord*. Mary in blue, John in red, and Mary Magdalen in purple are pictured with Jesus on the cross and the words *It is consummated*. St. Teresa of Avila is portrayed with Jesus as a young boy and her quote *Who Art Thou? I am Jesus of Teresa. I am Teresa of Jesus*. Her convent is in the background.

St. Francis of Assisi is pictured with three children, flowers, a book, and the words *Blessed are the poor of spirit for theirs is the Kingdom of Heaven*. The window depicting Sts. Francis and Dominic together has the words *This is my commandment, that you love one another as I have loved you*. St. Clare receiving the rosary is accompanied by *And I live now not I, but Christ lives in me*.

The window showing the Visit of the Magi includes *And falling down they adored him*. One window depicts Mary's protection during the 1571 Battle of Lepanto in the Gulf of Patras off the Greek coast, where a coalition of Christian galleys decisively defeated the Ottoman fleet. The scene includes the pope, two cardinals robed in brilliant red, and a Christian ship. Another window depicts Blessed Imelda (d. 1333) receiving Communion with nuns in the background. She died at the age of twelve in the Dominican cloister at Valdpietra near Bologna and received her First Communion shortly before her death, although she was below the accepted age. She was declared the patroness of First Communicants in 1910.

The upper windows in the nave are of ornamental glass and were installed in 1928. The large window in the choir loft shows Mary handing the rosary to St. Dominic. Above Mary are the words *Mary, Queen of the Rosary, Pray for Us.* A stained-glass window in the back room portrays the Baptism of Jesus.

Statues reflect the parish's evolving devotional preferences. In 1922, the church had statues of Mary, Joseph, St. Anne, St. Anthony, St. Dominic, St. Rita, and the Sacred Heart. By 1934, a statue of St. Francis had been added and that of St. Rita was removed. A decade later, the church inventory included a statue of St. Jude. In 1954, the church statuary included Our Lady of Fatima, Our Lady of Prompt Succor, and the Infant of Prague. Today the statuary includes St. Martin de Porres, the Infant of Prague, and St. Therese of Lisieux near the left side altar; St. Joseph with Jesus and St. Joseph the Worker near the right side altar; and St. Anthony and the Sacred Heart in the back. Additional statues in the back room include St. Michael slaying the dragon and the Immaculate Heart of Mary.

The stations of the cross were installed in 1922. Large figures stand on the fourteen pedestals, graphically portraying the agony of Christ's condemnation, walk to Calvary, crucifixion, and entombment.

Dominican priests continue to serve at St. Anthony of Padua. In 1938, the Spanish Dominicans returned to the Philippines, and the parish was entrusted to American Dominicans of the St Joseph Province in New York. Many Dominicans were among the martyred clergy during the Spanish Civil War. The Louisiana Dominicans were needed to replace the depleted ranks around the world. Several of the recently beatified Spanish martyrs were educated at the Dominican seminary in Rosaryville, Louisiana.

St. Anthony of Padua has remained a parish of many nationalities. A 1948 report listed members of Spanish, French, Irish, German, Italian, and American ancestry, with Italian and French backgrounds predominating. The very few who did not understand English were mostly French. In recent years, the parish has included a significant Hispanic community. A banner in the church honors Mary as *Nuestra Señora de Suyapa, Patrona de Honduras* (Our Lady of Suyapa, Patroness of Honduras). The shrine to *Nuestra Señora del Cobre* (Our Lady of Cobre) reflects a national Cuban devotion that dates from the seventeenth century and was brought to New Orleans by refugees and immigrants. Following Hurricane Katrina, a large number of Brazilian workers and families came to New Orleans to work in rebuilding the city. In late 2007, a Mass in Portuguese for their growing community was celebrated, and it became a regular weekly event at St. Anthony in 2008.

In the parish reorganizations that followed Hurricane Katrina, Sacred Heart of Jesus Parish on Canal Street, from which St. Anthony was originally carved, was closed and merged with St. Anthony Parish. Statues of St. Anthony and the Sacred Heart stand in the back of St. Anthony of Padua Church.

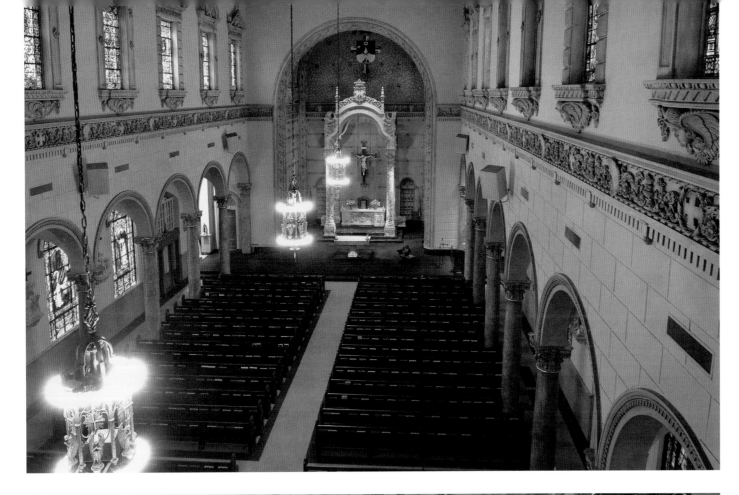

View of interior front

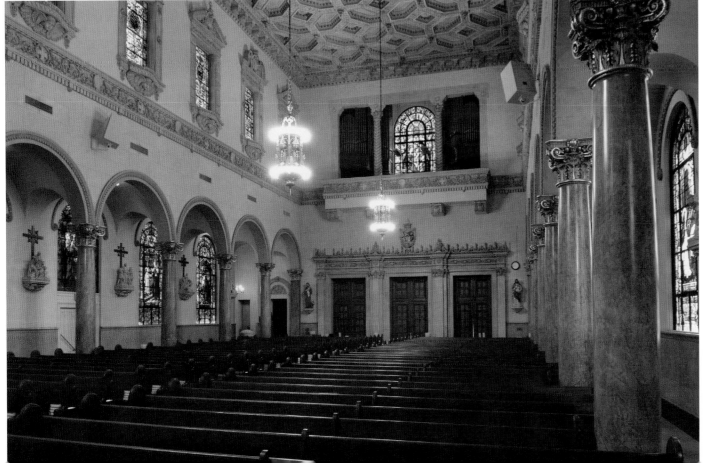

View of interior back

St. Anthony of Padua Church ◈ 73

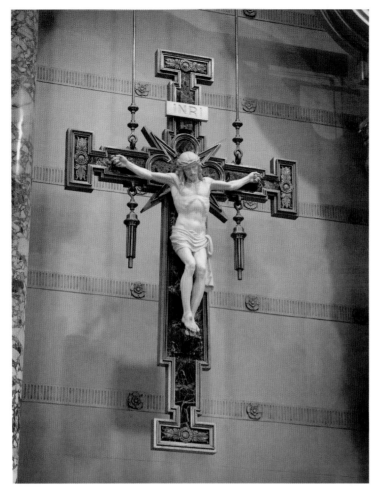

Crucifix

Altar pillar (*detail*)

Altar (*right*)

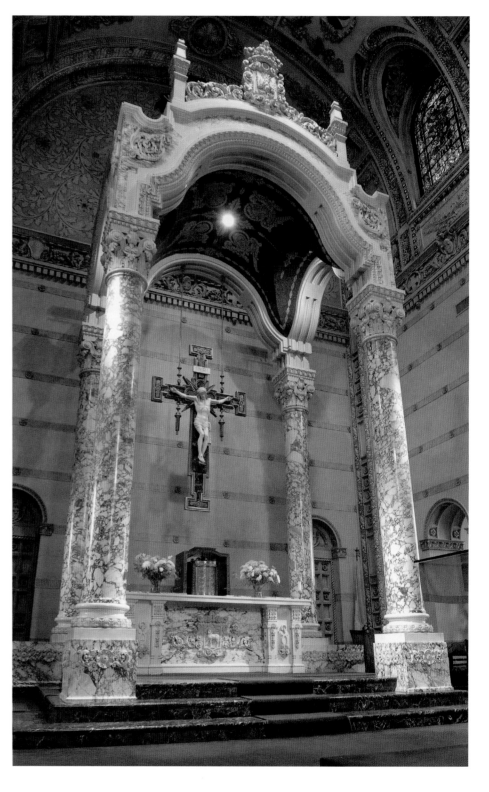

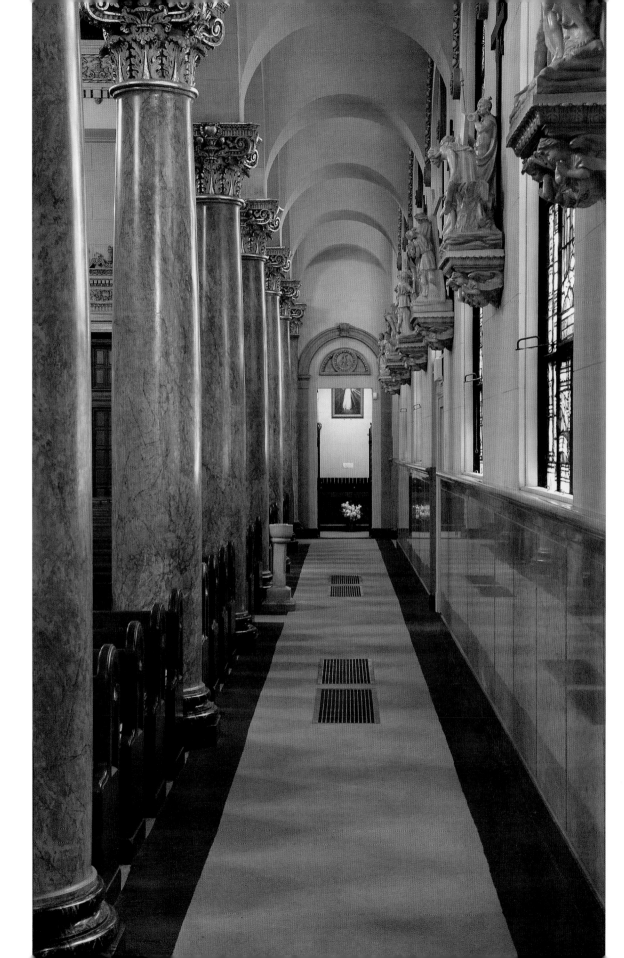

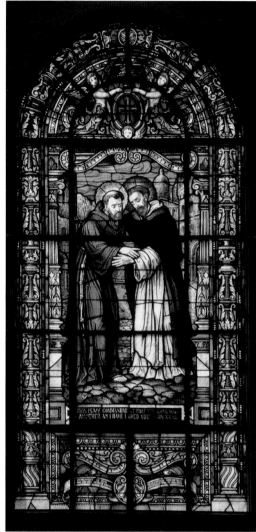

Stained glass: St. Francis and St. Dominic

View of side aisle and columns

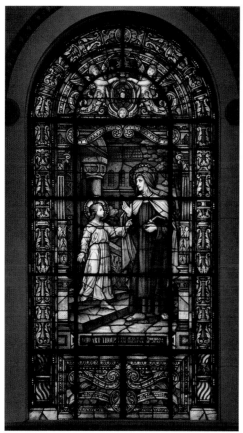

Stained glass: St. Teresa of Avila

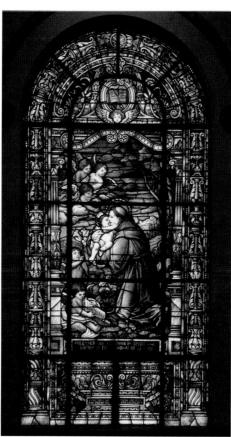

Stained glass: St. Anthony

Stained glass: Battle of Lepanto *(detail)*

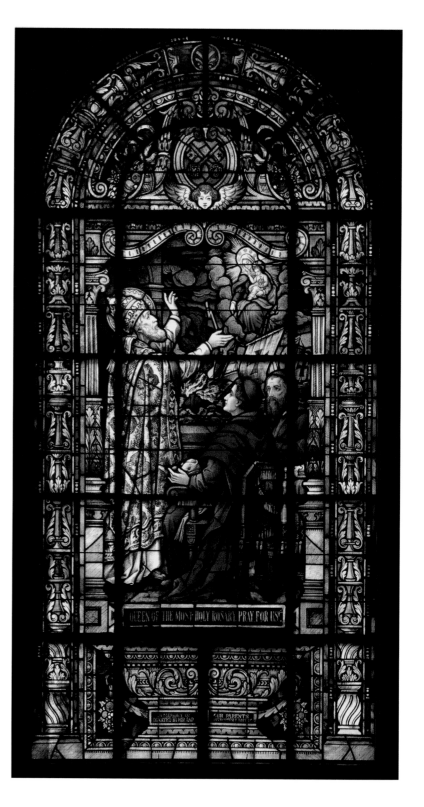

Stained glass: Battle of Lepanto

General view of upper stained glass with ornamentation (far left)

Station of the Cross I

St. Anthony offering box (below)

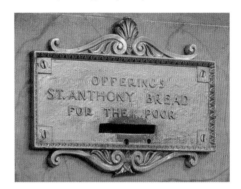

Statue of St. Joseph holding adult Jesus

Upper stained-glass window

Upper stained-glass window frame and ceiling

Facade

8. ST. FRANCIS OF ASSISI CHURCH

N EXQUISITE WOOD STATUE of Christ reaching down from the cross to embrace St. Francis stands above the tabernacle in St. Francis of Assisi Church. The piece is unusual in that it combines a biblical event with a later historical figure, signifying that Christ continues to reach across the centuries to touch lives as he did Francis's in such a profound way. Throughout the church, the themes of Christ, Mary, St. Francis, and St. Clare are expressed and intertwined through fine wood, mosaic, and stained glass.

A native of Assisi in Umbria, Francis enjoyed a carefree youth, spent a year as a prisoner of war in Perugia, and suffered several illnesses. He returned to Assisi, where he dedicated himself to seeking God, rebuilding churches, preaching the Gospel, and serving the poor. His simple, joyful, humble life of poverty attracted others who joined him in his work. In 1209, the first Franciscan rule of life, constructed from Gospel texts, was approved by Pope Innocent III. The order grew rapidly and became more formalized as one of the mendicant orders. Francis died in 1226 and was canonized in 1228.

St. Francis has been a popular figure in Christian devotion and art. He is often depicted in a Franciscan habit, accompanied by birds and animals or taming the violent wolf of Gubbio, a symbol of the Gospel subduing humankind's violence. St. Francis of Assisi Church portrays several major events in Francis's life as well as his association with St. Clare, who was inspired at a young age by Francis's preaching to leave her wealthy home in Assisi and dedicate herself to a life of

poverty. Others joined her, and Francis gave them a rule, the beginning of the cloistered Poor Clare Nuns.

St. Francis of Assisi Parish on State Street near Constance Street was officially established on November 6, 1890, with Father Adrian van der Heyde, a native of Holland, as the first pastor. The area's population of Irish, German, French, and African Americans had expanded slowly in the mid-1800s and more rapidly after the 1884 World's Industrial and Cotton Centennial Exposition in the present Audubon Park. Records of early baptisms reflect the neighborhood's ethnic mix. Mass was first celebrated in a private home, but by 1891 the parish numbered seven hundred individuals. On November 8 of that year, a frame church was blessed by Archbishop Francis Janssens, himself a native of Holland. A second wood church was completed in 1899, by which time the parish had fifteen hundred members. Four years later, the congregation had grown to twenty-five hundred, and the need for a larger, permanent church was evident to the German-born pastor, Father Charles Brockmeier, and his parishioners. In 1913, the frame church was moved to provide space for a new brick edifice. Ground was broken in 1914, but work was halted during World War I.

In 1916, the feast of St. Francis was celebrated in the 1899 church "with the splendor and dignity befitting the seventh centenary of the great Franciscan." Over the next five years, Father Brockmeier incorporated much of St. Francis's "life and character" into the new church, the completion of which he oversaw. Construction began again after the war, and on December 18, 1921, the finished church was dedicated and the bells were blessed. The first stained-glass windows arrived from Munich in 1922, and on Easter Sunday of that year the organ was heard for the first time. The ornate stations of the cross with each scene inset and framed were blessed on January 21, 1923.

The cruciform church was designed by General Allison Owen of the New Orleans firm Dibold and Owen. The parish's centennial history noted that the architecture "reflects the eclectic tendencies of church design in the early part of the twentieth century." The exterior of dark reddish brown brick with stucco trim was inspired by French Gothic architecture, while the asymmetrical towers reflect Italian design. The remarkable interior details are "decidedly English in their background."

Visitors are welcomed by a mosaic in the tympanum over the main entrance that was donated by Father Brockmeier. St. Francis appears with an angel on either side and the words *Sub Invocatione Santi Francisi Assisinatis* (Under the invocation of St. Francis of Assisi). The design is modeled on works of Italian Renaissance artists Andrea del Castagno and Andrea Mantegna.

One remarkable feature of the church interior is the wood ceiling above the nave and transept. Carved arches held in place by short beams projecting from the walls support the ceiling. The church underwent a major renovation that was completed in 2004. Its floor, pews, and other exposed wood were sanded and returned to their natural color. The original altar of sacrifice was moved forward and restored. New lighting—including spotlights, opera lights, and backlights—was installed. The wood carvings above the pulpit were replicated by artisans using computers and handwork. New wooden flourishes were added to canopies over the two altars honoring Mary and St. Joseph.

The main altar of carved wood displays statues of St. Therese of Lisieux and St. Gerard Majella (1726–55), a native of Muro outside Naples and a Redemptorist brother and miracle worker known in his lifetime as the "Father of the Poor." A wood relief depicting the Last Supper adorns the front of the altar of sacrifice. To the right and left of the sanctuary are altars honoring, respectively, Mary as Our Lady of Grace and St. Joseph. Mary's statue is flanked by those of her parents: St. Anne appears with young Mary, who holds a scroll with the Ten Commandments; Joachim has two turtle doves, the sacrificial offering at Mary's presentation in the temple. St. Joseph's statue is kept company by those of St. Aloysius Gonzaga, the patron of youth, and of St. Elizabeth of Hungary. Also on St. Joseph's altar is the Infant of Prague; nearby are statues of St. Clare, St. Francis, and the Pietà. The church's ornate pulpit is set off by statues of the four Evangelists, and the shell is graced with a painted dove.

The stained-glass windows have a triple theme: the Eucharist, Mary, and the life of St. Francis. Beginning on the left at the back, they depict Francis as a knight giving his garments to a beggar; Francis and his father before the bishop of Assisi; Francis receiving Clare's vows; Francis with the tamed wolf of Gubbio, a lamb, a deer, and other small animals; and a Nativity triple window with shepherds on one side, the Magi on the other, and a child and lamb below the Holy Family

Five stained-glass windows adorn the sanctuary walls. Beginning on the left, a nobleman and lady reach out to a beggar at their feet with the church of St. Francis in the background. In the second window, the Archangel Gabriel announces the conception of Jesus to Mary, who is kneeling at a prie dieu with a dove hovering above. A vase of lilies in the foreground represents Mary's purity. In the center window, Jesus breaks bread with the two disciples who encountered him on the way to Emmaus. The three crosses on Calvary are in the left background; the open tomb is to the right. The fourth window depicts Christ giving the Eucharist to a saintly woman, perhaps Margaret Mary Alacoque. In the final sanctuary window, a young man is receiving the Eucharist from a priest; both have halos, indicating their status as saints.

The triple window at the right front depicts Mary's Assumption into heaven. She is borne up by angels while other angels welcome her. Another angel carries her crown. A city, perhaps, the legendary city of Mary's Dormition, is below. The next window depicts Francis's vision of Christ at the Second Coming with Mary at his side. In the following window, Francis visits Sultan Melek-el-Kamel near Damietta, Egypt, in 1219, during the Fifth Crusade. In the next window, Francis and his companions worship the Infant Jesus in Francis's first crèche in 1223. The final window depicts Francis receiving the stigmata in 1224. In the back of the church is a large window of blue glass, a color associated with Mary.

Ceiling murals depict St. Paul and the apostles. At the left front, above Mary's altar, is Peter. James, John, Andrew, Philip, and Bartholomew continue along the upper wall. Above St. Joseph's altar is Paul. Simon, Mathias, Jude, James, and Thomas continue along that upper wall. Each of the apostles holds an instrument indicating his particular martyrdom. In the main arches are ornamental emblems: a basket, dove, crown, pitcher, grapes, chalice, bishop's miter, and book.

There are several statues at the back of church and in the small room to the side. They include Sts. Jude, Vincent de Paul, Anthony, Michael crushing the dragon (1908), and Martin de Porres with a dog and cat at his feet, as well as the Pietà, the Sacred Heart, and Our Lady of Fatima. Set in niches in the front of the choir loft are statues of the Sacred Heart, Joseph, Mary, and St. Jude.

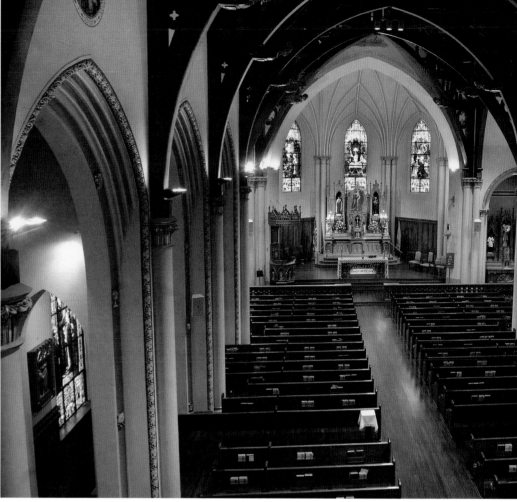

View of front interior

Ceiling (*detail*)

Miter (*arch detail*)

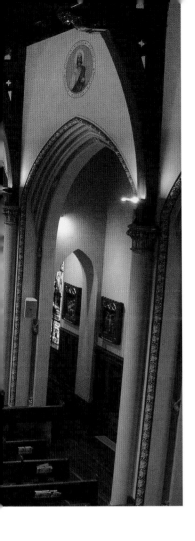

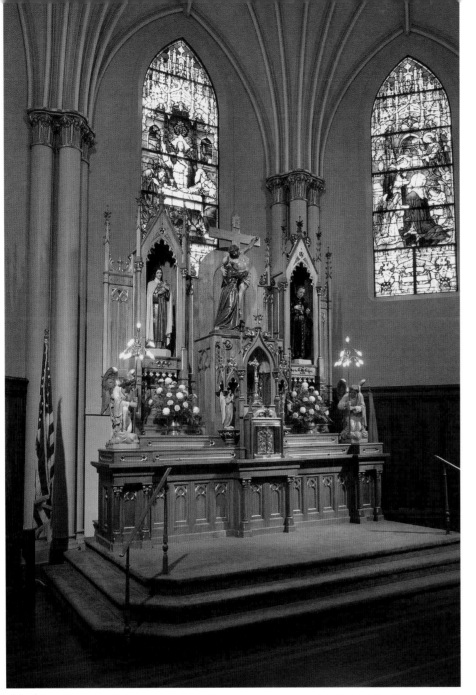

Main altar

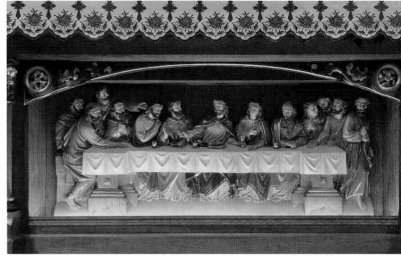

Altar carving of the Last Supper

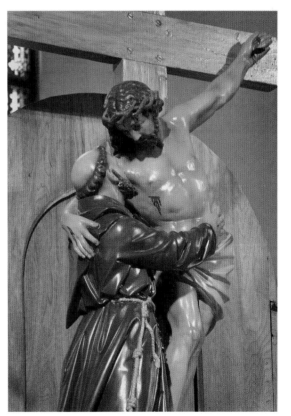

Altar statue of Christ and St. Francis

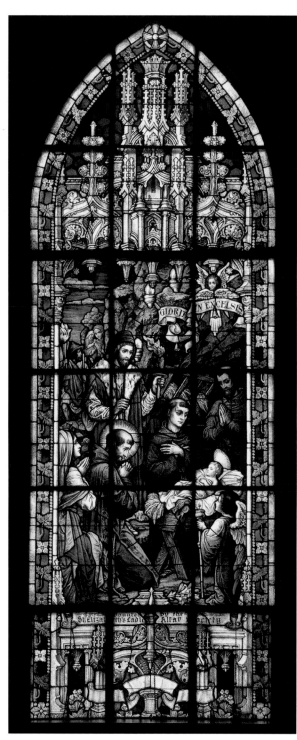

Stained glass: St. Francis with his first crèche (crib)

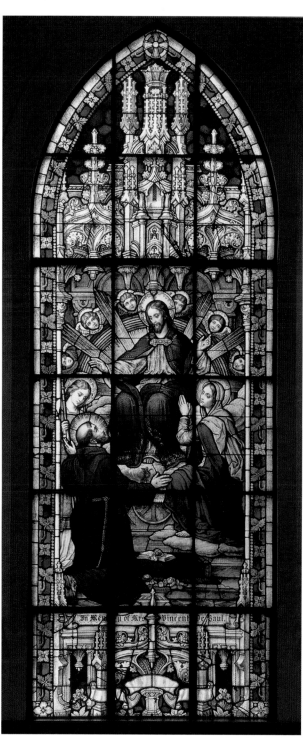

Stained glass: St. Francis's vision of Christ's Second Coming with Mary at His side

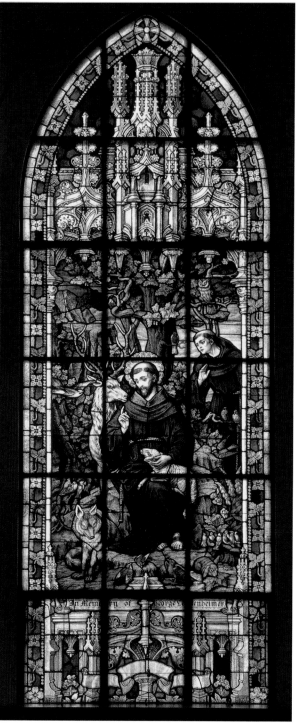

Stained glass: St. Francis with wolf, lamb, deer, and small animals

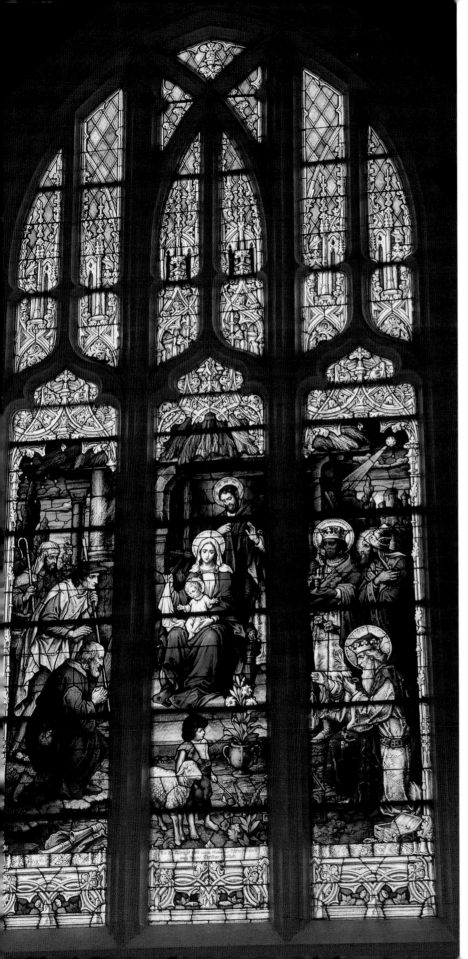

Mary's altar

St. Clare and St. Francis

Stained glass: Nativity *(left)*

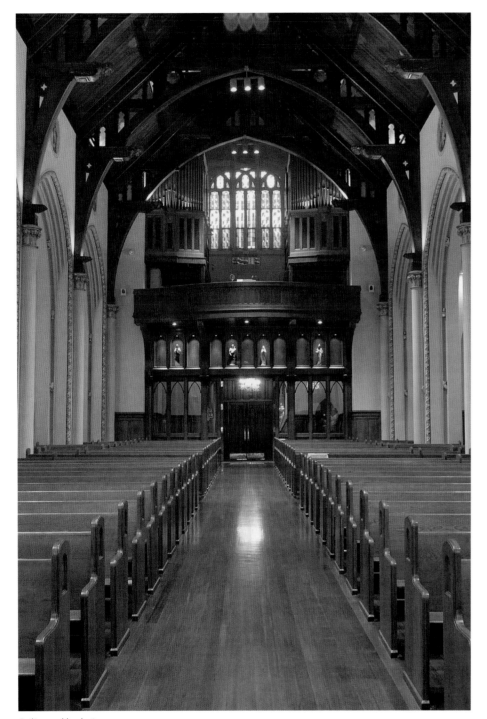

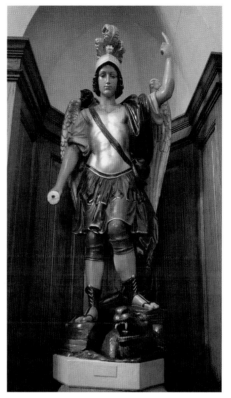

Statue of St. Michael crushing the dragon

Pulpit detail of St. Mark with the scroll and pen and a lion's head at his feet

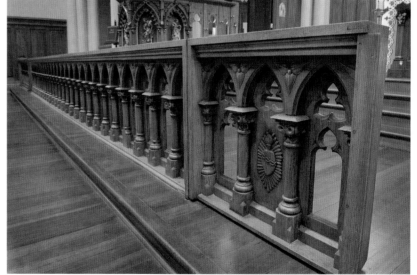

Altar rail

Ceiling and back view

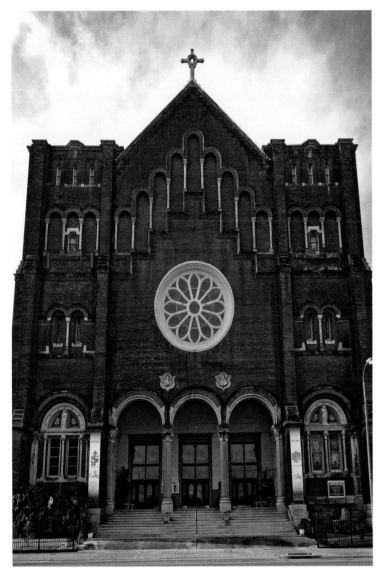

Exterior

9. ST. JOSEPH CHURCH

LTHOUGH ST. PATRICK was the first church in New Orleans associated with the Irish, a handful of other mid-nineteenth-century churches were built in the city to serve the influx of immigrants from Ireland: Immaculate Conception in 1843; Sts. Peter and Paul in 1844; St. Theresa of Avila in 1853; St. Alphonsus in 1858; St. Michael in 1869; and, prominent among these, St. Joseph, on Tulane Avenue near the city's principal medical complex.

St. Joseph Parish was established in 1844 to provide for the expanding Irish immigrant community in the American sector. The original church, "an attractive Gothic church," was quickly built across from the former Charity Hospital. Diocesan priests initially served the parish. In 1858, the Vincentian priests took charge of the parish and have served there ever since. They, like the Irish, have left their stamp on the church.

The second, and present-day, St. Joseph Church is New Orleans's largest Catholic church and took almost a quarter century to build. In 1866, Vincentian Father John Hayden purchased a square bounded by Tulane Avenue, Gravier, Derbigny, and Roman Streets for a new church. Early pledges and festival revenues surpassed expectations and provided funds to undertake the massive new building.

Ground-breaking took place on May 9, 1869. The lot was enclosed by a picket fence and contained brick and lumber purchased and piled there for the new edifice. Bishop William Elder of Natchez gave the main address, after which parishioner Hugh McManus drove two mules to plow the length and breadth of the lot.

The original plans by architect Thomas O'Neill called for a building 231 long, 115 feet wide, and 200 feet high in Greco-Roman style. James Reynolds was the builder. Bricks for the new building, an estimated two million, arrived at the Jackson Railroad Depot. On Pentecost Sunday 1870, the pastor made an unusual appeal to the congregation: "We most earnestly and respectfully solicit the assistance of such as have carts and wagons to convey bricks from the Jackson Depot to the new church." According to parish tradition, even women's aprons were used to carry bricks.

On October 8, 1871, two cornerstones, one on each side of the triple-arched entrance, were laid. One contained a time capsule of coins, journals, and newspapers that was retrieved in 2008. Father Abram Ryan of Mobile, the priest-poet of the South, preached at the ceremony. A yellow and green banner displayed the Gaelic greeting *Cead Mille Failte* (A hundred thousand welcomes).

By 1877, the walls and roof were in place, but little work followed. Defects in the foundation made the side walls lean precariously and the front crack. "The huge church seemed doomed," wrote historian Roger Baudier. In 1883–84, new plans were prepared by architect Patrick C. Keeley of Brooklyn, New York, that called for a Romanesque style with Gothic relief. D. M. Foley, Jr., was hired to complete the building. The new plans slightly reduced the building's size to 225 feet long, 100 feet wide, and 150 feet high. The original plans for spires, a cupola, and left and right wings across the back of the church were set aside. The foundation was solidified, and chains and rods were installed to draw the two side walls together. The rods are still visible in the church's upper structure. The finished church was dedicated on December 18, 1892, with an estimated three thousand in attendance. The building had bare walls, plain glass windows, and a "sanctuary unadorned." Lamented an early parish historian, "Only the four walls constituted the shell of the magnificent edifice."

In 1895, St. Katharine was established as the city's first Catholic parish for African Americans. The old St. Joseph Church became the place of worship for the new congregation, which remained active for almost seventy years, closing in 1964 when St. Joseph and St. Katharine were combined. The old church was then demolished and the altar donated to a church in Latin America.

St. Joseph's interior matches its exterior Romanesque-Gothic architecture. The ceiling of natural woods is supported by eight columns of polished Missouri granite and decorated with ribbed ornamentation. The latter were gifts of individual parishioners. Above the five large arches on either side wall are triple stained-glass windows depicting the life of Christ and, in the final window, Mary's Assumption.

Above these are a row of smaller windows with Old and New Testament symbols. Ornate cornices, elegant friezes, and bas-reliefs in flower and leaf design surround the windows and arches. The pews of carved oak and ash seat about two thousand.

The struggle to complete and decorate the interior of large churches often spanned decades and called forth both large and small donations from the parishioners. In 1915, Father Thomas Weldon, the pastor of St. Joseph, shared with his congregation the fulfillment of many years of waiting for a suitable completion to the sanctuary. "Our dear St. Joseph's Church has waited now for over twenty years in eloquent silence for the finishing touches, intended by the great architect, Keeley, who designed its beautiful lines and magnificent arches. All of us have been longing to see the vacant space in our Sanctuary properly filled with a new altar or picture."

A generous donation by Mrs. Hugh McManus provided for an altar, large painting, and St. Joseph's altar to be commissioned. An altar dedicated to Mary was also commissioned through a donation by Charles McCready. "What a change this will be," wrote Father Weldon. At the same time, Father Weldon asked parishioners to help complete the church furnishings "from a candlestick to a stained glass window." Seven stained-glass windows and four paintings were already in place due to individual, family, and parish society donations.

In March 1915 the main altar of Italian marble, designed by Augustine O'Callahan of Chicago, was installed by Shrader and Sons of St. Louis. Its graceful arches reflect the church's Romanesque design. Six marble pillars, each six feet tall, rise over the gold-doored tabernacle and support a dome evoking St. Peter's Basilica in Rome. The dome's roof is inlaid with mosaics. Matching inlaid mosaics were added on the base of the large solid-marble side arches, inscribed with *SV* for St. Vincent de Paul. In the base of the altar is a large mosaic with the sacrificial lamb, a symbol of Christ, flanked by four spheres containing the symbols of the Evangelists. This is surrounded by wheat and grapes.

The scene above the main altar was painted on canvas by Joseph B. Hamn of Chicago and finished in 1915. Christ hangs on the cross between the two thieves while more than thirty life-size figures gather around them with Jerusalem visible in the distance. On either side of the painting is a plaster cross with a ladder, a spear, and hyssop— symbols of Christ's death—superimposed over it. These match the stations of the cross. Above Hamn's canvas are paintings of Christ and the four Evangelists.

At the clerestory level is a stained-glass window of St. Joseph sitting over the dome of St. Peter's Basilica. In the window to the left, Pope Sylvester holds a triple

cross and kneels with an angel looking on. Emperor Constantine and his mother, St. Helena, appear in the window on the right. On the sides of the windows are paintings of two angels with banners that read *Go to St. Joseph, Patron of the Universal Church.*

A wooden altar of sacrifice installed after Vatican II was replaced in 1989 by the present marble altar, a gift of St. John's High School in Gulfport, Mississippi. The altar served originally in the old St. John's Church in Gulfport. Two small stained-glass windows flank the main altar. They show a lamb, representing Christ, and a family of pelicans, symbolic of the life-sustaining gift of Christ's blood. The lamb and pelicans are surrounded by six angels.

The altar honoring Mary is to the right of the sanctuary with a painting of the Annunciation above it. St. Joseph's altar is to the left of the sanctuary; above it is a painting of the death of St. Joseph. The main altar and Mary's altar were consecrated on March 19, 1929. The wooden altar rail, described as "a marvel of graceful carving," includes angels on its gates and crosses on the ten thick columns that support it.

St. Joseph's interior was furnished over many decades. The baptismal font is from the first St. Joseph Church. On January 6, 1893, the stations of cross were blessed, and the confessional and bell were moved from the previous church. In 1894, the first six statues were installed: the Sacred Heart; St. Benedict; St. Vincent de Paul; Jean Gabriel Perboyre, a Vincentian priest who was ordained in France by the former bishop of New Orleans; Louis William Dubourg, martyred in China in 1840, beatified in 1899, and canonized in 1996; and a pair of angels. At the same time, the holy water fonts, three feet tall and cut from sold red granite, were placed in the church. Father John Downing, pastor from 1885 to 1901, personally hand-tooled some of the elegant woodwork on a lathe in the church machine shop. Around 1915, the mosaics surrounding the two side altars were installed. The large and small bronze chandeliers, the terrazzo flooring, and the small stained-glass windows along the side date from 1926 to 1930. The oblong medallions between the arches were added in 1956–57.

The large stained-glass windows in the nave were executed by the Franz Mayer studio in Germany between 1900 and 1915. The first four were installed in 1903. Beginning at the left front of the church, the windows depict the Nativity; the Presentation of Jesus; the Finding of the Child Jesus in the Temple; the Wedding Feast of Cana; and Jesus blessing the little children. Continuing on the back right side, they show Jesus's Triumphal Entry into Jerusalem; the Resurrection; the Ascension; Pentecost; and, finally, the Assumption of Mary.

The ground-floor windows depict, beginning on the left front, Our Lady of Grace, St. Agnes, St. Cecilia, Jesus the High Priest, St. Louise de Marillac, St. Catherine Labouré, St. Catherine again as a seminary sister, St. Lucy, Our Lady of Sorrows, and the Scourging at the Pillar (not visible). Beginning on the right front, the windows portray St. Joseph, Blessed Francis Regis Clet (beatified in 1900), St. Vincent de Paul, St. Jean Gabriel Perboyre, the Archangel Gabriel, the Child Jesus, the Sacred Heart, Our Lady of Perpetual Help, St. Rita, and St. Therese of Lisieux (not visible). The rose window in the choir loft portrays Jesus as teacher, surrounded by the disciples. Over the large windows at the clerestory level are twenty-four small circular double-portal pink windows with Judeo-Christian symbols.

Above the foyer entrance are windows also executed by the Franz Mayer studio, in 1962. From left to right, they portray the marriage of Mary and Joseph; St. Joseph's dream; the second and first Miraculous Medal apparitions to St. Catherine Labouré; the Flight into Egypt; and the Holy Family at work.

Between the arches on the right are a set of medallions representing Father Felix de Andreis, a pioneer Vincentian priest in the United States; St. Jean Gabriel Perboyre; Blessed Francis Regis Clet; and St. Therese Fontau. Beginning on the left, back to front are medallions representing St. Elizabeth Ann Seton, St. Therese of Lisieux, St. Catherine Labouré, and a Daughter of Charity. Also included are seals of the Daughters of Charity and the Vincentians.

On the right back wall (as one faces the rear of the church) are paintings of the Baptism of Jesus and the Holy Family at work. On the left are paintings of the Prodigal Son and Mary Magdalen washing Jesus's feet.

Around 1980, the confessionals were converted to display statues. The many statues in the church are uniquely framed by the old confessionals. Along the left wall are statues of Sts. Catherine Labouré, Anne, Lucy, and Benedict as well as Our Lady of Victory and the Agony in the Garden. On the right wall are the Pietà; Sts. Rita, Anthony, Therese of Lisieux, and Martin de Porres; and the Sacred Heart.

In 1981, St. Joseph rectory was demolished and the priests' residence, the pastoral center, and the church offices were moved into the church. Immediately after Hurricane Katrina and the breach in the levees in August 2005, St. Joseph was an island surrounded by water. Nearby Charity Hospital was so badly damaged that it closed permanently, and almost every home in the parish sustained injury. The church basement with the air conditioning and electrical systems was flooded. Food gathered to distribute to the needy, as well as the kitchen equipment, were

all under water. Portions of the stained-glass windows were blown out, though parishioners retrieved some of the pieces.

St. Joseph quickly resumed services and became an archdiocesan disaster recovery center to assist both relief workers and returning residents. The traditional Vincentian ministry to the poor and needy took on dramatic new forms in the wake of the hurricane. In 2007, St. Joseph Parish opened the Rebuild Center "to serve people made homeless by Hurricane Katrina, the chronically homeless, and immigrant workers from Latin American who have come to New Orleans seeking work rebuilding the city." Those displaced, homeless, and immigrant people who also stop in St. Joseph's Church to pray and give thanks continue a heritage that extends more than a century and a half.

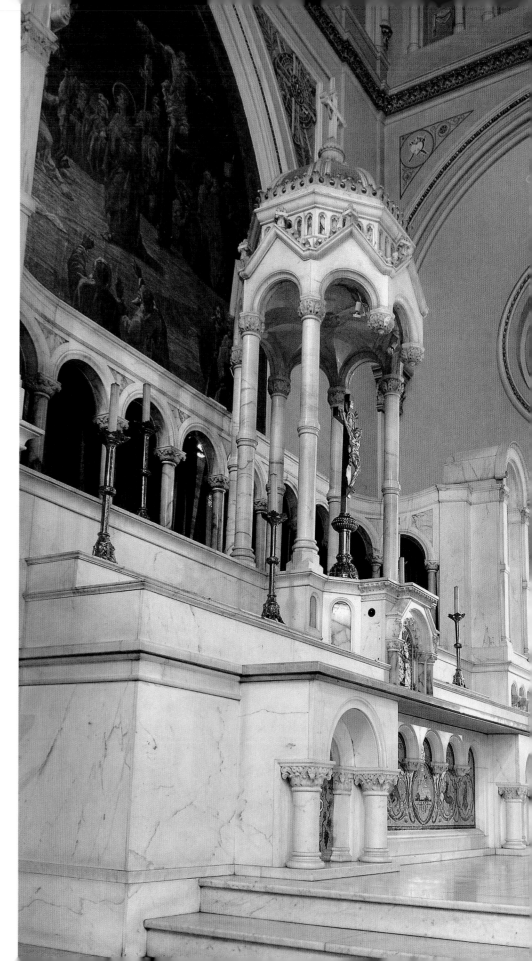

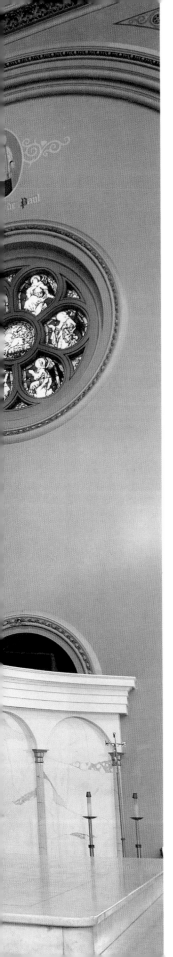

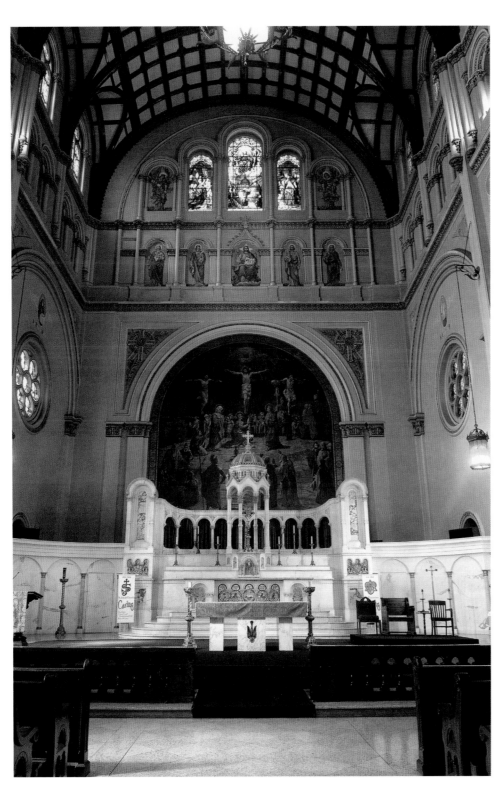

Sanctuary painting of the Crucifixion

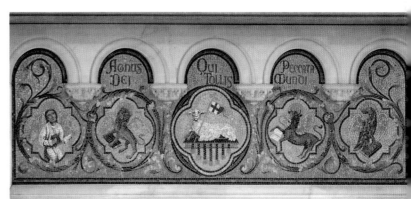

Main altar: lamb with symbols of the four Evangelists

Main altar *(far left)*

Front view of main altar and sanctuary *(left)*

Baptismal font (*detail*)

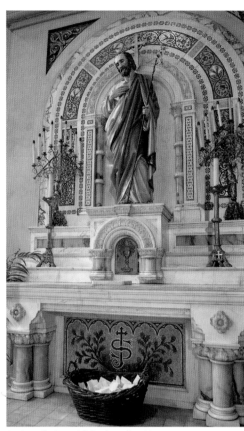

St. Joseph altar with basket of petitions

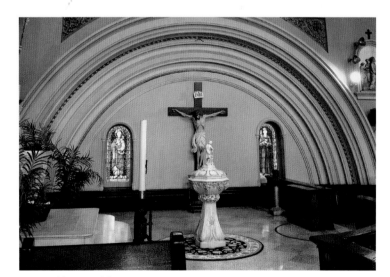

Cross and baptismal font

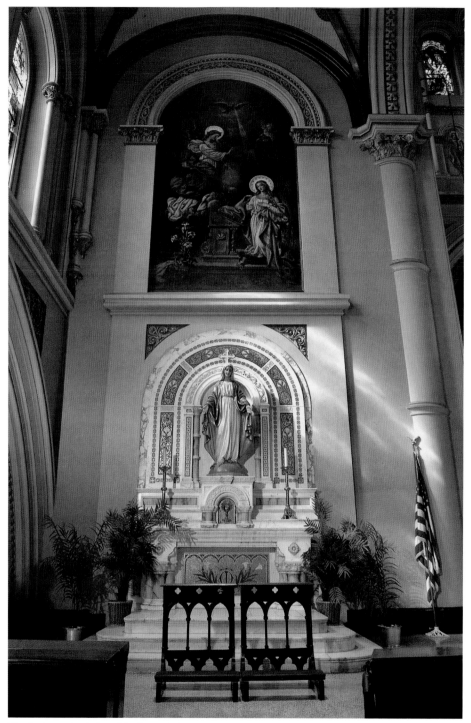

Mary's altar and painting of the Annunciation

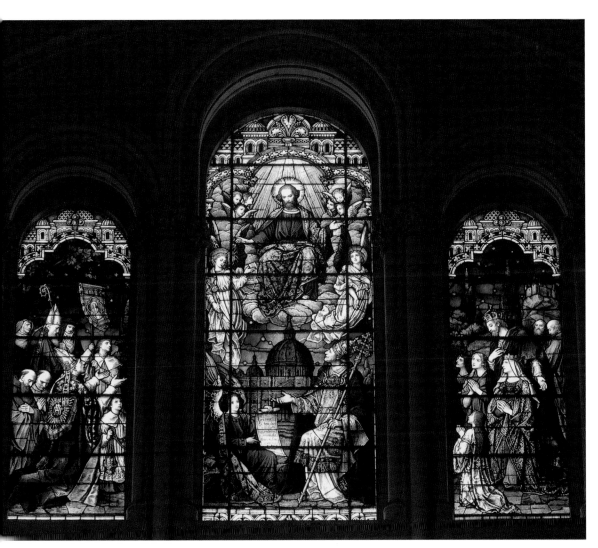

Stained glass: St. Joseph, Vatican

Rose window (*detail*)

Stained glass: St. Gregory Perboyre

Stained glass: Wedding feast of Cana (*detail*)

Statue of St. Lucy

Station of the Cross VII

St. Joseph and angel

Upper stained glass

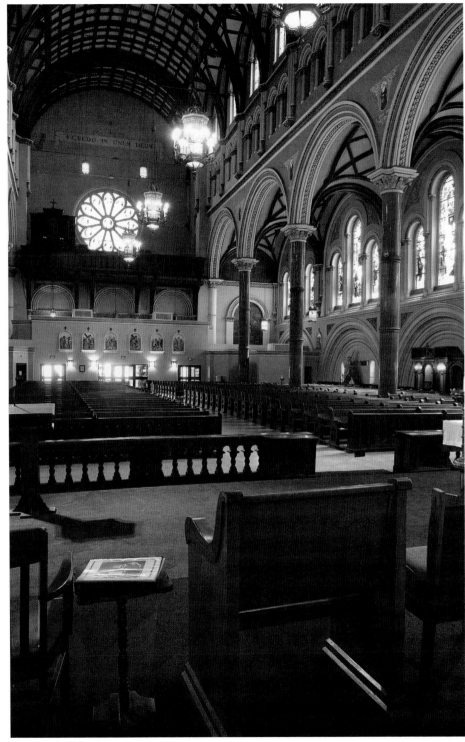

View of back of church

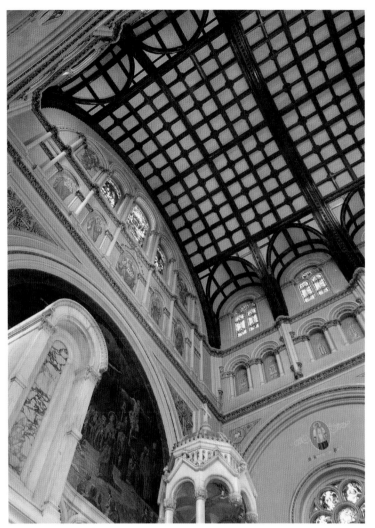

View of walls and ceiling

Ceiling (*detail*)

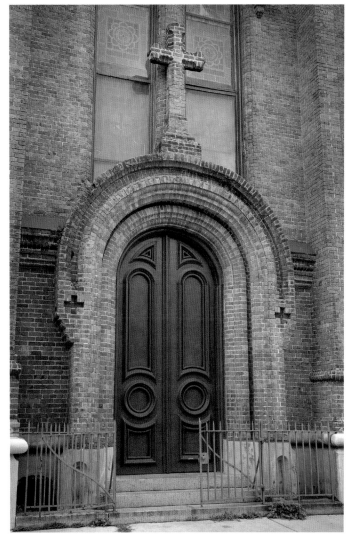

Facade

10. ST. MARY'S ASSUMPTION CHURCH

I N 1912, NEW ORLEANS Archbishop James H. Blenk, a German native raised in New Orleans, described St. Mary's Assumption Church as "remarkable for its classic architectural lines and particular for its pervading atmosphere which is one of piety and deep devotional influence. The altars are rich in design and of real artistic beauty and effect. . . . The stations of the cross, the statuary, the confessionals and the grand old organ—all bespeak the precious inheritance of a sturdy faith and staunch Catholicity, which the founders of this church have transmitted for several generations to their children and their children's children."

No New Orleans church portrays the city's German Catholic heritage more extensively and artistically than St. Mary's Assumption. The parish was founded in 1843 to serve the rapidly growing population of the Lafayette area, which included many German-speaking immigrants. The church is the only one in this volume where the donors are listed in German.

The Catholics of Lafayette were chartered as a parish in 1836 but initially had no church. When German Redemptorist Father Peter Chakert arrived in 1843 on a fund-raising trip, Bishop Antoine Blanc asked him to remain and minister to the Catholics in the Lafayette area, particularly the Germans. The city of Lafayette was incorporated into New Orleans in 1852.

Father Chakert first rented Kaiser's Hall on Chippewa and Josephine Streets to serve the parish. When the Redemptorists agreed to commit to the Lafayette

area, he purchased that property. The cornerstone of the parish's first small frame church, which measured ninety by forty-five by twenty-one feet, was laid on January 14, 1844; the church was dedicated to Mary under the title of the Assumption. Sermons initially were in French, English, and German. Chakert remained only a short time, and then diocesan priests took charge of the new parish. German Redemptorists returned in 1847.

When the need for a larger space to accommodate the rapidly growing German population became evident, adjoining property was purchased. The cornerstone for the new church was laid on April 25, 1858, the same day that St. Alphonsus, a church for English speakers, was consecrated across the street. Albert Diettel has been tentatively identified as the architect of St. Mary's Assumption. The massive building was completed in two years and blessed on June 24, 1860. A large section of the old church was transferred to nearby St. Joseph Cemetery as a mortuary chapel.

St. Mary's Assumption was designed in German baroque style with many Italianate features. Architect Allison Owen described the church as German Transitional architecture. "It could have been built with equal aptitude in Dresden or Munich so well has it been handled," he noted. The facade rises gracefully with arches, crosses, and niches creating a "rhythmically patterned surface." The 142-foot tower, called "a model of design and construction," is rectangular at floor level, becomes octagonal as it rises, and is topped with decorative buttress-like elements. Some bricks have rounded profiles, some rectangular. Owen described the building's exterior as "a splendid example of good honest brickwork." He cited the bell tower as one of the three best in the city.

The facade facing Josephine Street is unusual in that two main entrance doors on either side replace the customary central door. Above the left entrance door, in stained glass, St. Joseph holds the child Jesus. Below are windows portraying St. Joan of Arc and the archangel Raphael holding a staff and fish; the former, donated in memory of Herman A. Winter, bears the inscription "Made by F. X. Zettler, Munich, Germany." Most of the other window donors are acknowledged in German.

The church's interior is divided by a central nave with two side aisles separated by molded ribs. The central column dividing the nave from the aisles was omitted on either side and replaced with a large pendentive, similar to the vaulting in Henry VII Chapel at Westminster Abbey, King's College Chapel at Cambridge, and St. Etienne du Mont Church in Paris. The ceiling, decorated with foliated plaster ornamentation, has been described as "the most sumptuous of all New Orleans churches."

The church's centerpiece is the magnificent wooden altar made in Munich by the Mayer Studio and first used at Midnight Mass on Christmas 1874. With its hand-carved statues, the altar is the embodiment of the German Catholicism the parishioners brought to New Orleans. The tabernacle has two doors, an outer wood door with the letters alpha and omega and an inner gold door with the figure of the Lamb of God and emblems of the four Evangelists. Above the tabernacle are angels and a lamb, a symbol of Christ's sacrificial death.

Beneath the altar table are carved five prophets who foreshadowed the Eucharistic celebration. Moses's brow is marked with points of light while he holds the tables of the law in his hands. Aaron is vested in priestly robes and holds the emblems of a high priest. Melchizedek appears with bread and wine. David holds a harp on which he composed the psalms. Malachy, the last of the prophets, foretells a clean oblation from sunrise to sunset. At the prophets' feet are the words in Latin from Psalm 109, "You are a priest forever according to the order of Melchisedech."

On the left side of the altar are statues of St. John the Baptist and his mother, Elizabeth. Rarely are these two portrayed together. On the right side are Mary's parents, Sts. Anne and Joachim. Joachim holds in his hands the sacrificial turtle doves.

Above the altar table and to the left of the tabernacle are statues of three saints dear to the German people: St. Nicholas holding the Gospel with three golden apples, a sign of his generosity; St. Boniface, the apostle of Germany; and St. Henry II, King of Germany. To the left of them is a statue of St. Augustine holding a flaming heart and with books on his lap, symbolizing his written praise of Mary.

To the right of the tabernacle is a statue of St. Florian, a Roman officer martyred in 304; the patron of firemen and those threatened by fire, he is portrayed as a soldier pouring water on a burning building. Next to him is St. Cecilia, virgin, martyr, and patroness of musicians; she holds a small organ in her hands. Next to her is St. Elizabeth of Hungary with a loaf of bread and roses in her lap, symbols of her charity and tenderness. To her left is a statue of Pope St. Gregory the Great, who sent the first missionaries to Germany. A seated angel on each side of the altar, bears an inscription in Latin: on the left, "He who is mighty has done great things for me"; on the right, "Behold all generations shall call me blessed."

Perched atop these varied images are larger statues of St. Peter, on the far left, and St. Paul, on the far right. On the four columns in the sanctuary are statues of Matthew, Mark, Luke, and John, the four Evangelists. Below them are their symbols and names: a child (Matthew); an ox (Mark); a lion (Luke); and an eagle (John).

Above the altar is the majestic hand-carved scene of Mary's coronation as Queen of Heaven and Earth. The Holy Trinity—Father, Son, and Holy Spirit (a snow white dove)—lean forward to place the crown on youthful Mary. One angel holds her scepter, a symbol of her role as queen; another holds a lily, a sign of her

purity. Below Mary are four revering archangels: the legendary Uriel holding a page of scripture with the Greek alpha and omega; Michael, clothed in armor; Gabriel with a scroll (now lost) with the first words of the Annunciation; and Raphael with the staff with which he guided young Tobiah.

A circular stained-glass window above the coronation scene depicts the virtues of faith, hope, and charity. Above the window is an arch-enclosed grouping consisting of a carved image of a lamb; the Redemptorist seal—a cross with a lance that pierced Christ's side and a sponge with which he was offered vinegar and gall; *J* and *M* for Jesus and Mary on either side of the cross; and at the top, a single eye framed in a triangle, representing the all-seeing eye of God and the perfect unity of the Trinity. Around this grouping are the words *Copiosa apud eam Redemptio* (Redemption is plentiful with her). On either side are painted adoring angels.

The first sermon to be preached in the hand-carved wood pulpit was delivered on April 6, 1861. Around its front are bas-reliefs of six saints. St. Anthony of Padua holds the Infant Jesus in one hand and a lily in the other. St. Augustine holds a Bible with a flaming heart. Pope St. Gregory the Great, wearing his papal tiara, holds a staff, a book, and a dove. St. Martin of Tours holds a church in one hand and a Bible in the other, with a goose at his feet. According to legend, St. Martin initially tried to hide when he was chosen Bishop of Tours, and his presence was revealed by the quacking of a goose. It is a Bavarian custom to eat goose on St. Martin's Feast Day. A bishop saint with a miter, possibly St. Boniface, holds a Bible. St. Francis of Assisi holds a lily with the stigmata in his hands. A dove in the canopy signifies the preacher's inspiration with the Word of God, while Mary, above the shell, prays that the preacher's words will convert the sinner's heart.

Two smaller altars, blessed on February 13, 1861, flank the main altar. The one on the left honors St. Joseph and includes a statue of him holding the child Jesus in his arms with statues of two angels at his side. Above his head are wood carvings of carpenter's tools—ax, saw, square, and plane. On the right is an altar honoring Jesus as the Sacred Heart. A statue of that image is also accompanied by the figures of two angels. Above are wood carvings of a cross, crozier, and miter, episcopal signs.

Along the wall to the right is the shrine to Our Mother of Perpetual Help. A parish historian wrote, "From the very start, the people were taught to enshrine Mary in their hearts; to confide their troubles and problems to her; to make their parishes centers and models of public, childlike devotion to God's mother." The original picture of Mary as Mother of Perpetual Help was restored in 1866 in the Redemptorists' church in Rome. The Redemptorists were given care of this devotion and the privilege of enshrining it in every Redemptorist church through-

out the world. The first authentic copy of the Roman original arrived in New Orleans in 1874 and was installed in St. Mary's Assumption Church. Devotion spread to other New Orleans churches in the early 1900s. At one time, more than twenty-five thousand people came to Tuesday devotions at the three New Orleans Redemptorist churches; the first devotions service began at 5:30 a.m. and the last at 9:00 p.m. Special public transportation had to be provided to accommodate the large crowds.

The entrance to the shrine and museum of Redemptorist priest Blessed Francis Xavier Seelos is to the right of the Sacred Heart altar. Father Seelos died ministering to the afflicted during the 1867 yellow fever epidemic. He is buried in St. Mary's Assumption Church, where he served. He was beatified in 2000.

The stained-glass windows on either side of the church were installed in 1861. They reflect German traditions together with familiar biblical and Marian themes. Beginning in the front on the left, the upper window portrays St. Bartholomew the apostle with the flaying knife with which he was martyred; the lower window depicts St. Dominic receiving the rosary from Mary. The upper middle windows portray St. Henry II on the right and St. Cunegonde, St. Henry's wife and a model of prayer, penance, and charity, on the left. Below St. Henry, Mary Magdalene is seen washing Jesus's feet. Below St. Cunegonde, the window depicts the risen Jesus emerging from the tomb. The back upper window portrays St. Gertrude, a German nun and mystic who died around 1301; the lower window, the Flight into Egypt.

On the right side, the front upper window portrays St. Nicholas as the archbishop of Myra in Asia Minor; the lower window, the Presentation of the Blessed Virgin Mary in the Temple. In the center is the great window portraying angels freeing souls from purgatory through Mary's intercession. Mary is seated on a moon surrounded by angels and saints. John the Baptist, with a cross inscribed with *Behold the Lamb of God*, and King David are to her right; saints are on her left. Above Mary, the Father, Son, and Holy Spirit—the latter in the form of a dove—are surrounded by angels and saints. Above Mary and below the Trinity are St. Peter on the right and St. Paul on the left. The upper back window portrays St. Aloysius Gonzaga, the patron of youth; the lower window, the Transfiguration.

As one faces the rear of the church, to the left of the great organ are portrayed in stained glass St. Cecilia, the patroness of music, and a guardian angel watching over a little girl. To the right are King David with the harp he used to accompany his composition of the psalms and a guardian angel watching over a little boy. A magnificent window of blue stained glass rises above the organ.

Other statues also adorn the church: Mary near columns on the right and left sides; St. Alphonsus Ligouri, who founded the Redemptorist order in 1732;

Redemptorist St. Clement Hofbauer; Redemptorist St. Gerard Majella; the Sacred Heart; St. Martin de Porres; and St. Anthony. A small altar in the back of church has a bas-relief of souls being freed from purgatory through Mary's intercession.

St. Mary's Assumption formed part of a unique cluster of ethnic Catholic parishes in the South. St. Mary's Assumption (German speaking), St. Alphonsus (English speaking), and Notre Dame de Bon Secours (French speaking) were all served by Redemptorist fathers who shared a common rectory. By 1885, St. Mary's Assumption numbered 4,000 parishioners; St. Alphonsus, 5,200; and Notre Dame de Bon Secours, 340. St. Mary's Assumption ceased to function as a separate parish after Hurricane Betsy in 1965. Following a decade of repairs, the renovated church reopened on August 15, 1975, as the place of worship of St. Alphonsus Parish.

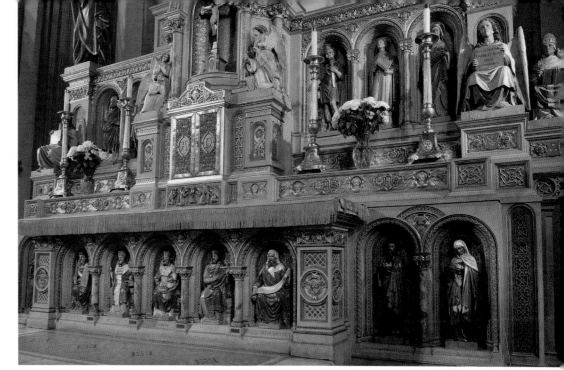

Side view of altar

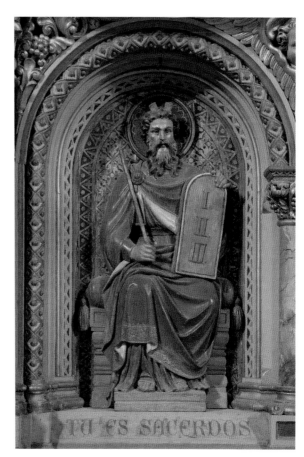

Statue of Moses

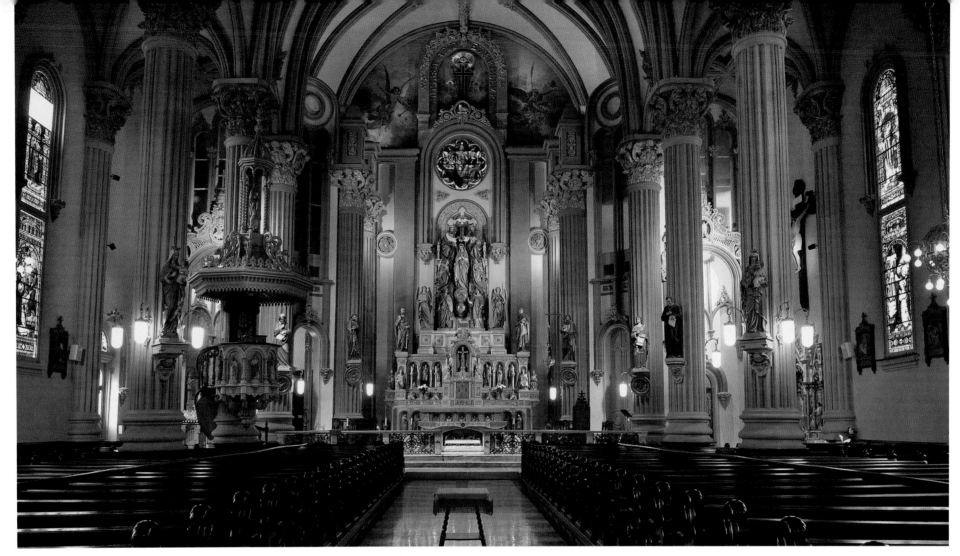

Front view of church

Angel (*altar detail*)

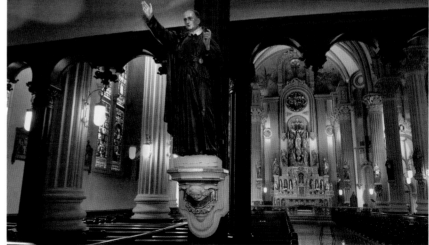

Statue of St Clement Hofbauer at front of church

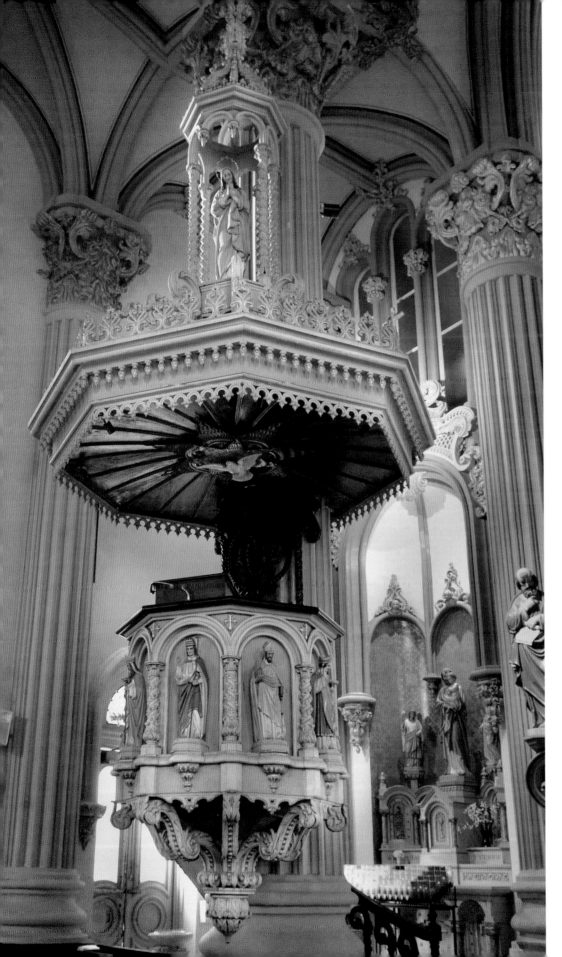

Full view of pulpit including statue of Mary

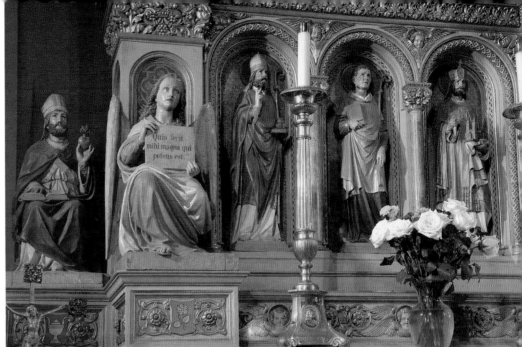

St. Augustine, angel, Sts. Nicholas, Boniface, and Henry

Dove in shell (*pulpit detail*)

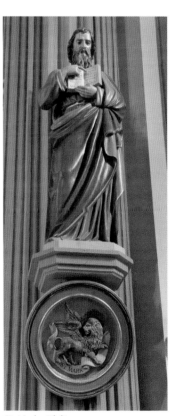

St. Mark with lion

Stained glass: Sts. Cunegonde and Henry; the Risen Christ and Mary Magdalen

Coronation of Mary (*detail of angel freeing soul from purgatory*)

Coronation of Mary (*detail*)

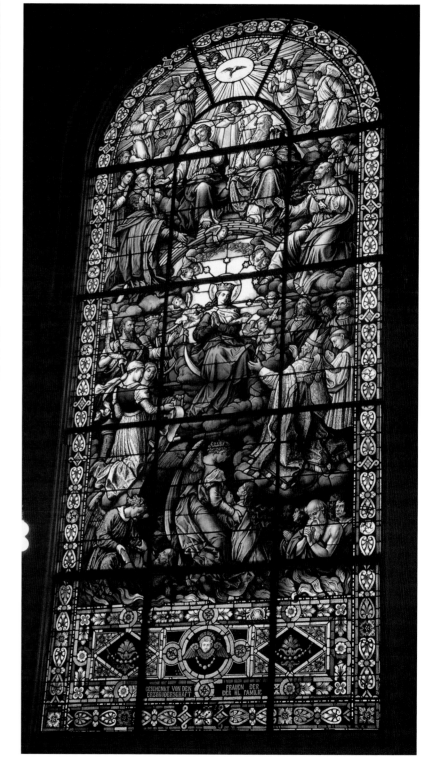

Stained glass: Coronation of Mary

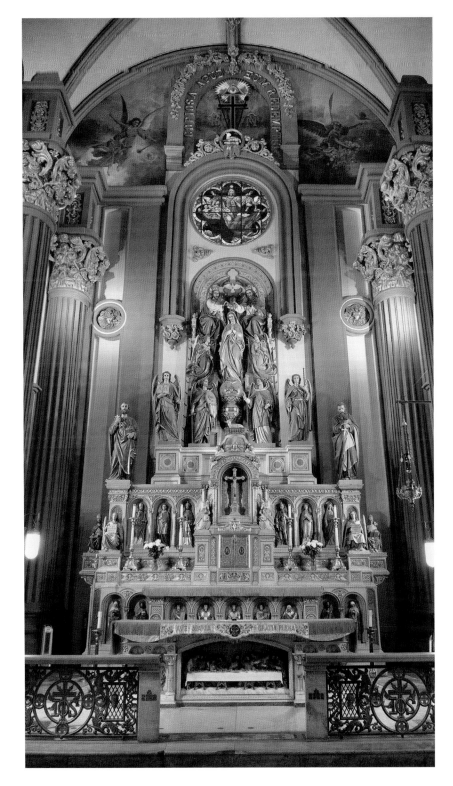

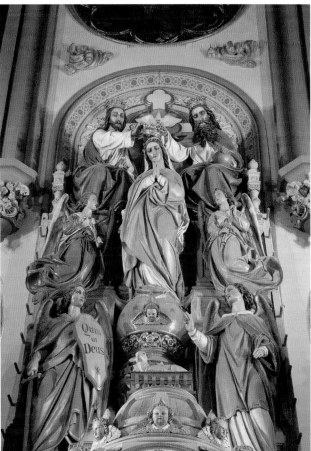

Coronation of Mary

Sanctuary: Eye and lamb

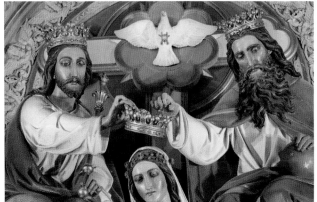

Coronation of Mary (*detail*)

Full view of altar (*left*)

Our Lady of Perpetual Help altar

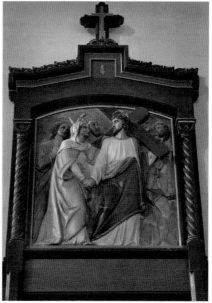

Station of the Cross IV *(left)*

Blessed Francis Xavier Seelos shrine *(far left)*

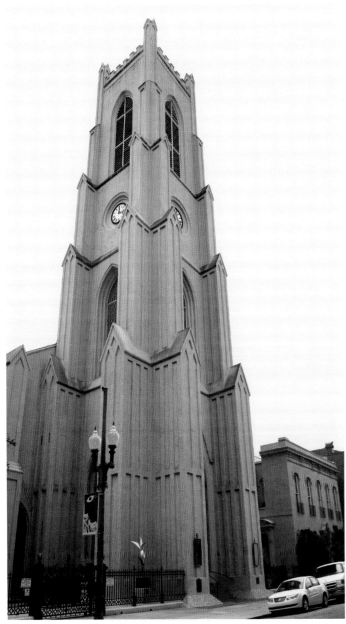

Exterior

11. ST. PATRICK CHURCH

I N A 1983 SERMON on the occasion of the 150th anniversary of St. Patrick Church, Archbishop Philip M. Hannan recalled the story, passed down for generations, that St. Patrick was built to provide New Orleans with "a church where God spoke English. Today," Hannan said, St. Patrick "is a church where God speaks not only English but also continues to speak Latin." When the Tridentine or Latin Mass was reinstated after Vatican II, St. Patrick was the first church in New Orleans where it was celebrated on Sundays.

In the 1830s, the rapidly growing Irish immigrant population was attending St. Louis Cathedral and Sainte Marie, the bishop's chapel on Chartres Street. French was the principal and often exclusive language at both churches. A group of Irishmen petitioned Bishop Leo de Neckère for a church for English speakers with an English-speaking pastor. The bishop responded favorably. On March 28, 1833, Governor A. B. Roman signed the act of incorporation that authorized the building of a church, rectory, school, and orphan asylum as well as the establishment of a cemetery. Located on Camp Street in Faubourg Ste. Marie, St. Patrick was the city's first Catholic church outside the French Quarter.

Within a decade, St. Patrick was a thriving parish. In 1843, more than fifteen hundred members attended a meeting of the Temperance Society at St. Patrick. The same year, the Irish parishioners reportedly told Bishop Antoine Blanc, then in a bitter controversy with the trustees of St. Louis Cathedral, that they would march a thousand strong to take back the cathedral if needed. Fortunately, the controversy was settled in the courts in favor of the bishop.

The original church, a frame building, was blessed by Bishop de Neckère on April 21, 1833. The bishop preached in English at the first service on May 1. Space soon proved inadequate to serve the increasing Irish and American populations. The present church, originally designed by local architects Charles Dakin and James Dakin, was begun in 1838. The Dakins incorporated elements from some of England's finest cathedrals—York Minster and Exeter—into their Gothic design.

The cornerstone of the new church was laid on July 1, 1838. A local newspaper noted that the plans, which included a vaulted design and windows and exquisite ceiling, indicated St. Patrick would be the most outstanding example of Gothic architecture in the United States. In the initial construction stages, the new church walls were built around the original wood structure, which continued in use. A house on Julia Street then served for worship until the new church was ready for occupancy.

When a dispute arose between the Dakins and the church trustees, the original contract was voided and architect James Gallier was called upon to complete the building. The massive tower began to lean toward the church, and Gallier installed two fifty-foot cast-iron pillars. The lower ends rested on the foundation inside the church; the upper ends were attached to the tower, effectively creating a sturdy prop. A column can be seen today adjoining the confessional.

The first Mass was celebrated in the new church on February 23, 1840, although the interior was not completed. Final construction was significantly delayed because of lack of finances. In 1843, the sheriff seized the church when bond payments could not be met. The parish, with the bishop's help, regained ownership of the property and buildings.

For many years, the church's 185-foot tower was New Orleans's tallest building—equivalent to a modern eighteen-story building. The tower was used as an observation post for fires, a beacon for navigation on the Mississippi River, and a focal point for the U.S. Coast and Geodetic Survey.

A faded portrait of Father James Mullon in the vestibule greets the visitor. Mullon, a native of Ireland, came to the United States as a young boy, joined the navy during the War of 1812, studied for the priesthood in Maryland and Ohio, served as the president of Cincinnati's first Catholic college, came to New Orleans in 1834, and was pastor of St. Patrick from 1834 to 1866. In addition to overseeing "with extraordinary zeal" the building of the present St. Patrick Church, he established St. Patrick Cemeteries, a parochial school, and an orphanage. He defied Union General Benjamin Butler from seizing the church's bell, which had been cast in Cincinnati and installed in 1847.

The church's ribbed, vaulted ceiling is part of Dakin and Dakin's original design. Gallier significantly changed the church interior by adding columns to support more of the roof and create a high nave and lower side aisles. Three galleries around the sides of the church are framed by the columns, which have cast iron centers with Gothic wood panels.

The sanctuary, designed by Gallier, is semioctagonal with a vaulted ceiling "composed of ribs of Gothic tracery and stained glass inserts." The sanctuary skylight provides illumination. The elaborate carved-wood high altar with its white marble *mensa,* or table, was designed by Gallier and reflected the courtyard screen for King's College in Cambridge, designed by prominent architect William Wilkins, with whom Gallier had worked in London. The altar, originally painted and grained in imitation oak, has been reconditioned on several occasions, most recently during the 1989–90 restoration. The brass tabernacle and shelf for the crucifix were added later.

The stained-glass half dome over the main altar was designed by Gallier. The original glass was severely damaged in the 1915 hurricane. The present stained glass representing angels and archangels was installed between the dome's Gothic ribs. The windows were donated in 1916 in memory of Joseph Lenes, a parishioner and former president of the old New Orleans and Carrollton Railroad.

Leon Pomerade, a young French artist, was commissioned to paint the three grand frescoes behind the altar. The central panel is a copy of Raphael's *Transfiguration.* The other two are original designs. The left panel depicts St. Patrick during his first visit to Ireland, baptizing the Princesses Ethnea and Fethlima, daughters of King Leoghaire. The king's palace is in the background. The right panel depicts Christ walking on the waters of the Sea of Galilee. The three paintings were completed by the end of 1841. A visitor to the church that year wrote that the two sisters are "of an angelic beauty and of the most pure and the most gracious design. The saint, capped with his miter, clothed with his pontifical insignia and leaning on his pastoral crozier, is a perfect model of man in his most noble type."

In 1854, the church interior was finally painted by Joseph Benson. The same year, granite steps to the three tower entrances were added. A cast-iron fence in Gothic design replaced the original wooden fence.

The side marble altars were later additions and date from the mid-twentieth century. The one on the left is dedicated to the Blessed Virgin; the one on the right, to the Sacred Heart. The Carrara marble statue of the Sacred Heart was blessed on April 10, 1904, and originally stood on its pedestal outside the sanctuary rail near its present location. A reporter at the ceremony noted the "mildness, gentleness, and forgiveness" in Christ's face. The statue of Mary as Our Lady of Lourdes also dates from 1904 and was originally placed outside the altar rail. Both statues were moved to their present location in the 1940s.

The full-length stained-glass window adjoining the Sacred Heart altar depicts the apparition of Christ to St. Margaret Mary Alacoque. The window next to Mary's altar shows Our Lady of Lourdes appearing to St. Bernadette Soubirous. Both were donated in 1916 and installed by Emil Frei Art Glass Company of St. Louis, Missouri. The baptismal font is in front of Mary's altar. Confederate General James Longstreet was baptized here in 1877.

The original wood altar rail was replaced in the 1940s by the present iron rail, which was designed by architect Hendrik M. M. Van Rappard and made by Sutton Iron Works of New Orleans. The original molded mahogany cap was reused. The pulpit was first installed outside the communion rail in 1864. It was moved into the sanctuary and the shell added probably in the early twentieth century. It is located on the right side, usually reserved for cathedrals. Indeed, St. Patrick served as the city's co-cathedral—the only Catholic church in the city to have had that distinction—from 1849 to 1851, while the present St. Louis Cathedral was under construction, and again from 1916 to 1919, when the cathedral was closed after suffering structural damage in the 1915 hurricane.

Four stained glass windows were installed between 1916 and 1920 on either side of the church. The windows on the left depict St. Rita of Cascia, the Nativity, Christ with the children, and the Good Samaritan. On the right are St. Anne, the Conversion of St. Paul, Mary as Patroness of the United States, and St. Patrick. The window of Mary includes the domes of St Peter's Basilica in Rome and the U.S. Capitol in Washington, with the pope sending missionaries to Native Americans in the foreground. The windows depicting St. Paul, Mary, and St. Patrick were probably made by F. X. Zettler Studio in Munich.

In 1914, the painting of a group of trumpeting angels with St. Cecilia, the patroness of music, was added to the choir gallery. The angels are modeled on those of Fra Angelico. The archway, carved mahogany doors, and panels separating the vestibule from the nave were added in 1914 by Romeo Celli, a native of Italy and skilled wood carver and sculptor. Carved angels adoring Christ in the host are at the base of the arch. The Pietà, originally on the left altar, was moved to the rear of the church in the 1940s. It reportedly was exhibited at the 1893 World's Columbian Exhibition in Chicago. A dozen statues are found throughout the church, including Sts. Patrick, John the Baptist, Joan of Arc, Joseph, Anthony, Anne with Mary, Therese of Lisieux, Jude, Lucy, Christopher, and Blaise, patron of throat ailments, holding crossed candles in his hands.

In 1950, a major renovation of the church was completed under the direction of Camillo Tango, a native of Naples who had worked previously on fifty churches in the United States. Tango himself painted new murals and new stations of the cross. Pomerade's murals were left untouched. The purpose of the restoration was "not so much to ornament the church as to emphasize the architectural lines that distinguish the Gothic design."

On May 4, 1952, St. Patrick became the first Catholic church in the city to be air-conditioned, and this was done without marring the church's architectural beauty. No ducts are exposed. During the first hot summer months, Sunday Mass attendance reached 2,400.

In 1990, a visitor described St. Patrick as "a delightful reminder of the past in the midst of change." That reminder almost was demolished a quarter century earlier. In 1965, St. Patrick, already in a deteriorating state, was badly damaged in Hurricane Betsy. The neighborhood, with its abandoned warehouses and vagrants, was considered a skid row. The church was in such a dilapidated state that the archdiocesan building commission voted unanimously to close St. Patrick Parish and tear down the church.

Recently arrived Archbishop Philip M. Hannan overturned the commission's decision. His refusal was "dictated by respect for the church as well as a desire for survival." Father John Reynolds, whose mother had been baptized in the church, was named pastor and immediately began laying the foundation for a twelve-year, three-million-dollar renovation. Work progressed as money was available, with no major fund-raiser. The pastor later recalled that the neighborhood was so run down that it was considered "hopeless; it was said it would never rise again." Preservation architect, historian, and parishioner Samuel Wilson, Jr., was the architect for the renovation. Wilson called St. Patrick "one of the great examples of the Gothic revival in the country."

Over the decades, many visitors have left their impressions of St. Patrick Church. Gibson's 1838 city directory described it as "a triumph worthy of the genius of Gothic architecture." In 1853, the *New Orleans Daily Delta* observed that St. Patrick had become "one of those venerable landmarks and pillars of the Faubourg St. Mary." One 1855 visitor to St. Patrick tower noted with exhilaration that his telescope provided a breathtaking sweep of the city for almost ten miles in each direction, from Lake Pontchartrain to the Mississippi River. "Our finest buildings, however, looked of very shrunken dimensions from the lofty height."

At the 150th anniversary celebration, Archbishop Philip M. Hannan paid tribute to the long history of the church building and the parish. "It has been and is the house of God and the refuge of the poor for the service of Christ. It was built by the faith of the people and it has preserved the faith of the people of every nationality, especially the Irish, for a century and a half. We celebrate a living church that changes and continues its ministry according to the needs of the people and their faith."

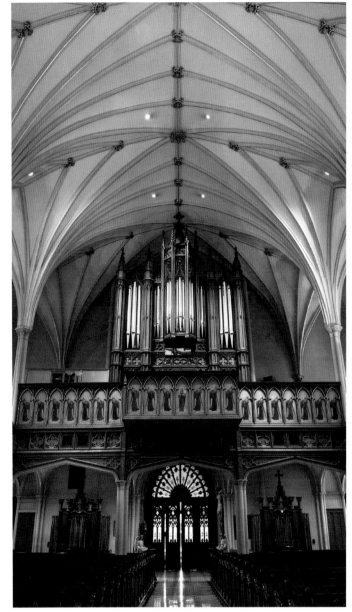

Interior view of rear

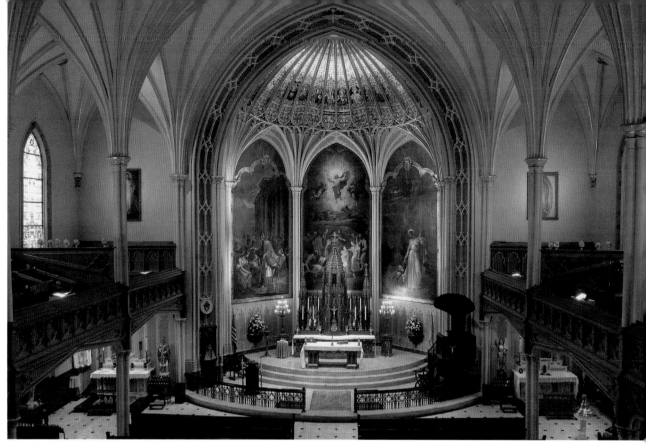

Front of church from balcony

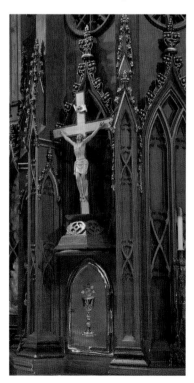

Altar (*detail*)

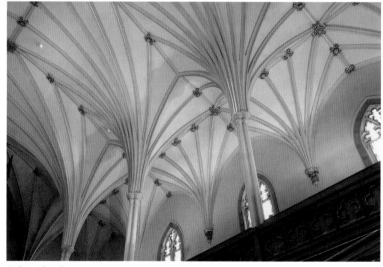

Ceiling (*detail*)

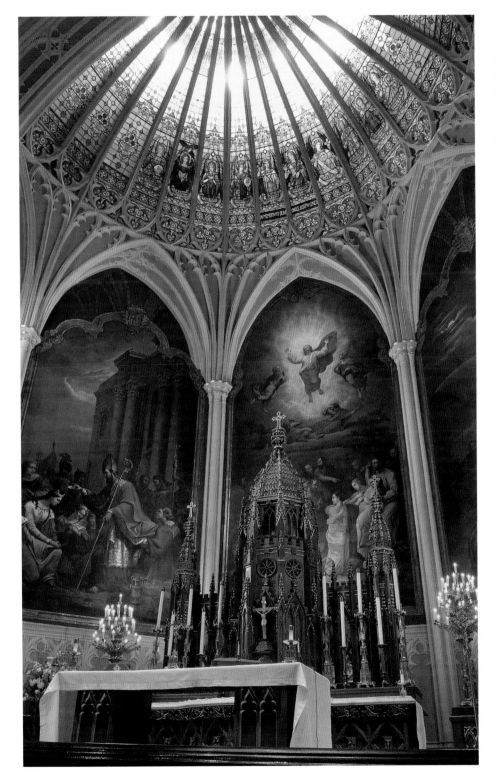

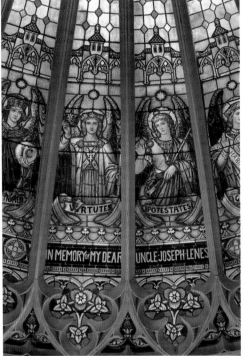

Sanctuary stained glass

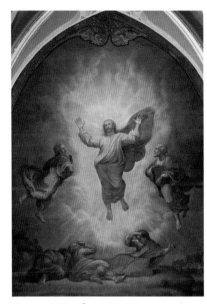

Sanctuary: Transfiguration

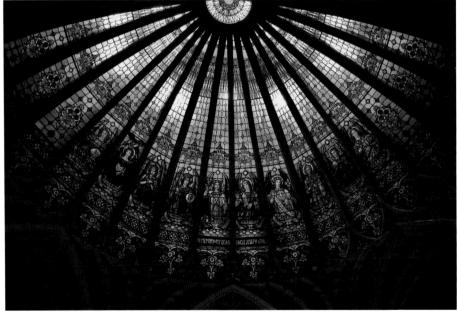

Dome

Sanctuary: Baptism of princesses mural and altar *(left)*

Mary's altar

Door panel (*detail*)

Mahogany doors between vestibule and nave

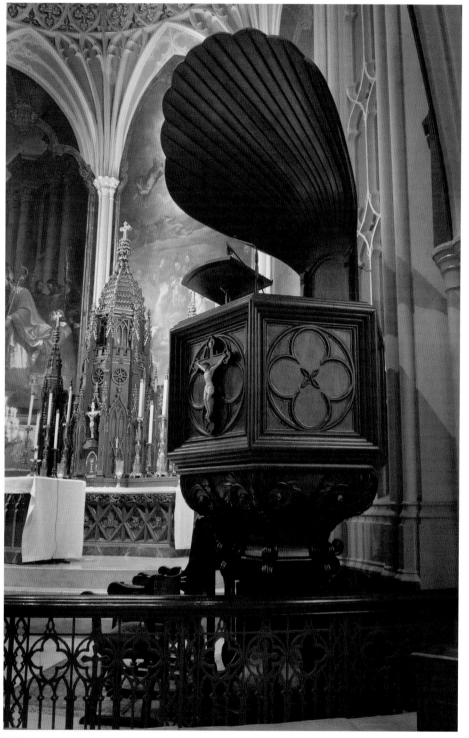

Pulpit

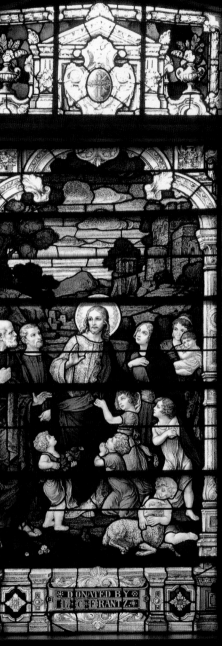

ned glass: Jesus and the children

Stained glass: The Good Samaritan

Stained glass: St. Patrick

Stained glass: Mary, patroness of the United States

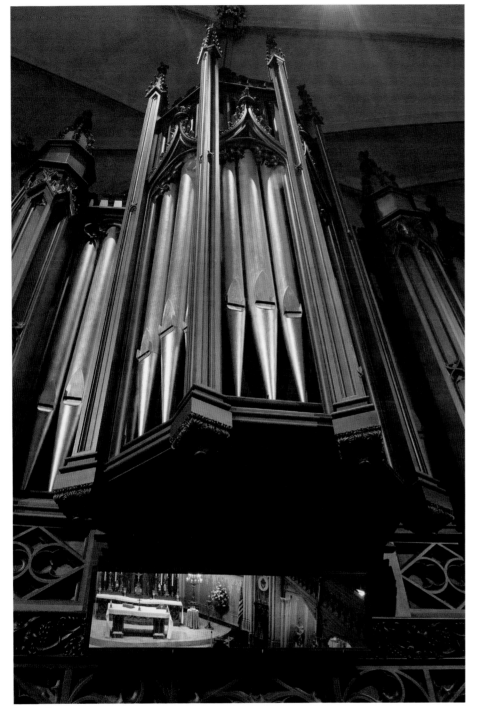

Organ pipes

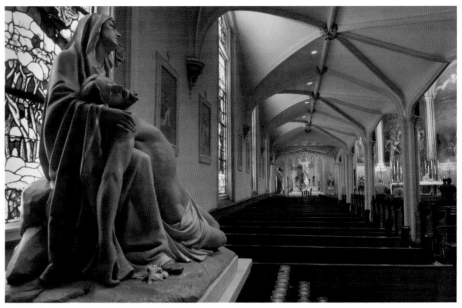

Pietà and side aisle

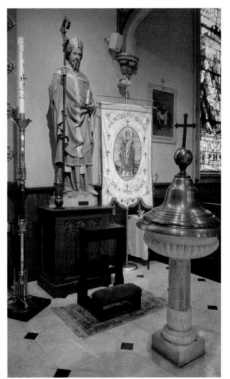

Baptismal font and statue of St. Patrick

Iron altar rail

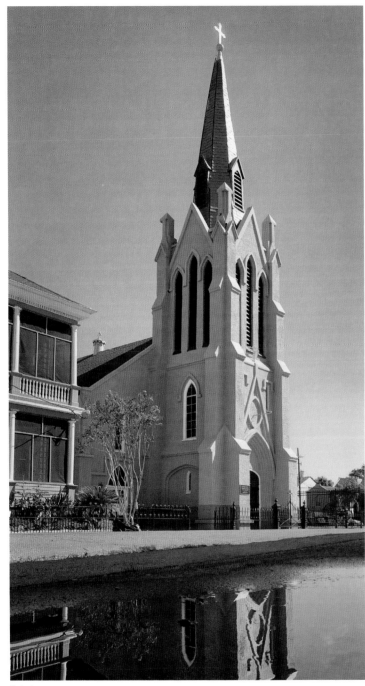
Exterior

12. ST. PETER CLAVER CHURCH

T. PETER CLAVER CHURCH is at the center of Tremé, one of the oldest neighborhoods in New Orleans and located west of the French Quarter near I-10. The area was devastated by Hurricane Katrina on August 29, 2005. Every house and business suffered major damage. Residents were forced to flee and relocate throughout the country. The church had six feet of water for almost five weeks.

The pastor, Edmundite Father Michael Jacques, quickly relocated to Lafayette, where he began forming a virtual parish. By early October, using a Web site to contact parishioners and disseminate a regular newsletter, he identified more than a thousand members dispersed to Houston, Dallas, Austin, Atlanta, Memphis, scattered Louisiana cities, and as far away as Los Angeles, Chicago, and Washington, D.C. Father Jacques traveled to those cities, appointed a displaced parishioner as local coordinator, contacted a Catholic church in each place to temporarily serve as a home away from home, and began reestablishing the congregation.

Amid these efforts, he returned to the devastated neighborhood in September. He recognized that rebuilding the church and reopening the school would be major factors in his parishioners' return to New Orleans. He also realized that the church had to help people rebuild their lives, homes, schools, and health-care facilities. St. Peter Claver Parish, in cooperation with Catholic Charities and several local community development corporations, established Providence, a nonprofit agency to implement these plans.

Father Jacques and his returning parishioners quickly began to repair and rebuild their church. Skilled carpenters from Mississippi were hired to recondition the flood-damaged wood, construct a choir loft, and fashion new furnishings from the rubble. The recovery process provided the parish with an opportunity to express its African American roots in new pieces of art and incorporate them into a sacred space that dates back to 1852.

St. Peter Claver is one of four parishes in this volume whose church previously served as the place of worship for another parish. St. Peter Claver Church was originally built to serve St. Ann Parish. Designed by architect T. E. Giraud in early-thirteenth-century English style, it measures 90 feet long, 46 feet wide, 32 feet high in the nave, and 21 feet high in the aisles. The tower and spire are 105 feet high. St. Peter Claver Parish was established in 1920 to serve the African American community above Claiborne Avenue. St. Ann Parish had just built a new church, and its old church was transferred to the new St. Peter Claver congregation in April of that year.

When Josephite Father J. A. St. Laurent was installed as the first pastor on October 24, 1920, "the church was thronged to its utmost capacity," including a large number of men. Father St. Laurent initially found the building "rather bare" and in need of repairs and furnishings. Despite this fact, the church was "beautifully decorated" for his installation. At the ceremony, Archbishop John Shaw told the congregation that he chose the parish's patron saint "because St. Peter Claver was one of the greatest apostles of the colored people." St. Peter Claver (1581–1654) was a Spanish Jesuit who ministered to the arriving African slaves in Cartagena, Colombia. He was canonized in 1888. In 1894, he was named the universal patron of all missions and missionaries among people of African descent.

In his initial report, Father St. Laurent estimated the congregation to be 3,500. Within two years, that number grew to 5,500. By the following year, five societies were active in the parish, including the 700-member League of the Sacred Heart. By 1950, the parish population was estimated at 8,830; seven masses were celebrated on Sunday.

Furnishing the church took a significant part of the new parish's budget. By the end of 1922, basic pieces were in place, including stations of the cross, a baptismal font, an organ, holy water fonts, and statues of the Sacred Heart, Mary, and Joseph, as well as Sts. Ann, Peter, Anthony, and Rita of Cascia. The side altars were dedicated to Mary and to St. Joseph.

In the wake of Vatican II, the church was renovated. The walls were repaired, a terrazzo floor was installed, and new, smaller hand-carved stations of the cross were executed. In 1984, the Society of St. Edmund replaced the Josephites, and Father Michael Jacques was named the pastor. The Edmundite mission is to promote the emergence of African American leadership and opportunities for service in the African American community. In 1995, the parish's seventy-fifth anniversary, the church underwent a major renovation. The sanctuary was elevated "to become more a part of the congregation," a raised baptismal pool was added, the new tabernacle was commissioned, and the choir section was improved.

The current interior, renovated on several occasions, blends post-Katrina remodeling with art that predates the parish's establishment. The first striking feature is that there is only a modern altar of sacrifice facing the people. The original main altar was dismantled and removed. The second feature is the remarkable baptismal pool to the left of the sanctuary. The third is the depiction of African and African American themes in statuary, mosaics, paintings, and hand-carved candle holders. St. Peter Claver Parish reaches beyond its membership to the wider neighborhood as well.

A simple, well-designed wood table, the altar is flanked on either side by new candlesticks alive with African symbolism. Behind the altar and in front of a wood screen is a unique tabernacle, designed and executed by artist Clifton Webb in 1995. The large crucifix stands above carved depictions of the ten sorrowful mysteries of the rosary.

The two candlesticks, also by Webb, are finely carved pieces with four columns of African and African American figures, symbols, and words. The candlestick on the left depicts Sts. Peter Claver, Martin de Porres, Joseph, Katharine Drexel, and Edmund. Also found there are Frederick Douglass; Sojourner Truth; Dr. Martin Luther King; Bishop Harold Perry of New Orleans, the first African American Catholic bishop in the twentieth century; and Sister Thea Bowman, the remarkable African American Franciscan nun who taught by example, song, and word before her death of cancer in 1990. The candlestick includes parishioner, street musician, and trombonist Jerome Green (d. 2001) and his wife, Dillard professor Irene Green (d. 2001). One panel honors the Josephite priests and brothers; another, the Sisters of the Blessed Sacrament, who founded Xavier High School and Xavier University in New Orleans. Also included are a series of African symbols, words, and phrases: GYE NYME; SANKOFA; NYAME BIRIRI; MUSUYIDEE; BINKABI; NYAME DIRE; MPUANNNUM; and NYANSAPU.

The right candlestick is likewise rich in African history, tradition, culture, and symbolism. Sts. Charles Lwanga; Augustine of Hippo; his mother, Monica; Pope Gelasius I; Josephine Bakhita; St. Kizito; and St. Cyprian are carved here. Augustine, Monica, Gelasius, and Cyprian, familiar figures in early Catholic history, are here depicted with the African features rather than the usual European features.

St. Anthony, the friend of the poor, and Simon of Cyrene, who helped Jesus carry his cross, are also on this piece. Among the African words are ANANSE NTONTAN, AKOBEN, HYEWONHYE, MPATAP, and DWENNIMMIM. Both candlesticks were donated by the Green children in memory of their remarkable parents.

In the dome above the altar, the image of a dove hovers, surrounded by the seven gifts of the Holy Spirit depicted in words rather than symbols: piety, knowledge, wisdom, understanding, fortitude, fear of the Lord, and counsel. In windows on the sanctuary's rear walls, a monstrance and grapes symbolize the Eucharist.

The church's stained-glass windows are unusual because they do not portray events from the lives of Jesus, Mary, or the saints. Rather, they symbolically depict faith, hope, charity, and the sacraments. The windows were donated by parishioners soon after St. Peter Claver Parish was established. Beginning at the right front, the windows illustrate faith, hope, charity, the Eucharist, and confirmation. The windows on the left, beginning in the front, illustrate the sacraments of matrimony, Holy Communion, the anointing of the sick, penance, and baptism. The recently installed back left window memorializes Hurricane Katrina and portrays the Holy Spirit in the middle. Two other recent windows over the side entrances depict baptism and the choir.

To the right of the sanctuary is a raised choir section with a modern statue of St. Peter Claver. Two larger contemporary paintings form a backdrop: the Last Supper and an impressionist depiction of the welcoming Christ. To the left of the sanctuary is the baptismal pool surrounded by burning votive candles, each with a donor name. Behind the pool are the holy oils, a statue of Mary modeled after one of Mary Queen of Africa in the Shrine of the Immaculate Conception in Washington, D.C., and a statue of St. Joseph.

The paschal candle in front of the pool is also richly carved with figures and symbols depicting the birth, life, miracles, death, and resurrection of Jesus Christ. Like the cross, this is a "tree of life," beginning with Christ's birth at the bottom. His entry into Jerusalem, scourging, and crucifixion are carved in rich detail in the middle. At the top, the resurrected Christ welcomes those rising from the dead.

The four new entrance doors are unusual. They are glass rather than wood, and each has one of the four archangels—Gabriel, Michael, Raphael, and Uriel—etched into the glass. These are among the several pieces in the church that were created or restored by local artist Ruth Goliwas.

Traditional statues of the Blessed Virgin Mary with the child Jesus and of St. Joseph with carpenter tools and the child Jesus stand in the entrance way. Across the back are statues of Sts. Jude, Anthony of Padua with Jesus, Therese of Lisieux, and Martin de Porres, as well as Christ with the Blessed Sacrament; all have dark features.

The main terrazzo aisle, redone after Hurricane Katrina, includes a series of symbols designed by Goliwas. These include a Jerusalem cross and African symbols of faith, God's mercy, God's patience, and perseverance (the turtle).

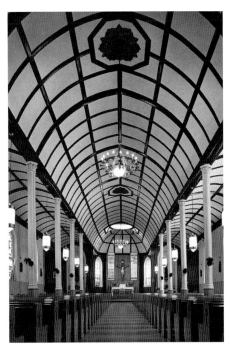

Interior before 1995 renovation

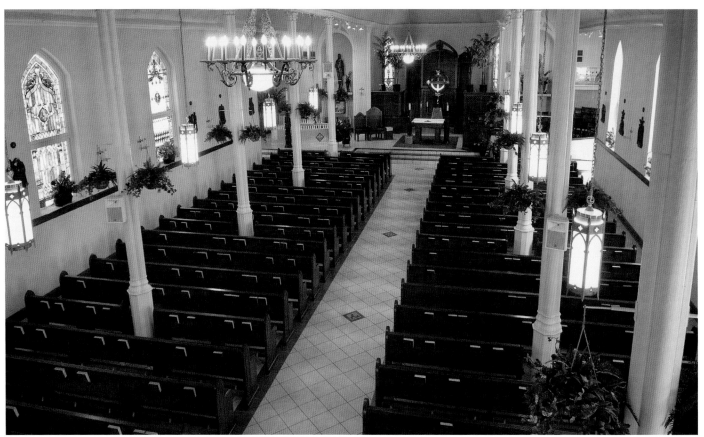

Central aisle as seen from balcony

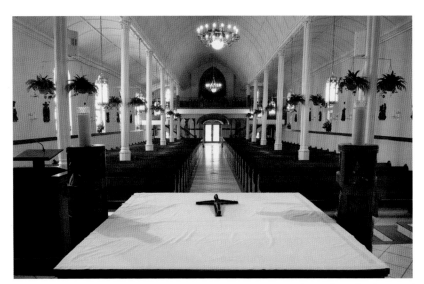

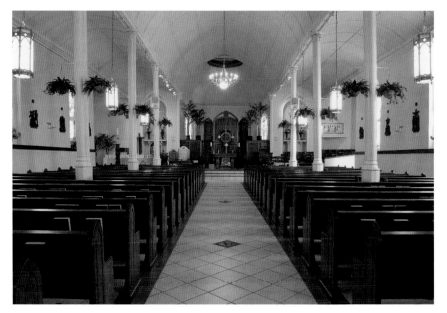

Views toward rear of church *(above)*, and
front *(right)*

Glass entry doors

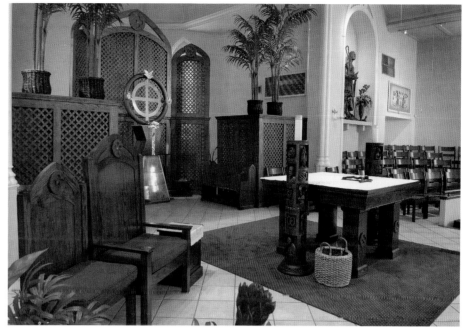

Sanctuary

Tabernacle

Tabernacle detail of fish

Candle (*detail*): Thea Bowman

Candle (*detail*): St. Peter Claver

Candle (*detail*): HYE WO NHYE

Paschal candle (*detail*): Resurrection

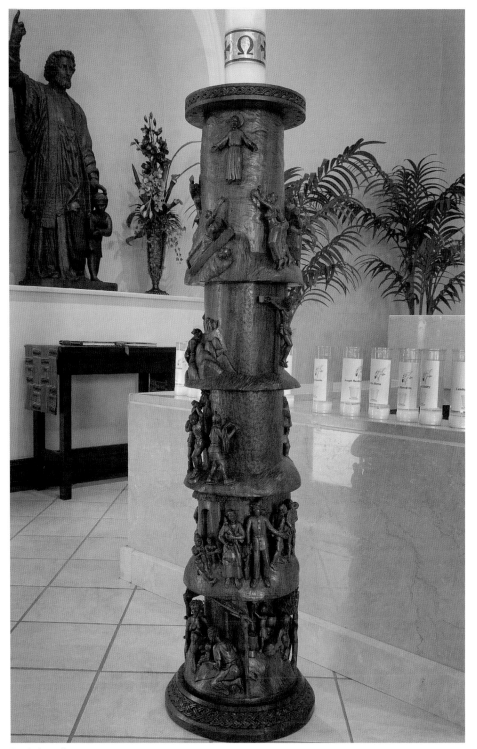

Paschal candle

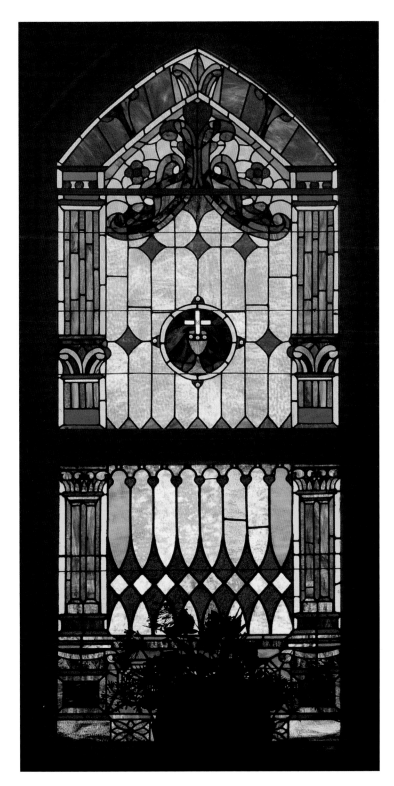

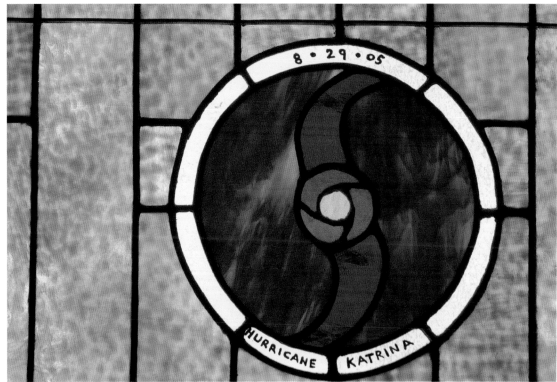

Stained glass: Katrina window *(detail)*

Cupola: Dove and gifts of the Holy Spirit

Station of the Cross XI *(detail)*

Stained glass: The Eucharist *(left)*

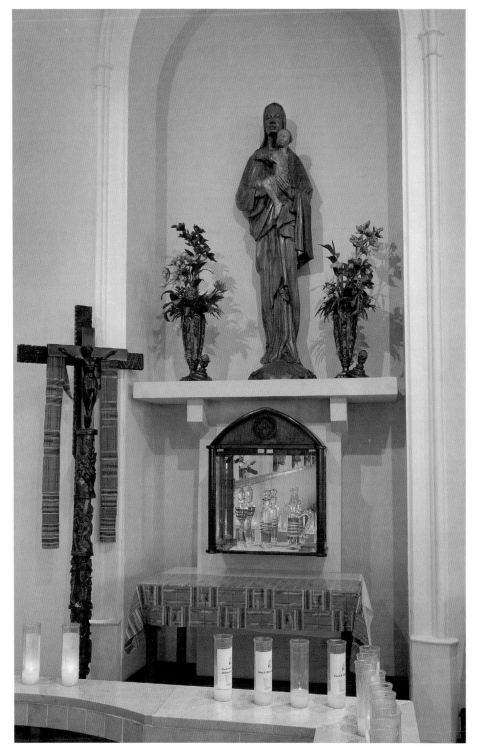

Statue of Madonna and Child (*detail*)

Floor mosaic

Baptismal pool

Carved crucifix, holy oils, Madonna statue

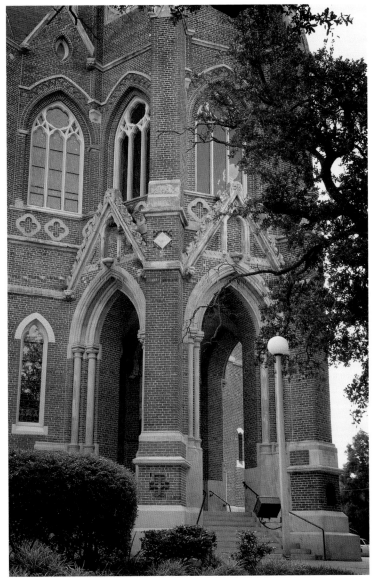

Exterior

13. ST. STEPHEN CHURCH

T. STEPHEN PARISH, founded by the Vincentian order of priests, celebrated its sesquicentennial in 1999. A parish calendar published for the occasion noted that the global Vincentian family of clergy, religious, and laity numbered more than two million people "who claim the spirit, tradition, patronage and spirituality of Sts. Vincent de Paul and Louise de Marillac."

This Vincentian spirit permeates St. Stephen Church. It is most visible in the remarkable stained-glass windows that depict events in the lives of Vincent de Paul and Louise de Marillac, and the communities they founded. It is also visible in the more recent shrines to St. Stephen and Blessed Frederick Ozanam, the windows honoring Saint Jean Gabriel Perboyre and Blessed Francis Regis Clet, and the statue of St. Elizabeth Ann Seton. These all embody the spirit of hospitality and service that the sesquicentennial celebrated as the parish's hallmarks.

Vincent de Paul (1581–1660), a native of Gascony, was known as the apostle of charity in mid-sixteenth-century France. He was instrumental in founding the Visitandines, an order of sisters; he founded the Vincentians in 1625 to evangelize rural France; he helped improve seminary education and training for priests; and he cofounded the Daughters of Charity in 1633. Louise de Marillac (1591–1660), a widow, was Vincent's cofounder of the Daughters of Charity, whose early mission was to the poor of Paris and rural France. Vincent de Paul was canonized in 1737; Louise de Marillac, in 1934.

St. Stephen Parish was founded in 1849 when Father Angelo Gandolfo, a Vincentian priest, was asked to serve the growing Catholic population in the Uptown area once known as Jefferson City. Mass was initially celebrated in private homes. On January 1, 1850, a chapel was dedicated. A second, larger church on Napoleon Avenue near Magazine Street was consecrated on June 8, 1851. The foundation of the present church was completed in 1868; its cornerstone was blessed in 1871. The parish struggled to raise the needed funds to complete the present massive church in the two decades following the Civil War.

In 1885, Father Anthony Verina, the pastor, reported a "floating" Catholic population of about thirty-five hundred, including five hundred African Americans. The predominate languages were French and English. Nearby St. Henry Church served the area's German residents.

The first mass was celebrated in the present church on December 26, 1887, the feast of St. Stephen. The completed building was dedicated on January 1, 1888. In 2008, St. Stephen Parish and neighboring St. Henry and Our Lady of Good Counsel Parishes were suppressed as part of the extensive post–Hurricane Katrina reorganization. The three parishes were merged to create Good Shepherd Parish. St. Stephen Church now serves as the place of worship of Good Shepherd Parish.

St. Stephen Church, early German Gothic in form, has been called one of the city's "most impressive religious buildings." Designed by English architect Thomas W. Carter, the building is 116 feet long and 100 feet wide and is New Orleans's second-largest Catholic church, after St. Joseph. Like its European models, the red-brick exterior features gargoyles. A six-sided tower with spire, designed by architects Favrot and Livaudais, was added later and blessed on December 31, 1906. It rises two hundred feet and was visible for miles in the early twentieth century.

The church's massive interior, intended to lift the soul toward heaven, rises gracefully amid the rounded arches, ribbed ceiling of varnished cypress, patterned walls, and Gothic windows. Like most of the churches in this book, the building has no transept. Carved angel heads, the work of German immigrant craftsmen, look down on the worshipers and visitors below.

The marble high altar was installed in 1949, replacing the original one of wood. On the tabernacle doors, bread and wine are offered by angels on either side of a large cross, with the letters alpha and omega above and below. On the reredos, the symbolic figures of the four Evangelists are featured. Above the altar is a large crucifix with a statue of Mary on the left and one of St. John, the apostle who stood with Mary at the foot of the cross, on the right.

Above the altar is a large painting of St. Stephen, the first martyr. In 1889, noted painter Achille Peretti completed the work, a replica of Raphael's *The Ston-ing of St. Stephen*. By 1912, the painting and the frescoes on either side of it were in a state of decay and in danger of permanent damage. On December 20, 1912, the pastor appealed to parishioners for $2,500 to repair the mural paintings and the sanctuary; they responded generously. The following year, Peretti painted on canvas, rather than refresco, the St. Stephen scene as well as those on either side. To the left are paintings of the Annunciation and the Nativity. To the right are the Visit of the Magi and the Presentation of Jesus in the Temple. Below on the left is a fresco of Abraham; on the right, one of Moses holding the Ten Commandments. Those are the only two remaining frescoes.

The dome in the sanctuary includes carved panels depicting twenty-four men and women, including Salome with the head of John the Baptist. Above the sanctuary entrance, a pelican—the symbol of Christ in the Eucharist as well as a motif on the state seal—is painted on the wall. The altar of sacrifice, installed in 1974, is of green marble from Pietrasanta in Italy. Originally behind the altar were four windows depicting the Evangelists, but two have been lost. The two remaining portray St. Matthew and St. Luke.

To the left of the sanctuary is an altar dedicated to Mary. Her statue looks down from the wall above the altar. Toward the ceiling is a stained-glass window of the Sacred Heart of Jesus. A round window high to the side depicts St. Vincent de Paul. The altar to the right of the sanctuary is dedicated to St. Joseph, and his statue is also attached to the wall above. Higher on the wall is a stained-glass window of the Immaculate Heart of Mary. A large stained-glass round window nearby depicts St. Jean Gabriel Perboyre. Both Mary's and Joseph's side altars are separated from the sanctuary by detailed iron grillwork.

St. Stephen's sesquicentennial celebration highlighted the church's stained-glass windows as "Windows of Faith—an artistic expression of the faith of the people of St. Stephen." The windows were completed in 1923 by Mayer Studio of Munich. Some of the windows were damaged and repaired after Hurricane Betsy in 1965 and again after Hurricane Katrina in 2005. Emil Frei and Associates in St. Louis repaired the windows after Katrina.

The top tri-Gothic windows—three sections with a single theme—on the side walls depict events in the life of Jesus. Beginning at the right front of the church, the first window portrays Jesus in the temple; the second, Peter's confession that Jesus is the messiah; the third, the Wedding Feast at Cana; the fourth, Jesus summoning the rich young man; and the fifth, Jesus with the children. The windows continue on the left. Beginning at the back, the first window shows Jesus healing the sick; the second, the Transfiguration; the third, Jesus's feet anointed in Simon's house; the fourth, the Last Supper; and the fifth, the Agony in the Garden.

Lower windows depict St. Vincent de Paul, St. Louise de Marillac, and the communities they founded. Beginning at the right front, the first window illustrates Mary's apparition to St. Catherine Labouré in 1830; the second, St. Vincent de Paul with galley slaves; the third, St. Vincent giving a rule of life to the first Vincentians in 1625; and the fourth, St. Vincent with a Daughter of Charity. The windows continue on the left. Beginning at the back is a window portraying St. Vincent giving a rule of life to the Daughters of Charity; the second, St. Vincent bringing orphans to St. Louise; the third, the death of St. Vincent in 1660; and the fourth, Jesus giving the red scapular to Sister Appoline in 1846. In the choir loft above the Wicks organ are stained-glass windows honoring St. Cecilia and King David.

Additional statuary is found along the side walls: at the right front, St. Vincent de Paul, the Sacred Heart of Jesus, St. Jude, and St. Anthony; in the back, Sts. Rita of Cascia, Therese of Lisieux, Agnes, and Anne. Also in the back of the church is a modern sculpture of St. Elizabeth Ann Seton, the foundress of the Daughters of Charity in Philadelphia and the first American-born saint. The sculpture is done in polyester with a sandstone patina. A statue of the Baptism of Jesus is in the former baptismal chapel, and one of the Good Shepherd is on stairs to the choir loft.

Over the entryways are stained-glass windows of St. Stephen as the friend of the poor, as teacher, on trial, and at his death by stoning. On the far left is a window of Vincentian Blessed Francis Regis Clet, martyred in China in 1820; on the far right, one of Saint Jean Gabriel Perboyre. Above the side doors are small stained-glass windows of the Eucharist and a lamb.

In 1999 as part of the parish's sesquicentennial celebration, two shrines were placed in the church. One, depicting St. Stephen as the first deacon, honors the ministry of the permanent diaconate in the archdiocese. The second shrine recalls Blessed Frederic Ozanam, founder of the Society of St. Vincent de Paul, a lay organization that assists the local needy.

Ceiling (*detail*)

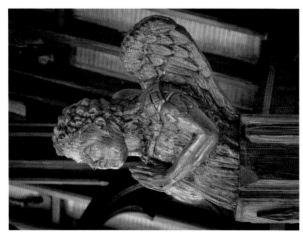

Ceiling (*detail*)

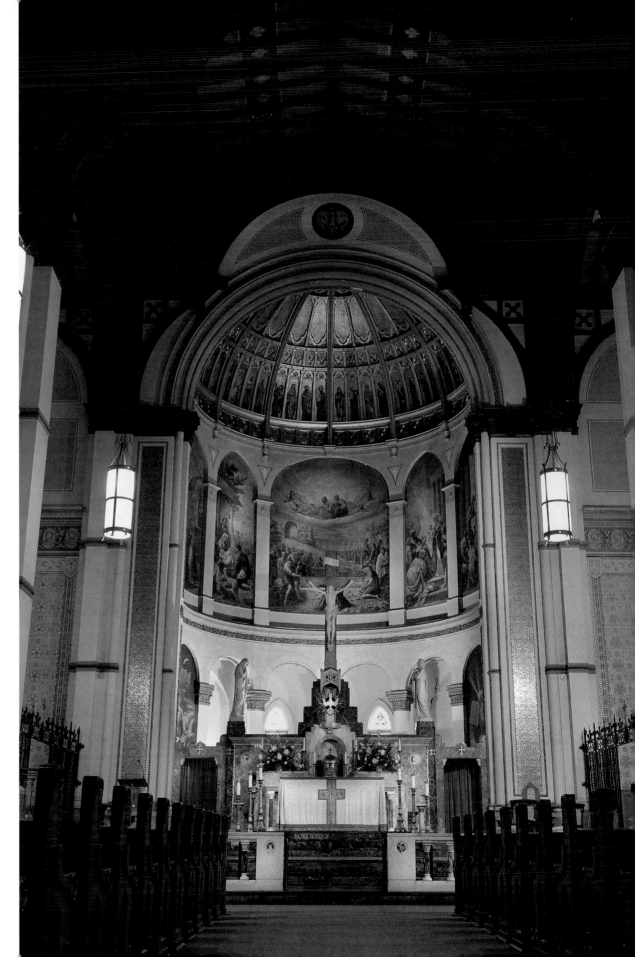

View of front of church

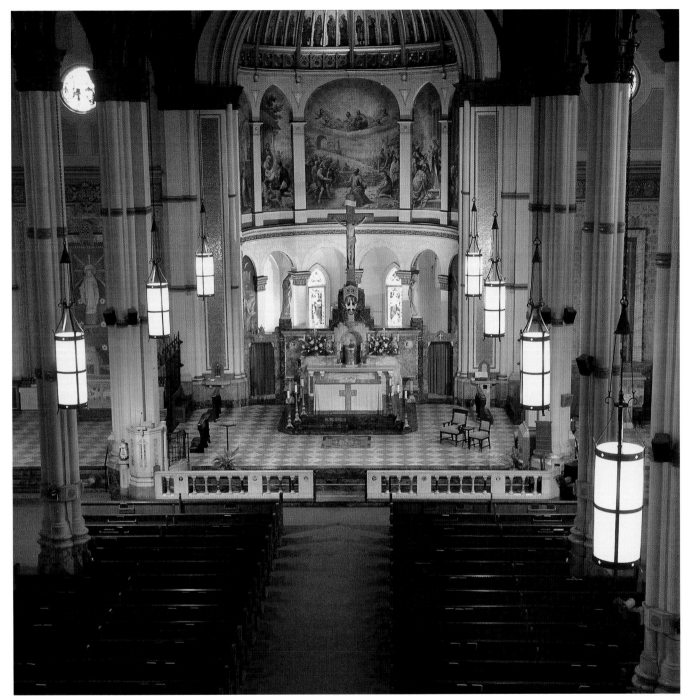

View of front of church from the choir loft

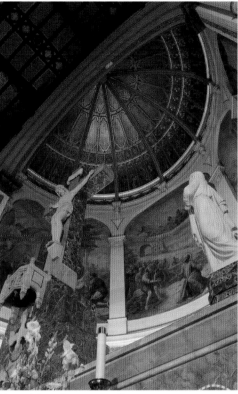

Upward view of sanctuary ceiling

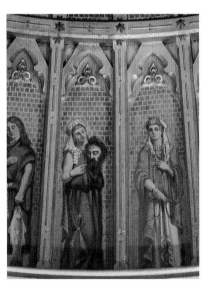

Dome detail of Salome with the head of John the Baptist

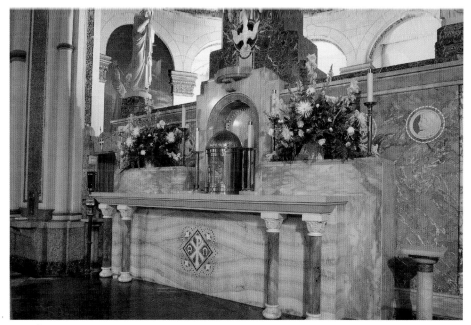

Main altar

Main altar, detail of Mary statue

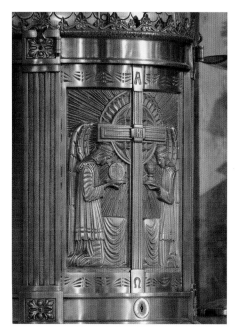

Tabernacle detail of alpha and omega, chalice and bread

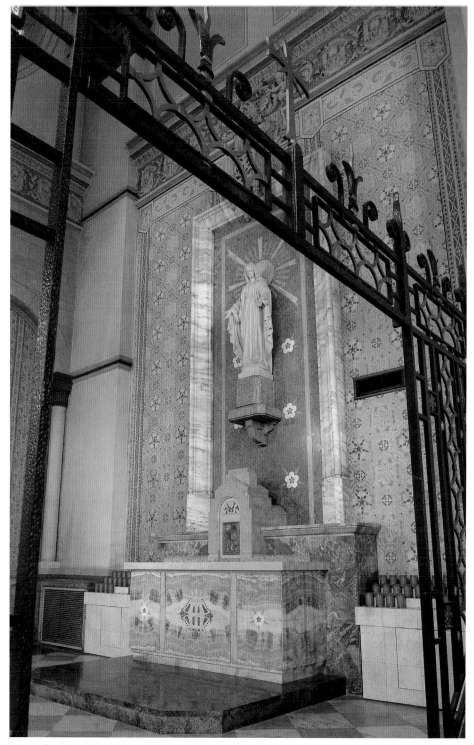

Mary's altar through iron grillwork

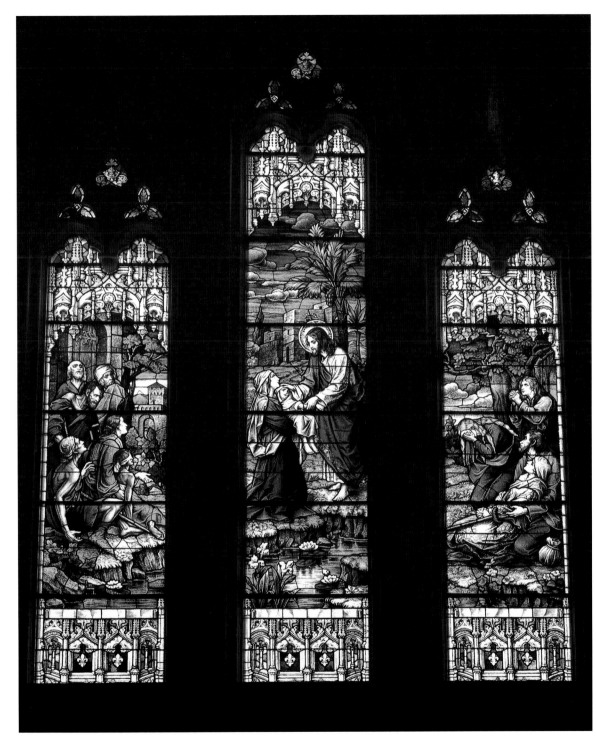

Stained glass: Jesus heals the sick

Stained glass: St. Vincent de Paul

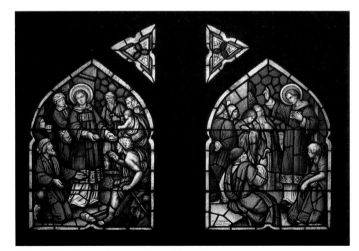

Stained glass: St. Stephen, preaching, friend of the poor

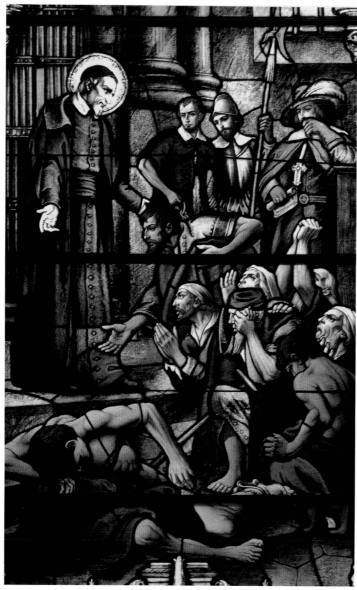

Stained glass: St. Vincent de Paul with galley slaves

Stained glass: St. Vincent de Paul brings orphans to Louise de Marillac and the Daughters of Charity

Station of the Cross X

Statue of St. Elizabeth Ann Seton *(left)*

Side wall and stained-glass windows *(far left)*

APPENDIX 1

Map and Addresses of Churches

1. Cathedral-Basilica of St. Louis King of France
615 Pere Antoine Alley
[Facing Jackson Square]

2. Blessed Francis Xavier Seelos Church
3053 Dauphine Street
[Dauphine between Montegut and Clouet]

3. Holy Name of Jesus Church
6367 St. Charles Avenue
[St. Charles across from Audubon Park]

4. Immaculate Conception Church
130 Baronne Street
[Baronne between Canal and Common]

5. Mater Dolorosa Church
8128 Plum Street
[Carrollton between Plum and Oak]

6. Our Lady of the Rosary Church
1322 Moss Street
[Esplanade between Leda and Verna]

7. St. Anthony of Padua Church
4640 Canal Street
[Canal between Olympia and St. Patrick]

8. St. Francis of Assisi Church
631 State Street
[State between Constance and Patton]

9. St. Joseph Church
1802 Tulane Avenue
[Tulane between Derbigny and Roman]

10. St Mary's Assumption Church of St. Alphonsus Parish
2030 Constance Street
[Josephine between Constance and Laurel]

11. St. Patrick Church
724 Camp Street
[Camp between Girod and Julia]

12. St. Peter Claver Church
1923 St. Philip Street
[St. Philip between Roman and Prieur]

13. St. Stephen Church of Good Shepherd Parish
1025 Napoleon Avenue
[Napoleon between Camp and Chestnut]

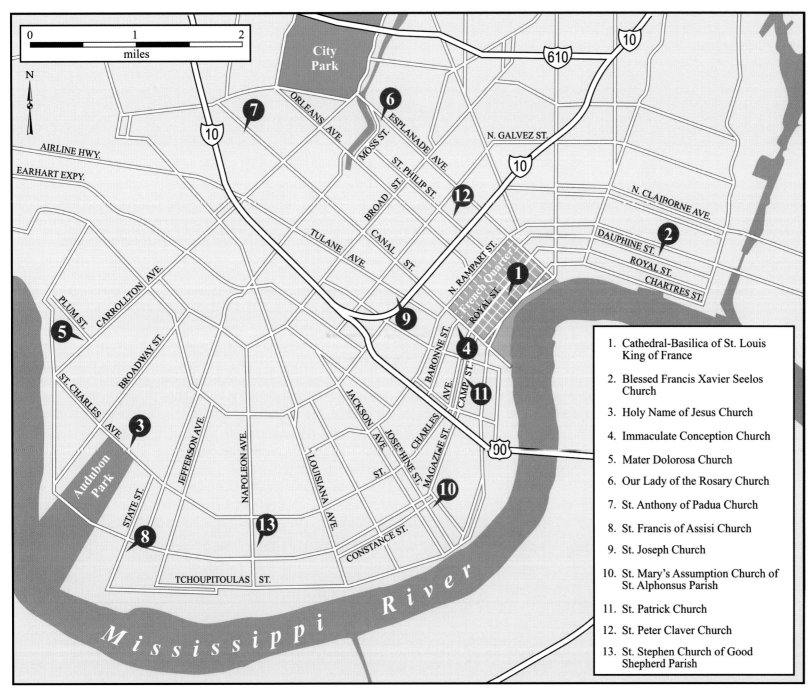

0 1 2
miles

N

City Park

AIRLINE HWY.
EARHART EXPY.

ORLEANS AVE.
ESPLANADE AVE.
MOSS ST.
ST. PHILIP ST.
BROAD ST.
TULANE AVE.
CANAL ST.
N. GALVEZ ST.
N. CLAIBORNE AVE.
DAUPHINE ST.
ROYAL ST.
CHARTRES ST.
N. RAMPART ST.
French Quarter
ROYAL ST.
BARONNE ST.
CAMP ST.
AVE.
ST. CHARLES AVE.
PLUM ST.
CARROLLTON AVE.
BROADWAY ST.
Audubon Park
JEFFERSON AVE.
NAPOLEON AVE.
LOUISIANA AVE.
JACKSON AVE.
JOSEPHINE ST.
ST. CHARLES ST.
MAGAZINE ST.
STATE ST.
CONSTANCE ST.
TCHOUPITOULAS ST.

Mississippi River

1. Cathedral-Basilica of St. Louis King of France

2. Blessed Francis Xavier Seelos Church

3. Holy Name of Jesus Church

4. Immaculate Conception Church

5. Mater Dolorosa Church

6. Our Lady of the Rosary Church

7. St. Anthony of Padua Church

8. St. Francis of Assisi Church

9. St. Joseph Church

10. St. Mary's Assumption Church of St. Alphonsus Parish

11. St. Patrick Church

12. St. Peter Claver Church

13. St. Stephen Church of Good Shepherd Parish

Map by Mary Lee Eggart

APPENDIX 2

New Orleans Catholic Parishes

The following list includes all of the Catholic parishes that have been officially established in Orleans Parish since the city of New Orleans's foundation in 1718. The date that each congregation was founded is indicated, as well as its status as of 2010. Thirty-five of the parishes are presently open; fifty are closed. The eight parishes formed after 2000 were created by merging existing parishes and using one church for the combined congregations.

In Catholic Church law, a parish and its church are distinct entities. A bishop or archbishop, when the need arises, establishes a parish, determines its boundaries, appoints a pastor, and names the parish. The place of worship receives the parish name. A permanent church is blessed and, when the debt is retired, dedicated.

When circumstances dictate, the bishop or archbishop, after mandatory consultation, can suppress, or close, a parish. A formal decree of suppression is issued. The church, however, remains a place of worship until otherwise designated. A church can serve as the place of worship for another parish, be returned to secular use, or be rededicated under a new name. The bishop or archbishop returns a church to secular use; permission from the Vatican is needed to rename a church.

Four churches in this book no longer serve as a place of worship for their original parish. St. Peter Claver (formerly St. Ann) and Blessed Frances Xavier Seelos (formerly St. Vincent de Paul) Churches have been renamed and rededicated. St. Mary's Assumption Church retains its original name but now serves St. Alphonsus Parish. St. Stephen Church also has kept its name but now serves as the place of worship for newly established Good Shepherd Parish.

As of March 1, 2009, the Archdiocese of New Orleans was divided into twelve deaneries or regions. Seven of the deaneries do or did include parishes in Orleans civil parish: 1 (Cathedral Deanery); 2 (City Park–Gentilly Deanery); 3 (Uptown Deanery); 4 (Inner City Deanery); 8 (Algiers-Plaquemines Deanery); 9 (St. Bernard Deanery); and 11 (New Orleans East Deanery). The deanery number, indicating the general section of the city where a parish is or was located, is included in the list below after the founding date. The thirteen parishes represented by the churches in this volume are indicated by italics, as are eleven closed parishes associated with the thirteen churches.

PARISH NAME	FOUNDED	DEANERY	STATUS
1. St. Louis Cathedral	1718	1	
2. St. Mary on Chartres	1805	1	Closed
3. St. Patrick	1833	4	
4. St. Vincent de Paul	1838	1	Closed
5. St. Augustine	1841	1	
6. St. Anthony on Rampart St. [aka Mortuary Chapel & Our Lady of Guadalupe]	1841	1	Closed
7. St. Mary's Assumption	1843	4	Closed
8. St. Joseph	1844	4	
9. Annunciation	1844	1	Closed
10. Holy Trinity	1847	1	Closed
11. Holy Name of Mary [aka St. Barthomew] (Algiers)	1848	8	
12. St. Mary of the Nativity	(1848)	3	Close
13. St. Theresa of Avila	1848	4	
14. Sts. Peter and Paul	1849	1	Closed
15. St. Stephen	1849	3	Closed
16. St. Alphonsus	1850	4	Using St. Mary's Assumption Church
17. Immaculate Conception	1851	4	
18. St. John the Baptist	1851	4	Closed
19. St. Ann	1852	1	Closed; transferred to Metairie
20. St. Maurice	1852	9	Closed
21. St. Henry	1856	3	Closed
22. St. Rose of Lima	1857	2	Closed
23. Notre Dame de Bon Secours	1857	4	Closed
24. St. Michael	1869	4	Closed
25. St. Boniface	1869	1	Closed
26. St. Francis de Sales	1870	4	Closed
27. Mater Dolorosa	1871	3	
28. Resurrection 1	1873	1	Closed
29. Sacred Heart of Jesus	1879	4	Closed
30. Our Lady of Good Counsel	1887	3	Closed
31. St. Francis Assisi (Ursuline Street)	1889	1	Closed
32. St. Francis of Assisi	1890	3	
33. Holy Name of Jesus	1892	3	
34. St. Katharine	1892	4	Closed
35. St. Cecilia	1897	4	Closed
36. Our Lady of Lourdes	1905	3	Closed
37. Our Lady of the Rosary	1907	2	
38. St. Joan of Arc	1909	3	Closed
39. Our Lady Star of the Sea	1911	1	
40. Holy Ghost	1915	4	Closed
41. St. Anthony of Padua	1915	4	
42. Blessed Sacrament	1915	3	Closed
43. Corpus Christi	1916	1	Closed
44. All Saints	1919	8	
45. Holy Redeemer	1919	1	Closed
46. St. Peter Claver	1920	1	Using former St. Ann Church
47. St. Matthias	1920	3	Closed
48. St. James Major	1920	2	
49. St. Leo the Great	1920	2	Closed
50. St. Rita	1921	3	
51. Incarnate Word	1922	3	Closed
52. St. Dominic	1924	2	
53. St. Monica	1924	4	Closed
54. St. Mary of the Angels	1925	1	
55. St. Theresa of the Child Jesus	1929	3	Closed
56. St. Raymond	1929	2	Closed
57. St. David	1937	1	
58. St. Paul the Apostle	1947	11	
59. St. Raphael the Archangel	1947	2	Closed
60. Epiphany	1948	1	Closed
61. St. Philip the Apostle	1949	1	Closed
62. St. Andrew the Apostle	1952	8	
63. St. Julian Eymard	1952	8	Closed
64. St. Francis Xavier Cabrini	1952	2	Closed
65. St. Pius X	1953	2	
66. Immaculate Heart of Mary	1954	11	Closed
67. St. Gabriel the Archangel	1954	2	
68. Resurrection of Our Lord	1963	11	
69. St. Maria Goretti	1965	11	
70. St. Thomas More (Tulane University)	1970	3	Closed
71. St. Gerard for the Hearing Impaired	1971	1	Closed
72. St. Nicholas of Myra	1971	11	Closed
73. Holy Spirit	1972	8	
74. St. Thomas the Apostle (UNO)	1974	2	Closed
75. St. Brigid	1977	11	Closed
76. St. Simon Peter	1986	11	Closed
77. Mary Queen of Vietnam	1983	11	
78. Blessed Francis Xavier Seelos	2001	1	Using former St. Vincent de Paul Church
79. Good Shepherd	2008	3	Using St. Stephen Church
80. St. Raymond–St. Leo the Great	2008	2	Using St. Leo the Great Church
81. St. Katharine Drexel	2008	4	Using Holy Ghost Church
82. Blessed Sacrament–St. Joan of Arc	2008	3	Using St. Joan of Arc Church
83. Blessed Trinity	2008	3	Using St. Matthias Church
84. Corpus Christi–Epiphany	2008	1	Using Corpus Christ Church
85. Transfiguration of the Lord	2008	2	Will use St. Raphael Church

BIBLIOGRAPHY

ARCHIVAL SOURCES

Archives, Archdiocese of New Orleans
(AANO). New Orleans.
 Archdiocese of New Orleans Newspa-
 pers Collection.
 Hanging File (Parishes, Persons, and
 Events).
 Nolan, Charles, Professional Papers
 Collection.
 Official Catholic Directories,
 1836–2008.
 Parish Reports and Correspondence.
Archives, *Catholic Action of the South*
 and *Clarion Herald. Clarion Herald*
 Offices. New Orleans.
 Hanging File (Parishes, Persons,
 Events).

BOOKS

Apostolos-Cappadona, Diane. *Dictionary
 of Christian Art.* New York: Con-
 tinuum, 1995.
Baudier, Roger. *The Catholic Church in
 Louisiana.* New Orleans: 1939. Re-
 print, Louisiana Library Association
 Public Library Section, 1972.

Christovich, Mary Louise, et al. *New
 Orleans Architecture.* 7 vols. Gretna:
 Pelican Publishing Company/Friends
 of the Cabildo, 1971–1989.
Gurtner, George. *Historic Churches of
 Old New Orleans.* With photography
 by Frank H. Methe III. New Orleans:
 Friends of St. Alphonsus, 1997.
Meagher, Paul Kevin, Thomas C.
 O'Brien, and Consuelo Maria Aherne.
 Encyclopedic Dictionary of Religion.
 3 vols. Washington, D.C.: Corpus
 Publications, 1978.
Nolan, Charles E. *A History of the Arch-
 diocese of New Orleans.* Strasbourg:
 Editions du Signe, 2000.
———. "Modest and Humble Crosses: A
 History of Catholic Parishes in the
 South Central Region, 1850–1984."
 In *The American Catholic Parish:
 A History from 1850 to the Present,*
 edited by Jay Dolan, I:235–346. 2 vols.
 New York: Paulist Press, 1987.

PERIODICALS

Catholic Action of the South, July 20,

1950; August 10, 1950; September 28, 1950.

Clarion Herald, November 11, 1999; June 28, 2008; July 20, 2008.

Farnsworth, Jean M. "The Stained Glass of New Orleans." *Stained Glass Quarterly* (Winter 1990): 283–90.

Morning Star and Catholic Messenger (aka *Morning Star*), February 16, 1868; April 12, 1868; July 12, 1868; January 26, 1889; March 14, 1908; April 18, 1908; April 25, 1908; May 16, 1908; December 12, 1908; March 6, 1909; March 13, 1909; July 1912 (Louisiana Statehood Centennial Edition); January 23, 1915; August 14, 1915; September 25, 1915; October 9, 1915; January 1, 1916; January 8, 1916; June 10, 1916; August 19, 1916; October 7, 1916.

Villarrubia, Jan. "Making the Nine Churches." *Gambit*, March 26, 1983.

Following are sources consulted for specific churches.

THE CATHEDRAL-BASILICA OF ST. LOUIS KING OF FRANCE

Chambon, C. M. *In and Around the Old St. Louis Cathedral.* New Orleans, 1908.

Huber, Leonard V., and Samuel Wilson, Jr. *The Basilica on Jackson Square: The History of the St. Louis Cathedral and Its Predecessors, 1727–1965.* New Orleans, 1965.

Nolan, Charles E. *Cathedral-Basilica of St. Louis King of France, New Orleans, Louisiana.* With photographs by Frank J. Methe. Strasbourg: Editions du Signe, 2009.

———. *St. Louis Cathedral/Old Ursuline Convent: A Catholic Cultural Heritage Center.* With photographs by Frank J. Methe. Strasbourg: Editions du Signe, 2004.

Sellers, Charles, O.M.I. *The Life of St. Louis IX King of France through Ten Stained Glass Windows.* New Orleans: Laborde Printing Company, 1996.

BLESSED FRANCIS XAVIER SEELOS CHURCH

Toy, Joseph C., S.F.S.F., ed. *A History of St. Vincent de Paul Parish (1838–1967), Commemorating the 100th Anniversary of St. Vincent de Paul Church (1866–1966).* New Orleans, 1967.

HOLY NAME OF JESUS CHURCH

Hawkins, Donald, S.J. *Church on the Park: Holy Name of Jesus Church.* New Orleans, 1987.

IMMACULATE CONCEPTION CHURCH

Rivet, Hilton L., S.J. *The History of the Immaculate Conception Church in New Orleans (The Jesuits).* New Orleans, 1978.

MATER DOLOROSA CHURCH

Baudier, Roger. *Mater Dolorosa Church, Parish Centennial, 1848–1948.* New Orleans, 1948.

OUR LADY OF THE ROSARY CHURCH

Baudier, Roger. *Our Lady of the Holy Rosary Golden Jubilee, 1958.* New Orleans, 1958.

Caillouet, L. Abel. *Story of the Building of a Parish Church: Our Lady of the Holy Rosary, New Orleans, with Descriptions of Statuary, Windows, Apsidal Decoration.* New Orleans, n.d.

ST. ANTHONY OF PADUA CHURCH

Cote, Arthur B., O.P. *St. Anthony of Padua Parish Silver Anniversary, 1915–1940.* New Orleans, 1940.

St. Anthony of Padua Church through Fifty Years: Dominican Fathers, Brothers and Sisters, New Orleans, Louisiana. New Orleans, 1965.

ST. FRANCIS OF ASSISI CHURCH

Campbell, Margaret M., ed. *St. Francis of Assisi Parish, New Orleans, Louisiana, 1890–1990.* New Orleans, 1990.

ST. JOSEPH CHURCH

Andrews, Patricia. "Windows of St. Joseph Church." Report, July 14, 2008. Copy, St. Joseph Parish.

150th Anniversary Celebration of the Vincentian Order at St. Joseph Church, 1858–2008, and the 25th Jubilee of Father Perry Henry. New Orleans, 2008.

St. Joseph Church, "One Hundred Years of Service," 1892–1992. New Orleans, 1992.

ST. MARY'S ASSUMPTION CHURCH

Krieger, B. J. *Seventy Years of Service (1923), One Hundred Years in New Orleans, La., Centenary Souvenir, Redemptorist Fathers (1944).* New Orleans, 1944.

St. Mary Assumption Church. New Orleans, n.d.

One Hundred Years in New Orleans, La., 1843[–]1943, Centenary Souvenir, Redemptorist Fathers, January 12, 13, 14, 1944. New Orleans: 1944.

ST. PATRICK CHURCH

Dufour, Charles L., ed. *St. Patrick's of New Orleans, 1933–1958.* New Orleans: St. Patrick's Parish, 1959.

Wilson, Samuel L., Jr. *St. Patrick's Church, 1833–1992, A National Historic Landmark: Its History and Its Pastors.* New Orleans, 1992.

ST. PETER CLAVER CHURCH

Jacques, Michael, S.S.E. Interview with the author. April 19, 2009.

St. Peter Claver Church, New Orleans, Louisiana. South Hackensack, N.J.: Custombooks, Inc., 1971.

St. Peter Claver Church 75 Year Anniversary, 1920–1995. New Orleans, 1995.

ST. STEPHEN CHURCH

St. Stephen's Parish 125th Anniversary, 1849–1974. New Orleans, 1974.

St. Stephen Catholic Church, 1025 Napoleon Avenue, New Orleans, Louisiana. New Orleans, n.d.

.